MON AFRIQUE

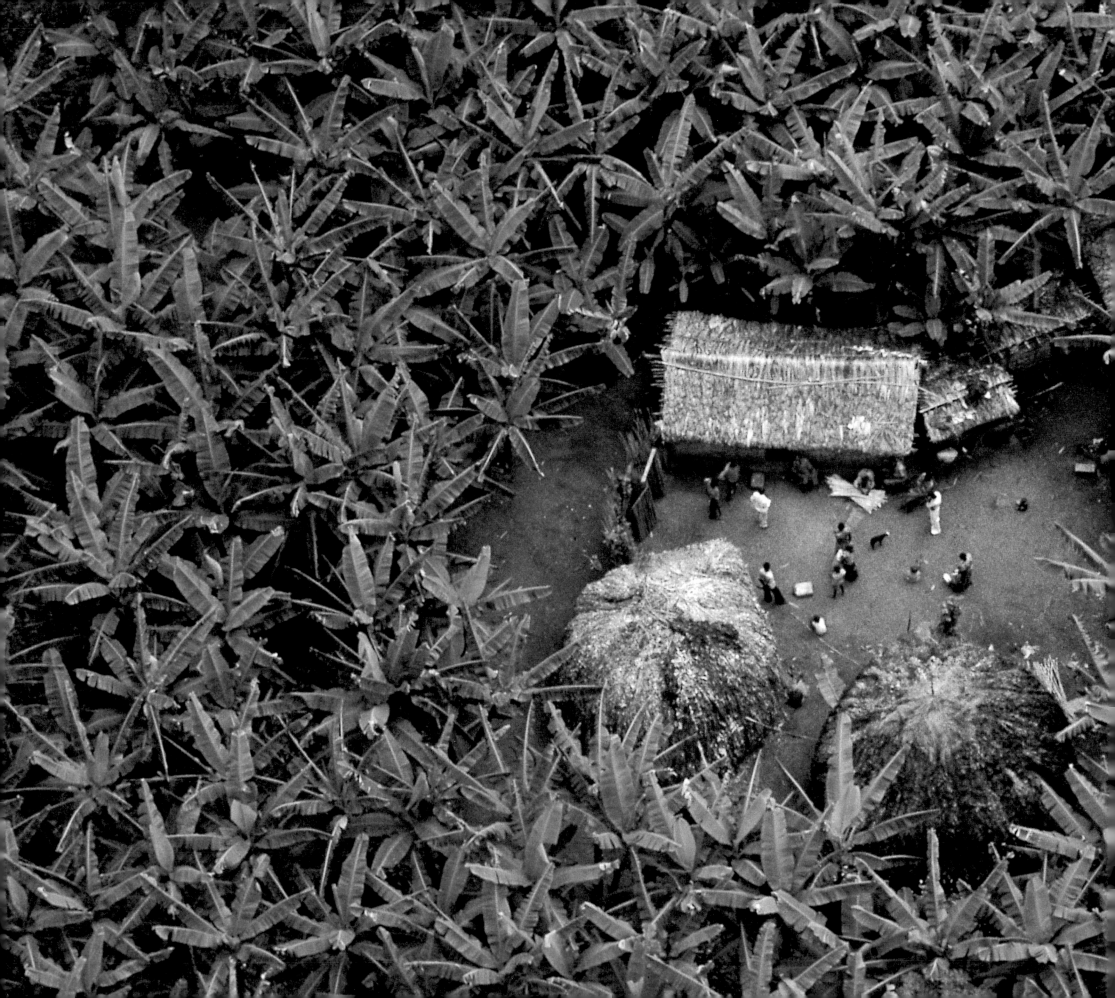

MON AFRIQUE

PHOTOGRAPHS OF SUB-SAHARAN AFRICA BY PASCAL MAITRE

PREFACE BY CALIXTHE BEYALA

CHAPTER TEXTS BY JEAN-CLAUDE NOUVELIÈRE

APERTURE

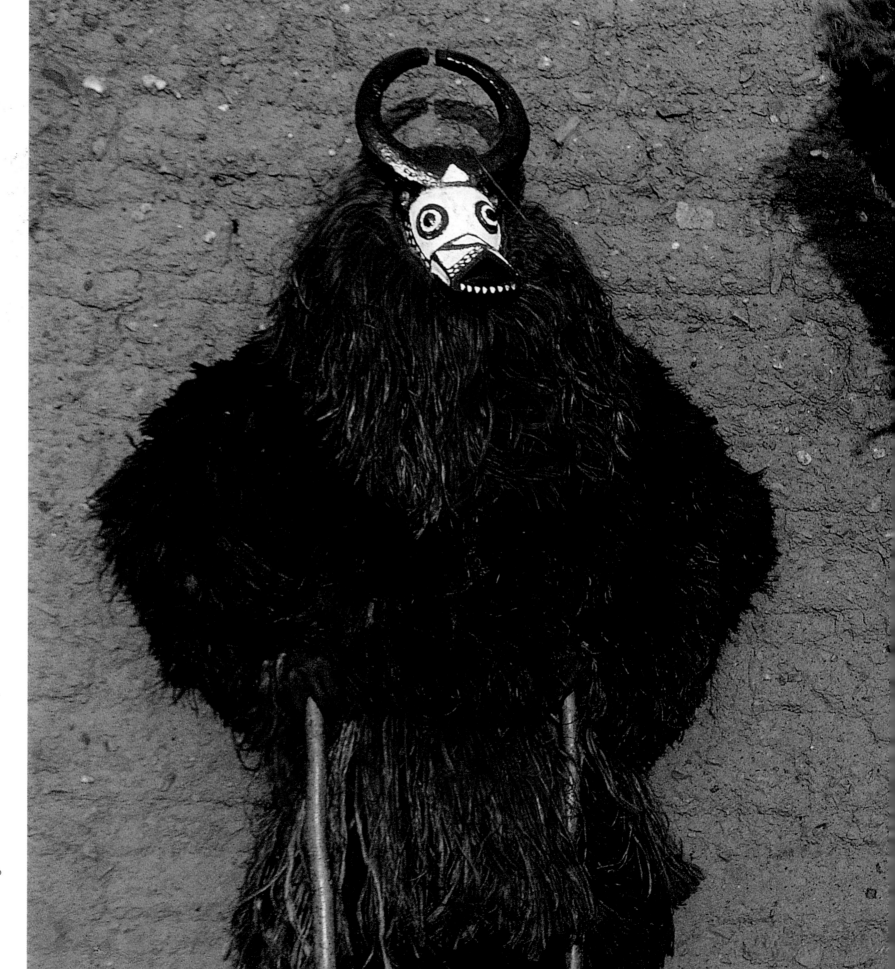

CONGO (DEMOCRATIC REPUBLIC OF THE CONGO, FORMERLY ZAIRE), 1985. (previous page)
In the Kivu region near Goma, on every little hill is a family plantation isolated and surrounded by banana trees. This type of isolated habitation facilitated the Rwandan genocide.

BURKINA FASO, 1994. (right)
Funeral services for the Chief of Masks among the Bwa (also known as the Bobo) at Boni. These masks represent antelopes and buffalos; they serve as reminders to the clan that the life of one of their earliest ancestors was saved by a buffalo and an antelope.

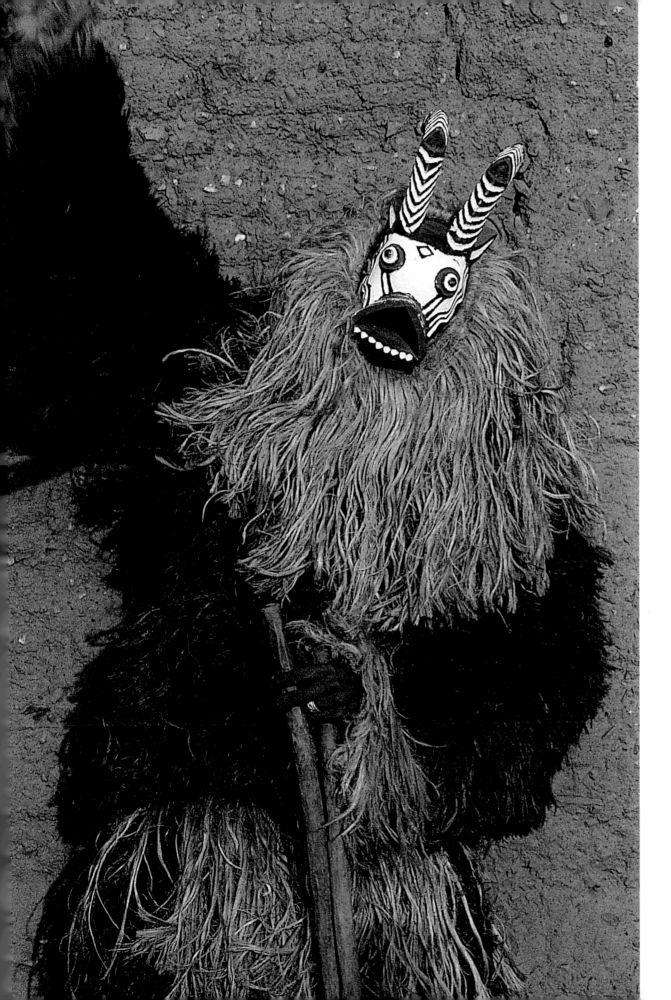

CONTENTS

OUR AFRICA CAME ON SUNDAYS

Calixthe Beyala

I t always happens that I find myself listening to distinguished specialists, experts on the continent of Africa, prophesying her imminent death unless the world's governments immediately adopt proper measures to alleviate her suffering, her strange tribal wars, her mangled economy, her marsh fever, cholera, dysentery, malaria, her desperate ills, and her ancestral practices. Whether these sentences are pronounced by foreigners in the grip of a fascination with their thousand-year-old past or by the elite of the African societies burdened with complexes—those sponges absorbing the favors of the West—I look at the azure sky, and my face, battling the sun's assault, hides a parade of syncopated images, images based in the soil that give them meaning. Stocky and muscular men, tamers of forests and mountains; androgynous men of the Sahel, withered like the surviving branches of a dead tree; mother-women, flame-women pounding the millet of life, serpent-women, veiled women as straight as the guide to truth. And again our women, breeding courage as nowhere else in the world. Whether prostrate and silent like a dove whose brood has just hatched, or demonic and so suave it makes you forget a return to your native land, they are the backbone of the black continent. They are the green of its trees, the pink of its bougainvillea, the yellow of its royal poinciana and other colors of various plants the names of which I do not know. Then a smile broadens my lips: what absurdity to think, even for the blink of an eye, that the flames of the civilizations that have seen mankind burgeon and shine for ages could be extinguished like green wood! Pure insanity to imagine that this land prominently placed at the bottom of the world, with its ability to adapt, its imagination, and its creativity, could stop like a breath caught in the throat! Africa disappearing. . . Sure. When her women no longer exist.

"What your eyes think they're seeing," my grandmother used to say in her voice as sweet as sugarcane, "might only be an illusion." The illusion is the hairy monkey that in its invisible reality is a child; it is the tree that is a brook; it is the woman who is an elephant. Grandmother would sit down in the shade of a mango tree, her emaciated legs crossed in all their dignity. Motionless, she would fly off into places of beginnings. Her dragonfly wings would spin in the air, sever skies, and burst the heart of mountains. In her ears the leopard-man would murmur scenes to render one speechless. The lion-bird would whirl and whimper in the trees: "Tell me, when will you marry me?" And each of the gods would preach the sole principle of the animist moral to the stones: respect for life in each and every thing.

Although I have been Westernized, I am like Africa, steeped in the invisible. My perception of the universe, the events that cross my destiny, my relationships with others have all been conditioned by my animist education. "The dead are not dead, they are in this leaf, trembling in the wind; they are in this moaning brook," our old men would chant. "Your totem animal is what you are. When he is hurt, you bleed; whatever becomes of him will become of you."

Even by using literal translations, it is difficult to explain the meaning of this truth to a Cartesian mind. It took me years to take Western culture with the left hand and African civilizations with the right hand, to bring them together into an indivisible whole in order to understand that, white and black, we were looking at the same events but hardly seeing the same things. What absurdities, what misconceptions, and what incomprehension have marked our common histories! What hasty judgments! How much laughter where there should have been tears! How many tears where an explosion of joy would have been fitting! The stars could enumerate the many misunderstandings they have witnessed as helpless bystanders: from the first conquests of the white man to the fall of the great empires of Mali or Ghana; from the enslavement of the black peoples to the colonization of Africa; from the wars to the days of independence.

Indeed, these days of independence were undoubtedly the greatest farce in the history of modern humanity. In Africa

they exploded like fireworks into bouquets of airplanes criss-crossing the sky. People burst out of joyfully garlanded houses like a dark conscience: "Long live independence!" The wings of the mango trees, the trunks of the coconut trees, and even the coffee trees' vertebrae swayed in the arms of the wind like the locks of an old woman possessed by spirits.

Grandmother told me that she was sitting beneath the dusty verandah, grinding manioc. Dust and manioc, that was our reality, which explains why she did not participate in the festivities. She sharply bit her tongue when my Aunt Balbine dragged herself out of the kitchen, her face covered with sweat:

"Where are you going when you should be helping me prepare the manioc sticks?"

"It's independence day today, mother!"

"Who is that, independence? Who is its father, who is its mother?"

"It means that we are free!"

"Oh really? I thought that only my mind was capable of liberating or imprisoning me."

"Drop it, mother. You don't understand." Then she added: "Neither do I, for that matter. But the President of the Republic says it's a holiday!"

And President Ahmadou Ahidjo shouted out his joy emphatically: "Long live independent Cameroon!" In the Central African Republic, David Dacko celebrated the event on the required scale. In Senegal, Senghor organized with great exultation, receiving his intellectual friends with pomp and the impressive words "We shall achieve great things!" With whom? we were tempted to ask them. It was a euphemism to assert that when independence came, the continent counted so few intellectuals, engineers, accountants, and office employees that one's mental arithmetic would hardly be lost.

"Who is that, independence? Who is its father, who is its mother?" Every 1st of January, the few descendants of the Etung peoples, to which I belong, would seek, like millions of Africans, the genealogy of the independence and its reason for being. I would go to the parade, almost apprehensive. I was worried, too: Was I holding my head straight? Were my arms properly balanced when I marched? We really had to show

our dignitaries that we were totally obedient citizens. The fact remains that we didn't understand anything of their political speeches, of national unity, and of what sovereignty of the state meant.

Admittedly, there were the fifteen kilometers I walked to go to school. Our teachers were supposed to explain to us by what process of transmutation it would be possible to have such different peoples as the Bamileke and the Beti of Cameroon survive under a single flag; the castes of blacksmiths and jewelry makers of Senegal; the Malinke and the Toucouleurs! Despite the cultural, ethnic, and linguistic differences, French and English were to be adopted as national languages. We recited "Our ancestors the Gauls." We sang "To Cameroon, the cradle of our ancestors–In days gone by you lived in barbarity." We reeled off *Mamadou and Bineta Are Going to School*, a mythical book for pupils in the French-speaking zone.

At the time I did not know a human being could be called Mamadou or Bineta. My classmates' names were Ngoyobi or Biloa. For our leaders the disparity between schooling and local realities seemed to hold no importance whatsoever. The objective was the edification of a nation according to the universalist model, French-style.

When school let out we used to shriek with joy; one would have thought we were robins taking flight. We were so happy to escape from that incomprehensible elsewhere that we'd catch baby chicks and disembowel them, for a moment forgetting the animist principles of respect. We'd steal juicy mangoes from the compounds, devour them before using the pits to pelt the scrawny dogs; we'd catch gray mice, pour kerosene over them, and burn them alive, clapping our hands with joy until they exploded. Then, since we were only children, we would go home, exhausted from the sun. We'd dawdle in front of the bars where prostitutes were distracting their clients by gyrating their backsides like fans. Our Africa's sudden dusk would chase us toward our dwellings of corrugated metal, thatch, mud, and German roofing materials inherited from the Second World War.

Later, when my work as a writer led me to Dakar or Niamey, Libreville or Bangui (the place I was mattered little),

I would inhabit my bird-woman skin, my totem animal. I would fly over cities and countryside. I would whirl above improvement and reorganization projects. I would whine about the challenges thrust at development and democratization. These situations seemed hilarious to me, for traditional societies were already democratic long before the white people arrived. And when I'd land beneath a tree, my wings broken with fatigue, I thought with a smile that where independence and development of the black continent were concerned, the West was behaving like a polygamist giving its multiple wives the same dress, the same jewelry, at the same time so as not to cause a scene . . . Unless it was only an elegant way of throwing them out the window like a poisonous gift.

I was a child, and Grandmother was sitting in front of a bowl of manioc. She wouldn't ask me about school, for what we learned there had no place in the traditional education she was giving me. She would hook her pipe between her lips and we'd be off to the evening market, toward the glow of the streetlights. We would sell our manioc sticks and other women sold whatever it was they had for sale: steamed or fried fish, plantains or yams, pineapple or wild mango, peanuts or palm nuts, taro or pine fruit. The whole culinary diversity of Africa was present in that serenade of smells, colors, and flavors that would cause foreigners to say: what magic!

The women perspired, quibbled, shifted things, saving their last bits of energy so their families would survive, so Africa would exist. People came and went, buying, gathering by social class, which was determined by their level of education. Some discussed Molière, others Sartre or Einstein. But whenever the conversation broached problems of witchcraft, the evil eye, spirit-women who would take on a human body in order to cast a spell over men and deceive them about their true nature, the crowd would become one. Our hearts pounded at these tales; our flesh would crawl with horror because these mysteries of Africa, these worlds of the invisible were our truths. Granted, they were obscure and mystical, but they were the only ones put forth as obvious facts. Every African, no matter what his origins or social lineage, whether rich or poor, farmer or city dweller, whether he lives in a mul-

tistory house or in a shantytown, will swear to you on his mother's head that, at least once on his path, he has come across a spirit, and he will describe its strengths and weaknesses, its look and its behavior for you.

Like everyone of my generation, I was rocked to sleep with these stories, which in no way kept me from opening my notebooks, studying my arithmetic, geometry, and science. Like a coconut, the world seemed cut in two. One part was steeped in Cartesian logic; the other was twisted by the very roots of the soil still entangled in my hair today. Later in the evening, Grandmother would set the table to feed the spirits. For them she would choose the best morsels of porcupine or crocodile, the thickest plantains and the tenderest bananas. Reluctantly we'd go to our bedroom: "You shouldn't frighten the spirits," she'd mutter. We slept on a straw mattress. Its acrid smell would prickle my nostrils and plunge me into nameless bliss. She told me the epic of our people, how they crossed the Sanaga on the back of a boa; she spoke of my great-grandfather, who had tremendous magical powers. I would picture him, tall and so thin that he melted away in the landscape. At daybreak he would plant a banana tree. He would remain standing, as straight as a rope being pulled. He would assemble the genies of the water and the forest, and make them comply with his wish to see the tree grow before the world of ghosts was to throw its mauve veil over the sun. And his will was done.

Grandmother said that he was living in my mortal flesh. She'd chew a kola nut and spit its juice on my face: "Daughter of Assanga Djuli," she would add, "I hope that the school of the whites will not make you lose your powers." And to better catch my attention, she'd conclude: "My teachings are not found in any book!"

During nights of the full moon, we would leave the space of modern time behind to penetrate the Africa that was, is, and will be. In that suspended time, in that brief pause meant to be eternal, Grandmother would light such an enormous fire that its flames crackled in the sky. I would get undressed and crouch in front of the fire while she burned tree bark and leaves. And in the hours when the heat was no longer blazing, the breeze would emerge from the marshland and

come across walls, rush between paths, slide into the arms of palm trees, and stop above the fire to catch these scents and impart them to the depths of my heart. Grandmother would rub my body with that mixture and in a pure and bewitching voice she'd say: "Find yourself, wake up in knowledge," she would ceaselessly repeat. "Find yourself in what used to be." Then, as the ceremony came to an end, she'd add: "A bucket of water thrown into the ocean does not make the tide go higher." And this sentence underlined the profound gap that separated the future from the past, torment from hope.

We retraced our steps in silence without turning around. Then I'd fall asleep in this universe where the wind carried the tormented soul of the dead–who had lived the way one survives, blind, deaf, indifferent to the desires of the ancestors– and where rivers were many mysterious voices moaning in the stream of time.

Dawn brought a rainfall of soldiers. They flooded our huts: "Where are the resistance workers? Where are you hiding them?" They broke our furniture. They crushed our calabashes. They seized our men. They killed what could be killed, animals or people. Then they hanged them on the trees so that we would not forget the extreme power of our President for Life. We said nothing because they were doing their work. What could we have said in opposition? Besides, our President for Life, following the example of Bokassa or Mobutu, Houphouet Boigny or Tombolbaye, was practicing white magic. People whispered that invisible powers were informing him of the least of our tiniest intentions. Henceforth, he was able to assume the shape of a storm, emerge at the plotter's home and slit his throat. In the face of these threats, we were left with only one freedom, the freedom to remain silent. The soldiers disappeared among the trees. We gathered around our fires, ate our midday meal of bean and banana fritters, of millet or sorghum gruel. Life began again. Cats were meowing. Dogs barking. The resistance workers were decomposing in the sun. We did not mourn them, for we did not know what the words "resistance worker" meant. They were too high up, too far away; like independence, with its arcane politics that would trample without seeing those who fell in the way and

would walk over the remains of the innocent. This was not our Africa.

Our Africa came on Sundays and, incredibly, resembled the photographs of Pascal Maitre. In the compounds, half-naked children ran after fowl. They'd catch them in a rustling of wings. They would strangle them and little girls would pluck them, as scrawny dogs watched attentively. Then we would go to the well, because the moment of beautiful white clothes had come, of church hymns, drums, balafons, and of women who, for the love of God, caused the dust to rise while they chanted. As for the kids, they would take communion several times in a row in order to better enjoy the body of Christ.

I remember my first communion and each one of the three little girls in Maitre's photo could have been me. They are Africa in the overstated adoption of certain elements from that elsewhere which Westerners label a caricature. Is it for real, is it to be laughed at? On our soil, Christ has evolved to the sound of balafons and drums; he has become manioc stick and gumbo, has become mixed in with ganga drum, fetish, marabout, the genies of the waters, and the malevolent Kong spirit, although he already was all of that rolled into one since his beginning. And the Latin prayers, of which we understood nothing at all, intensified the sense of a still more complex divine spirit in us. Like the West, in its hands it brought together cars, refrigerators, airplanes, submachine guns, gas stoves, and all the excess to which we aspired but that passed by us in the distance, as luminous as a faraway comet.

At the end of the mass, we would go home so exhausted with fatigue and hunger that very often we would cross the path of someone more dead than alive, or a ghost, a spirit or a genie of the waters. We would blink our eyes in the sun: "Did you see what I just saw?" We would clear our throats and look at our wrists that had no watches: "It's their time . . ." Then we'd continue on our way, our feet screaming with pain in their too-tight shoes. The least brave would take them off and put them on top of their heads. We would go inside our house, faces as sad as penitents, and drop down in the benevolent shade of the trees. My aunt would poke her head through the half-open window. "Dinner's ready!"

We'd flock together around a calabash of rice and chicken, which we ate with our fingers, while in the distance a radio spouted the news, essentially made up of decrees and death notices. From time to time, we would hear that a rebellion of the Kasaï peoples had been suppressed; that the inhabitants of Chad or Biafra were fleeing in droves from their countries and coming to find refuge in our land. This news, parsimoniously spelled out, came to us emptied of meaning, of the suffering it implied, of the wretchedness it brought, and gave free course to our baroque imagination: "What happens to the spirits of their ancestors when they abandon their homes?" Grandmother wondered. "Who takes care of them?" And these unfortunate individuals who, in their haste, must have lost their spirits in nature, became true subjects of concern for us. Were they being deposited in camps surrounded by barbed wire? Soldiers armed like bombs watching them with their bloodshot eyes? We went our way, because it was impossible for us to add even greater burdens to those we already had and which, once again, we didn't understand.

The man who runs after time is already late, the proverb says, and we would take that time in the shade of trees. We'd drink palm wine or ginger juice, corn beer or coconut milk, because there is a time for everything, a time to be lost and a time to meet again. And on those African Sundays, when the sun would tilt slightly to the West, would come the initiation celebrations, the ceremonies for the dead, and the spirits passing on their rounds. Christian-Animists, Buddhist-Animists, Muslim-Animists, men, women, and children, daubed with the colors of their tribe, would invade forests, savannas, seas, or deserts, while those who lived in the cities would transform their alleys into a vast magic field where the roles of man and gods grew intermingled and complementary in order to give meaning to the world.

How many times did I attend these scenes? A hundred times, a thousand times? I still have the same passion for participating or for watching this original Africa, this banished, degraded, scorned, cannibalized, enslaved, colonized Africa reconsider herself for a few hours, a few days, excited and extravagant in her demonstrations of joy, hatred, or sadness.

In these moments, the poor shed their misery; the for-

tunes of the rich explode in a myriad of illusions; the disabled display their beauty. Faced with this profusion of one's deepest self, Western intellectuals speak of the "contradiction of Africa." They stand dumbfounded when they notice that, despite the scientific knowledge with which they inculcate us, our traditions clasp us tightly like the bonds of perpetual imprisonment, like slugs that glue us in their whorls. During my university years, I was to remain bewildered when reading articles about the black continent written by eminent academicians, political analysts, and other individuals able to evaluate the development of peoples. They identify the contradictions in a society by the clothing styles of its inhabitants, by their hats, their shoes, and as a result they confuse being with appearance, what is with what seems to be. In completely good faith they associate animism with savagery, primitive cultures. They are quick to forget one irrefutable fact: all religions are animist! The African peoples have always understood this. They lift themselves up to universalism by making the ancestral totems cohabit with figures of Christ carved from pieces of wood eaten through by vermin; with prayer rugs of Allah and cowry shells of the spirits.

In the name of a voice that carries others along with it, there is something in me that makes their certainties quaver: we've been taking only that from the West which did not debilitate our souls.

Africa has understood: animism is the underpinning of every belief. Like the oracle, she will not tell as long as the question has not been posed. Political experts will never know that what they believe to be the truth is merely their own fiction. We have realized that no culture is wholly dark or light; that each one carries a seed of truth of which ours is the bedrock. Our soil will tell you that its redness comes from the hemorrhage it suffered when it opened itself up to let men stream out; our sick are smeared with it to revive them, thanks to the beneficial effects of its protective womb. Our rivers will tell you that they are the seven bitter tears wept by generations of women; that the fish, fauna, and flora were born from the incarnation of the sufferings of mothers. In our forests or our savannas, in our mountains or our plains, every tree, every plant, every liana saves us from the oblivion of

what has been and reminds us of the sacred bonds between humanity, spirit, and nature. This complicity between each element of life explains the vitality of our ancestral customs, despite the ceaseless assault of Western technological progress. It is the secular strength, the eye through which Africa grasps the world.

One morning in the red glow of the sun, Grandmother went away to the land of the spirits: "The time has come for me to go back to my father's place," she said to us in all simplicity. I saw her move farther and farther away, step by step, until she disappeared where the woods began. Nobody wept: she had accomplished her mission as woman, mother, and grandmother. Her rest was well deserved, her body never found.

I went elsewhere as well, with my spirits in my suitcase, in pursuit of material comfort. I often go back home, steeped in the West, but the soles of my feet are covered with Africa's dust, her lianas, her mud, her puddles of water and her winds. First I visit one of my sisters, the midwife, gynecologist, cardiologist, urologist, and cancer specialist of a small clinic in the bush. For me she is the Africa that Westerners characterize as contradictory: she was married in white and carried orange blossoms in the Apostolic Catholic Church, and this in her ninth month of pregnancy with her eighth child, and after more than twenty years of traditional marriage. This is the way we are, we are Africa, for ourselves, without the shadow of any contradiction. Our feet are immersed in antiquity and our heads in the third millennium.

When I come out of the plane, I run to the stand where dozens of bush taxis with crazy names try to lure the customers with phrases like "one hundred per hour!" or "the Boeing of Conakry" or "life doesn't give a damn." I pay my fare to the driver: why must they always hide their eyes behind Raybans made in Hong Kong? People stare suspiciously at me, me, so new and shiny, looking so foreign. I know this land, but I am still dazed by all these men, women, dogs, chickens cackling in baskets, bleating goats, these pushcarts weighted down with bags of coal, bananas, leather, merchandise of every sort that is being loaded on or unloaded from the top of taxis. In mud or dust, there is the smoke of fried or grilled food, the offal of beef, soybeans and cries, clamoring and curses. I am happy in this sumptuous, rich, and cascading Africa. She unsettles me, intoxicates me, erodes me and consumes my contemplative brain. These scenes fit together, are connected, and arranged inside me in doublets and triads, in echoes and variations. Each story seems to frame several more, like the play of reflections, multiplied images, and mirrors.

As the taxi starts moving and the procession of landscapes passes by, I lean over to a passing field of palm trees or hevea with the gesture of a chief. I greet the coconut and pine trees, the soursop, and the baobab, our tree where meetings are held, stories told, our tree of justice and peace: "I love you!" And in the indifferent heat I watch our cities rush by, cities that have grown into megalopolises. I notice men in suits but I know that every one of them is wearing a protective amulet underneath his clothes. Then come the villages. I see children running, women in colorful boubous, and another woman sitting beneath a verandah nursing a baby. I see minuscule shacks or houses of corrugated metal, but still and always with totems, idols, and masks in the courtyards. There they stand like buttresses or ramparts against the invasion of Western culture.

I already know that tonight, when evening falls and the opaline globe appears against the blue, I shall be sitting on one of the tombs of my ancestors, surrounded by my cousins, my brothers, my sisters, breathing the merciful coolness the sea air will pour over us. As usual, they will erupt as no other people do with the pleasure of seeing me; as usual, they will urge me on with questions and wait for me to tell them all about Paris with words that will make their eyes light up with blue sparks; they will listen to me and then it will be their turn to talk.

In the emptiness of a starless night, I will shudder with spine-tingling fear as they tell me about the grandeur of the woman who gave birth to a serpent, or the man who changed into a leopard.

Indeed, as Grandmother used to say, a bucket of water thrown into the sea does not make the tide go higher. A century from now, Africa will still be a garland without beginning and without end for the rest of humanity.

Translated by Marjolijn de Jager

WESTERN AFRICA

Competing Histories and Traditions

Until quite recently, the so-called Tuareg of the Sahara were comfortably ensconced in legend. Never would the famous "Blue Men" have believed that one day their nomadic lifestyle, their culture—in short, their civilization—might be called into question completely and perhaps even wiped out.

Under attack from Nigerian government forces in 1990, they took up arms, unaware that this would turn out to be a fight for their very survival that would last for five long years. The thousand-year epic of the Sahara, which has engendered one of the most exciting chapters in the history of all West Africa, was coming to a close.

In fact, the end of the Tuareg was determined as early as the fifteenth century. Their last battles, fought at the end of the twentieth century, were lost in 1498, when the Portuguese mariner Vasco da Gama was skirting the African coastline in order to open a sea passage to the Indies. This initiative, fraught with consequences, led to an enormous turnaround in the economy throughout West Africa, the Sahara, and the Sahel, including the countries on the Gulf of Guinea. All trade, as well as most of the population, abandoned the great empires of the Sahel and the Sahara for the new metropolises that lined the Gulf of Guinea: Dakar, Conakry, Monrovia, Abidjan, Cotonou, Lomé, Lagos, and so forth. Very few of the former Sahelians made their fortune with the European navigators and traders. Instead the vast majority of them were deported en masse aboard slave ships to the plantations of the New World.

The general decline of the Sahel and Sahara regions was accompanied by a decrease in the use of caravans, as the dromedary was dethroned by more

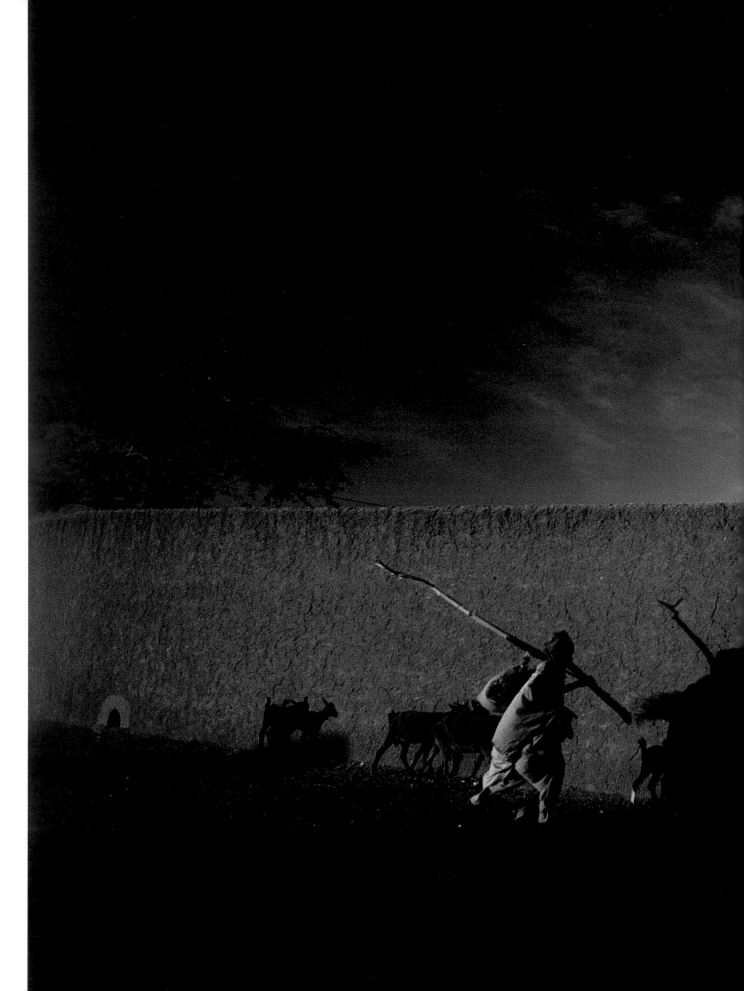

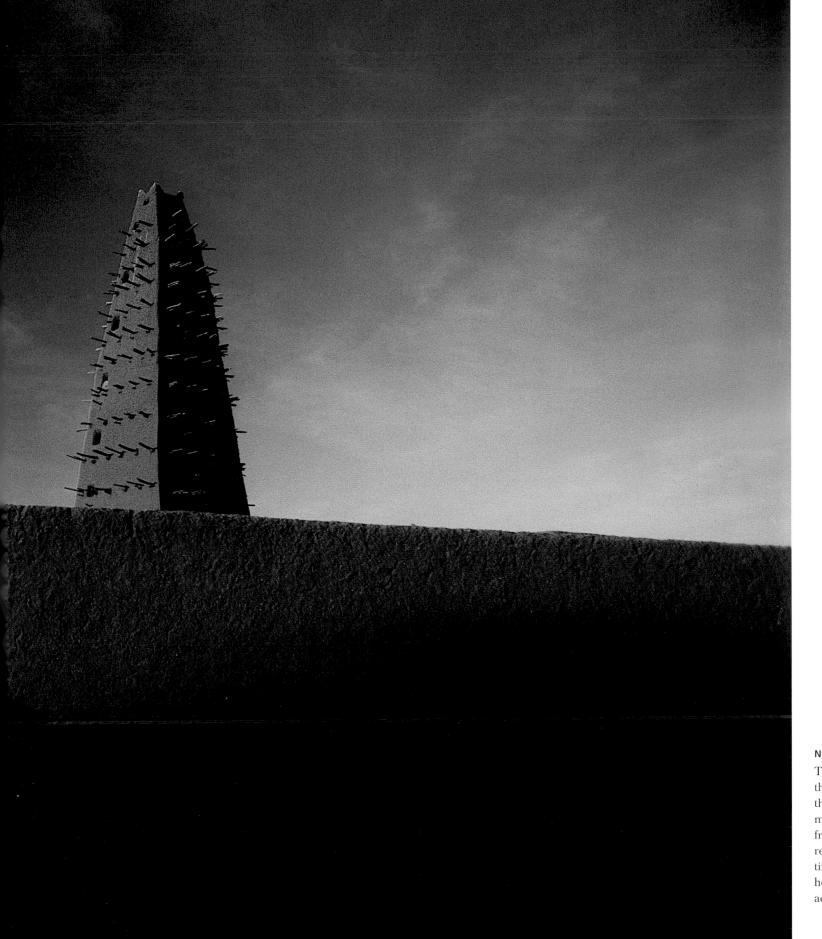

NIGER, 1990.

The city of Agadez is both the threshold and the true capital of the desert. Its mosque is the highest monument in the region, dating from the fifteenth century. It is a reminder to everyone of prayer time. Here, as dusk falls, a shepherd walks beside the mosque, accompanied by his hungry flock.

efficient means of transport, such as trains, trucks, and four-wheel-drive vehicles. As for the commodities once carried by the nomads, they suddenly lost their value. Less expensive sea salt from the West, which at one time had been literally worth its weight in gold, replaced the salt from Taudenit, Fachi, Bilma, and Seguedine. As for African gold, it was extracted by increasingly industrial methods and sent in ingots to Europe by plane, a more reliable and faster means of transport than the camel.

Having lost their livelihood, the proud Tuareg warriors abandoned the great open spaces for the city—where their particular talents and survival skills were less essential.

THE PEUL CATTLE FARMERS. On the steppes, men and women wage a daily battle against sandstorms, dry wells, and infrequent rain. Settled farmers and nomadic herdsmen argue over the immense spaces where grass rarely grows and wells must be drilled to compensate for the lack of rain. These wells are gathering places for the large herds of the Peul cattle farmers, who for centuries have relocated their cows with the lyre-shaped horns from one pasture to the next. Originating in East Africa, perhaps in Yemen, the Peul have been migrating in waves toward the west for two thousand years. In each country they crossed, some of them settled down and converted to Islam, then went on to take power and build great kingdoms: the sultanates of northern Cameroon, the Sokoto Empire in Nigeria, and the Macina Empire in Mali, the kingdoms of the Fouta Djalon in Guinea, and of the Tekrur in Senegal.

Those Peul who continued to be nomads (the Bororo and the Wodabe) did not convert, and revere only the beauty of "the ways of the Peul": the beauty of wandering through vast spaces, the beauty of their cattle, the beauty of their own bodies.

The great dry steppes of the Sahel countries, dotted with thin acacia trees and offering difficult living conditions, are also the domain of poor, hardworking peasants. The living

conditions to which Africans are subjected require them to be resistant to bad weather and disease, but also to be capable of defending themselves against wild animals, and, as in earlier days, to wage war against all sorts of invaders. Tradition dictates that young people, the future pillars of the village, must be as hardened as the Spartans of ancient Greece. This is the reason behind the initiation rites of children and adolescents in most regions on the African continent.

"UNIVERSITIES" OF THE BUSH. Not all initiation rites consist merely of ill treatment, however. In the sacred woods, actual bush universities were developed to teach traditions to the young, including the complicated rituals of religion and taboos, law, pharmacopoeia and therapeutics, history, agricultural techniques, and so on. These periods of initiation can be quite long: among the Senufo in the Ivory Coast they last twenty-one years, during which the future initiate must endure a training period divided into three cycles of seven years each. At the end of his education, the young man, previously considered an unformed being, at last achieves the status of a true man. He has, in effect, been born again.

LIFE IN THE DESERT. It was in the Sahel that traditional huts were first built, symbols of Africa, with their daub walls and pointed thatched roofs. This is the traditional Africa, which once seemed eternal, until the rural exodus into the cities began. The memory of beautiful villages surrounded by millet or sorghum fields and large cotton, coffee, cocoa, or peanut plantations will be preserved for a long time to come.

As in the Sahara, water is increasingly rare in the Sahel, which is periodically stricken by waves of drought. A good part of the Sahelians' existence is taken up by the incessant search for a few precious liters of water, used sparingly for family needs, cattle, and meager plantings. Coming and going incessantly, the women of the Sahel fill their basins at the well in order to water the fields. Animist farmers too, however, continue to call on the forces of the occult to bring rain. This is true, for instance, of the Samoro of Burkina Faso, who believe the constant droughts to be a punishment by the gods.

THE PLACE OF RELIGION. Many other peoples of West Africa, resisting both Islam and Christianity, still worship a nature that is populated, according to animist beliefs, by a multiplicity of traditional divinities. Through their libations and sacrifices of animals to gods, genies, and deceased ancestors, they seek to ward off all forms of disaster: droughts that burn harvests and decimate herds; famines; diseases of man and beast; sterility of women; and tribal wars. With some variations, these traditional beliefs can still be found among the Dogon of the Bandiagara Cliffs in Mali, as well as among the Asanti in Ghana, the Tiv in Nigeria, the Lobi in the Côte d'Ivoire and Burkina Faso, the Bijago of the islands of Guinea-Bissau, and the Bassari of eastern Senegal.

By conniving with the forces of darkness, animist priests and priestesses are able to heal insidious illnesses and wasting diseases induced by sorcerers. In village courtyards and urban compounds alike, these healer-priests, gifted with the power to "see in the dark," hold strange nighttime ceremonies.

Better-known still is vodun, with its temples, convents, priests, initiates, and specialized gods (e.g., Shango, the god of thunder, and Sakpata, the god of smallpox). In fact, vodun as practiced in Africa is a distant ancestor to the religion followed by Haitians. While in Haiti it is a mixture of African rites and the Christian liturgy, vodun (ancestor worship), from which voodoo in part derives, is purely African. The Fon and the Goun practice it in Benin, as do the Ewe in Togo. As for the religion of the Orisha, which is related to vodun, it was transplanted to Brazil by Africans from Nigeria and carried on the European slave ships.

Islam became widespread among the farmers of the Sahel, and is now moving farther and farther south. The religion of Allah made its way across the desert with the trans-Saharan caravans and overtook black Africa after the death of the Prophet Mohammed in the seventh century. Often practicing jihad (Islamic holy war), the marabouts who came from Arabia and crossed North Africa have influenced several countries on the Gulf of Guinea, establishing numerous bastions in Senegal, Guinea, Nigeria, and elsewhere.

One of the most important bastions in West Africa is Nigeria, land of the Kano-Kaduna emirs, and Zaria in north Nigeria. They are the disciples of Ousmane Dan Fodio, who created the first Islamic theocracy in Africa and launched the "holy war" in every direction from his capital, Sokoto.

THE CALL OF THE COAST. Born of the maritime trade, these cities all grew up around their ports and are aligned in a tight string of beads along the coast, while the interior, the bush, is almost empty. People pack into Abidjan, Lagos, and Conakry, while Korhogo, Nzerekore, Ayorou, and Natitingou—even Niamey and Bobo-Dioulasso—have a hard time holding on to their youth, who are tempted to give in to the siren song of emigration, the famous "call of the coast."

Tired of laboring in the fields each year, the young people of Niger, Mali, and Burkina Faso leave for the Promised Land by the thousands, if not the millions. They are lured by the mirage of city lights, the throbbing beat of *soukous* and *makossa*, urban consumer society, shot through with the magic of neon, transistor radios, portable phones, and, for those who "make it," Mercedes and Toyotas.

Most recently they landed in Nigeria, where oil is still being discovered all along the coast. The most densely populated nation in Africa, this colossus is poised to become a new Kuwait. Nigeria is a country of superlatives: as in South Africa, here one finds the largest fortunes, the largest industrial complexes, and the largest highways, but also the biggest traffic jams and the highest rates of crime and corruption on the continent.

It is a dangerous country, yet all of the splendors of the Arabic East can be seen in the north of Nigeria, in the Hausa and Poul sultanates. Surrounded by guards on horseback, whose coats of mail and pointed helmets evoke the Saracens, emirs parade to the sound of trumpets in large palanquins during the great Islamic celebrations. Yet these same individuals also fly on private planes to negotiate huge contracts in London, sometimes following their colleagues from Kuwait or Abu Dabi.

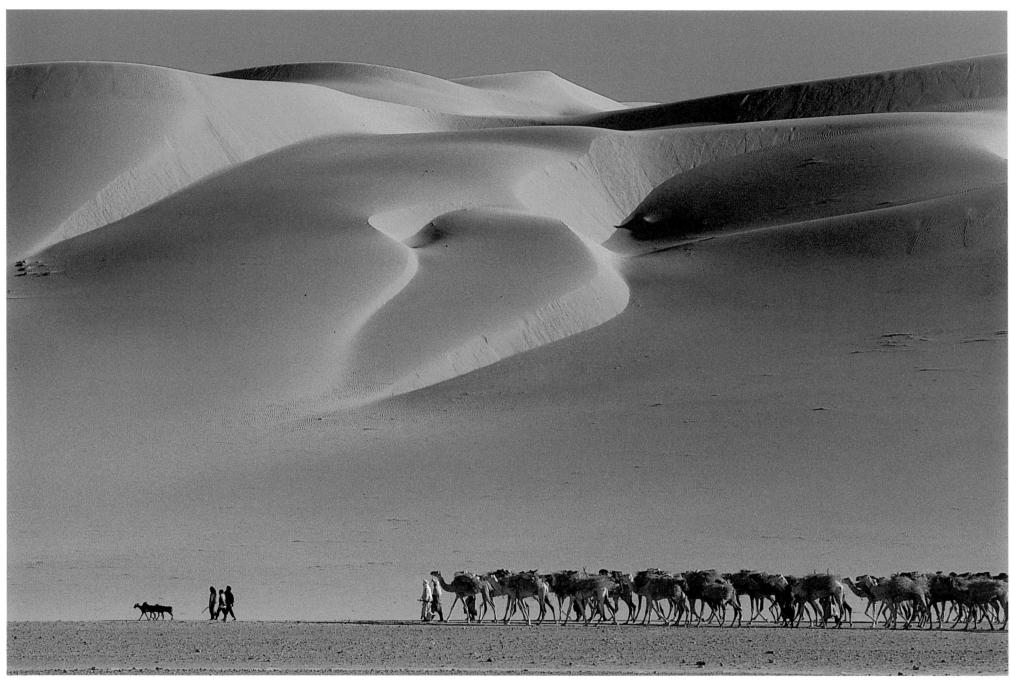

NIGER, 1993. A caravan transports animal fodder to be exchanged for salt at the salt marshes of Bilma in the village of Fachi. The caravan carries all necessities: supplies, water, and animals for food. It usually takes forty-five days to make the journey.

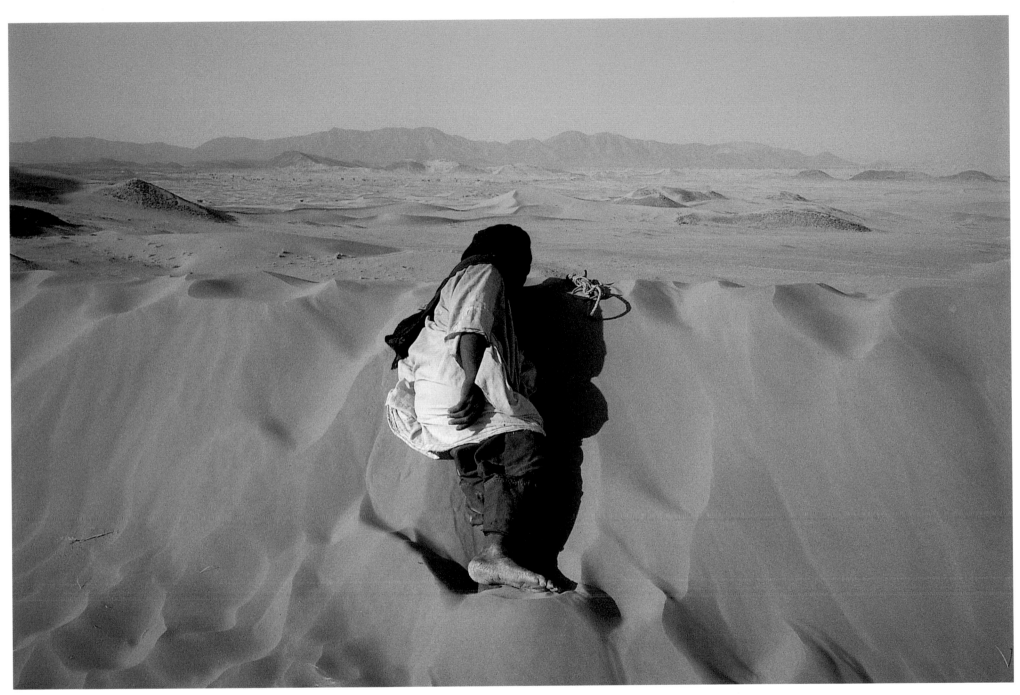

NIGER, 1993. At the foot of the Taghmert massif, a Tuareg watches the arrival of the army hunting FLT rebels. FLT stands for Front for the Liberation of Tamoust, a splinter group of the Tuareg liberation organizations that formed in the early 1990s. The Tuareg are not a singular tribe, but a collection of numerous clan-based units of Berber and black descent. The name Tuareg, which means "abandoned by God," was bestowed upon them by the Arabs. They refer to themselves as Tamashegh, which means "the noble and the free."

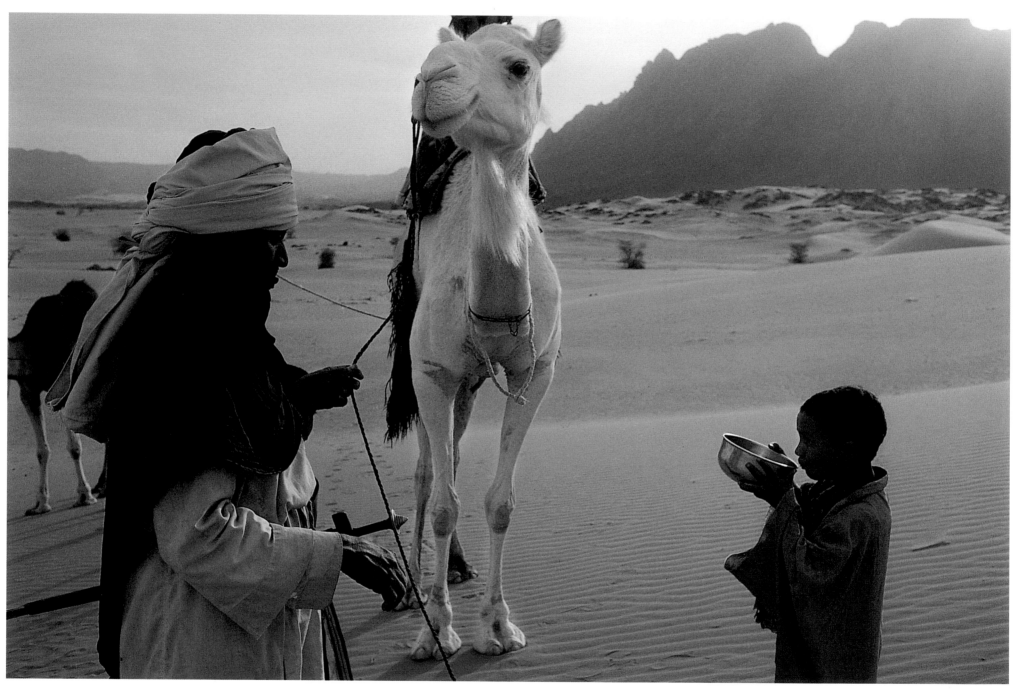

NIGER, 1996. In the Zagado wadi, Kalakoua, a member of the Tuareg peoples, teaches his son the basics of the caravan–how to navigate by the stars, by tracks in the sand, by the wind, how to saddle a dromedary, and how to drink and conserve water. These traditions have been passed down over many generations.

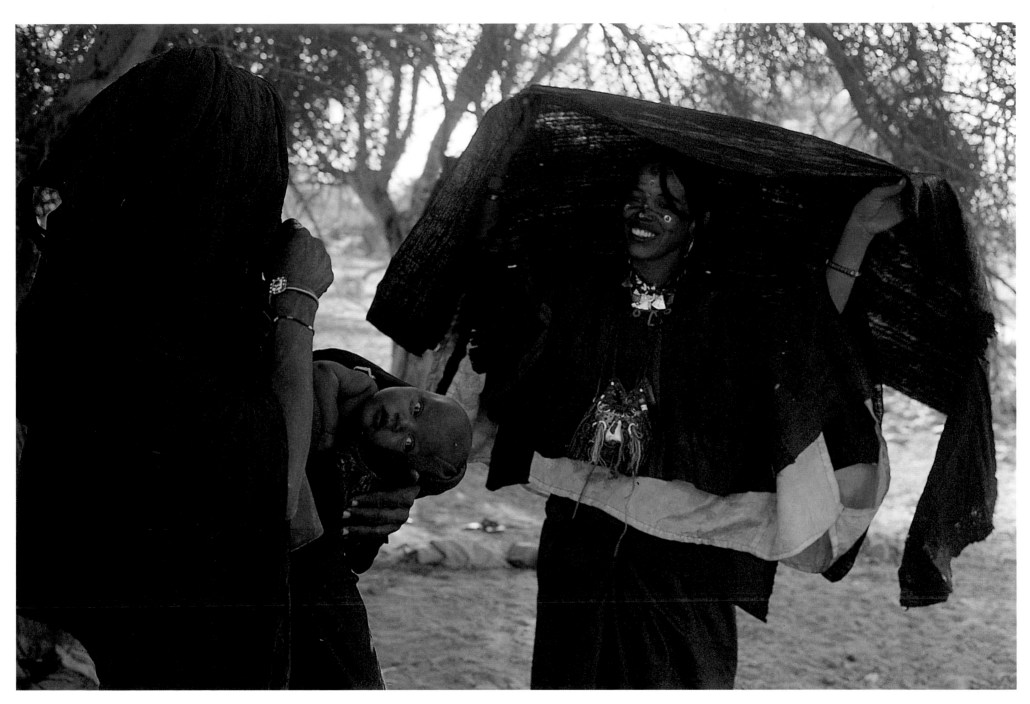

NIGER, 1996. These women are preparing for the dance of the *tendé*. The various tribes of Tuareg peoples are Muslim and matrilineal. Women are not veiled and may freely choose their spouses.

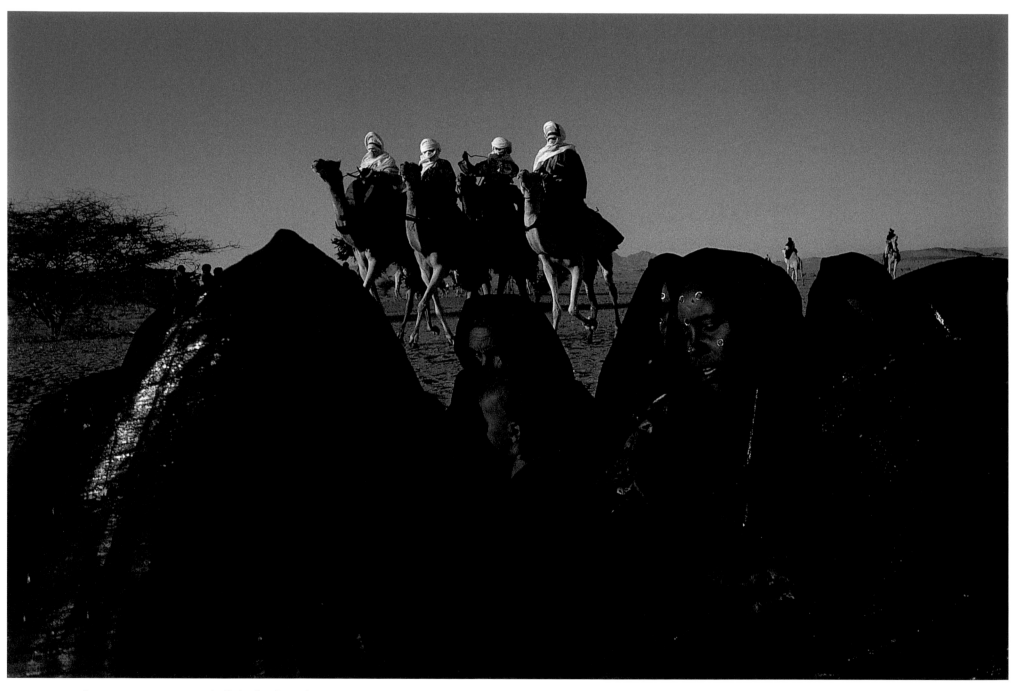

NIGER, 1993. On important occasions, women play the *tendé*, a drum made of skin stretched over a mortar, and sing war ballads glorifying their men. At the same time, the men circle around the women, mounted on their finest steeds.

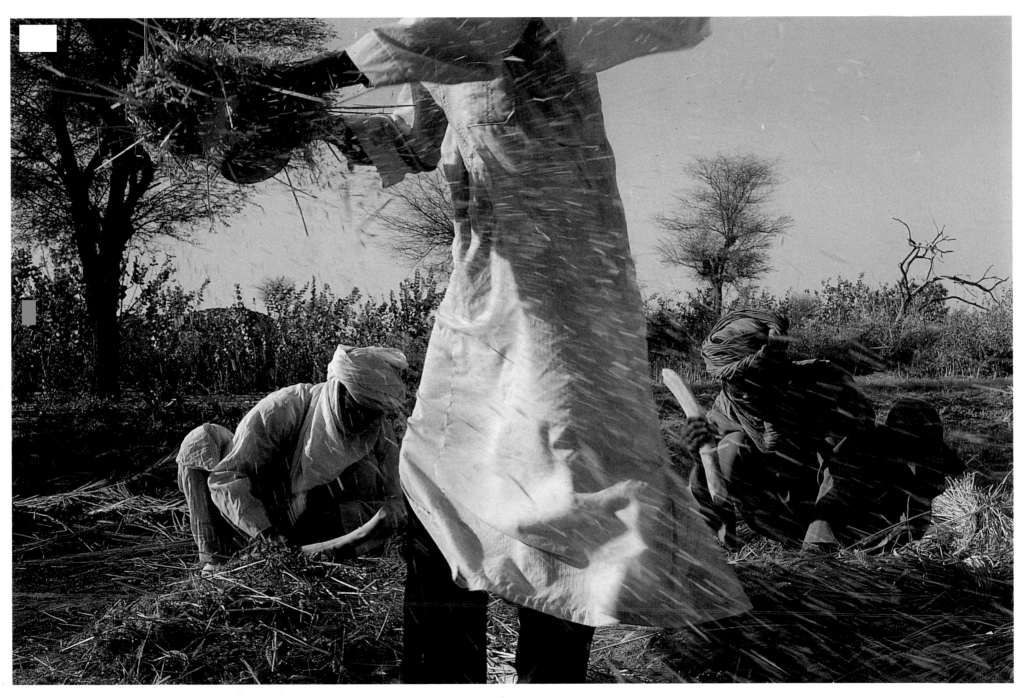

NIGER, 1996. At the Tidéne oasis, the Tuareg grow wheat with the help of irrigation channels fed by water from the wells.

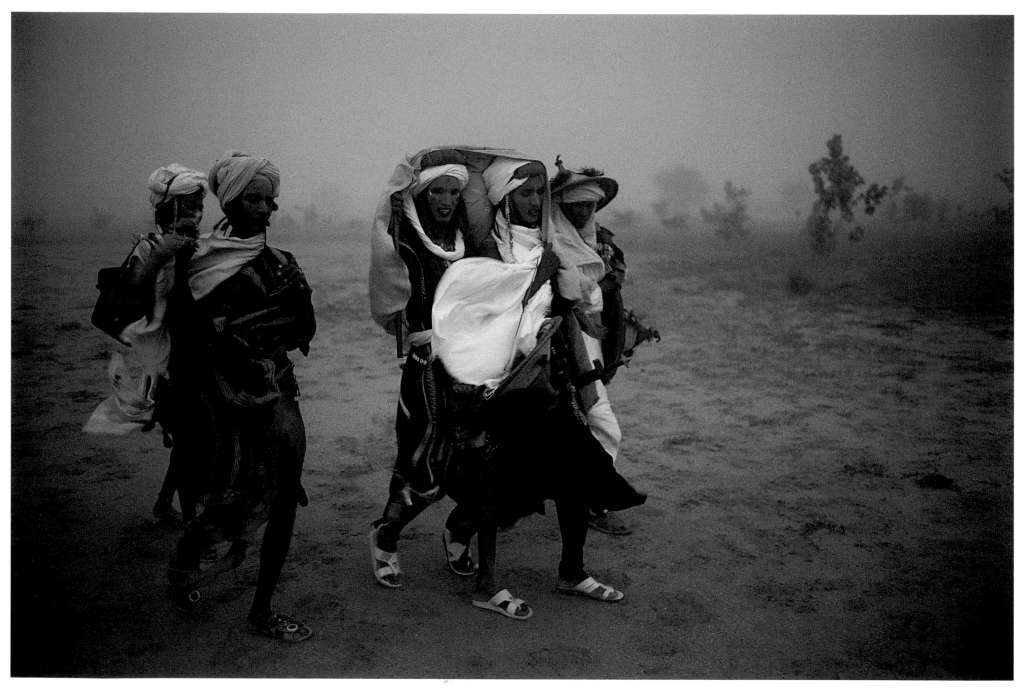

NIGER, 1996. *(above and opposite)*
Nomadic Fula Wodaabe convene by watering spots and rainwater lakes on the Azawagh plain during the time of the Gerewol festival. This lavish ceremony takes place once a year in late September to early October, after the rains have gone. Here, in the middle of a sandstorm, the Fula Wodaabe make preparations for Yaake, one of three dances at Gerewol. They roll their eyes to show the whites, and display the brilliance of their teeth and the beauty of their willowy silhouettes.

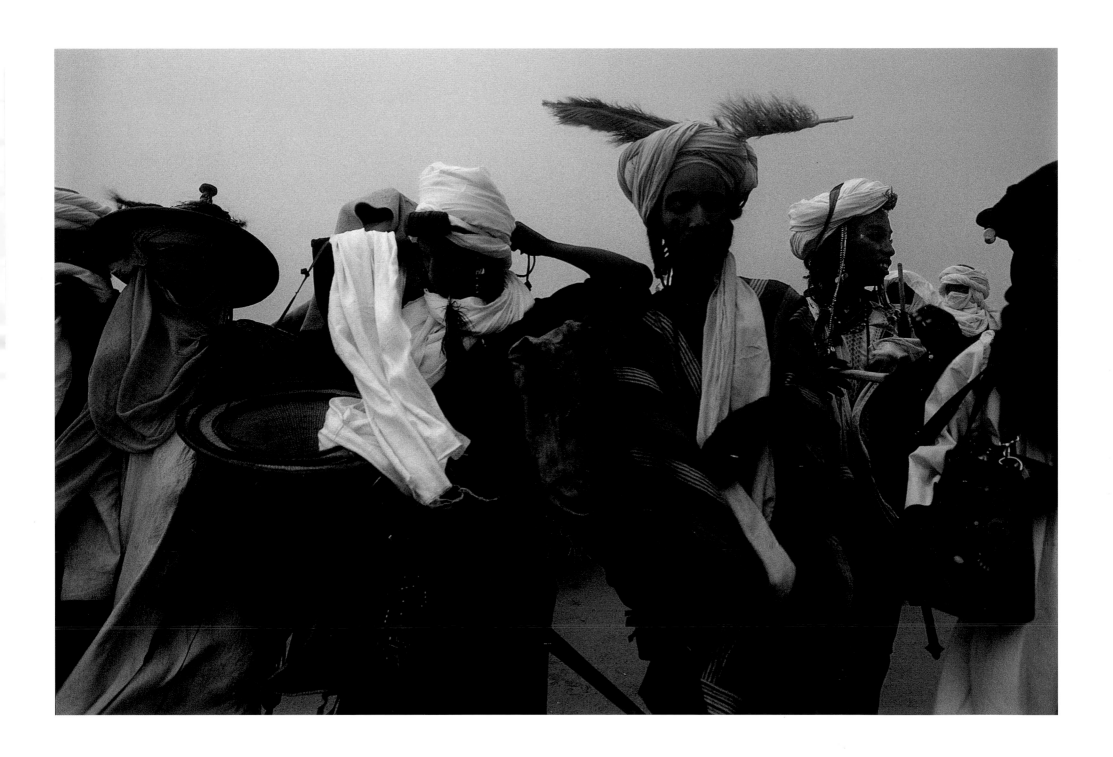

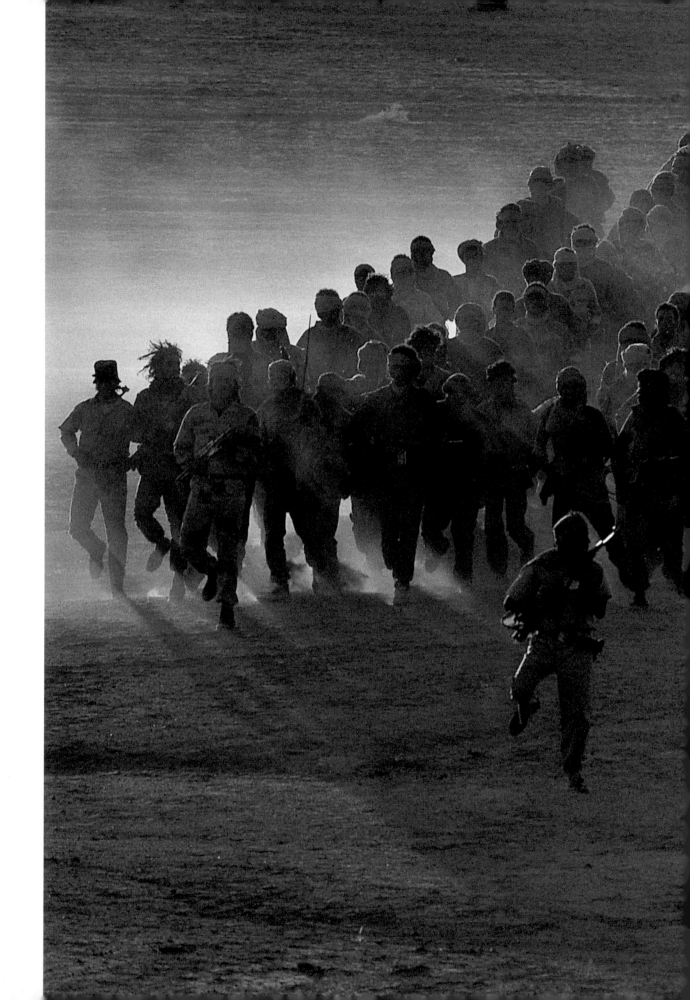

NIGER, 1993. The procession of men at Aïr was the principal component of the Tuareg peoples' rebellion. In 1990, Nigerian officials reacted to unrest by arresting and detaining numerous members of the Tuareg community. Tuareg rebels then attacked the prison and gendarmerie at Tchin Tabaradan. What followed was mass repression; hundreds of Tuaregs were arrested, tortured, or executed. At least one thousand died. The Tuareg communities decided that they would no longer accept injustice and humiliation. They formed the rebel movement that would fight for five years.

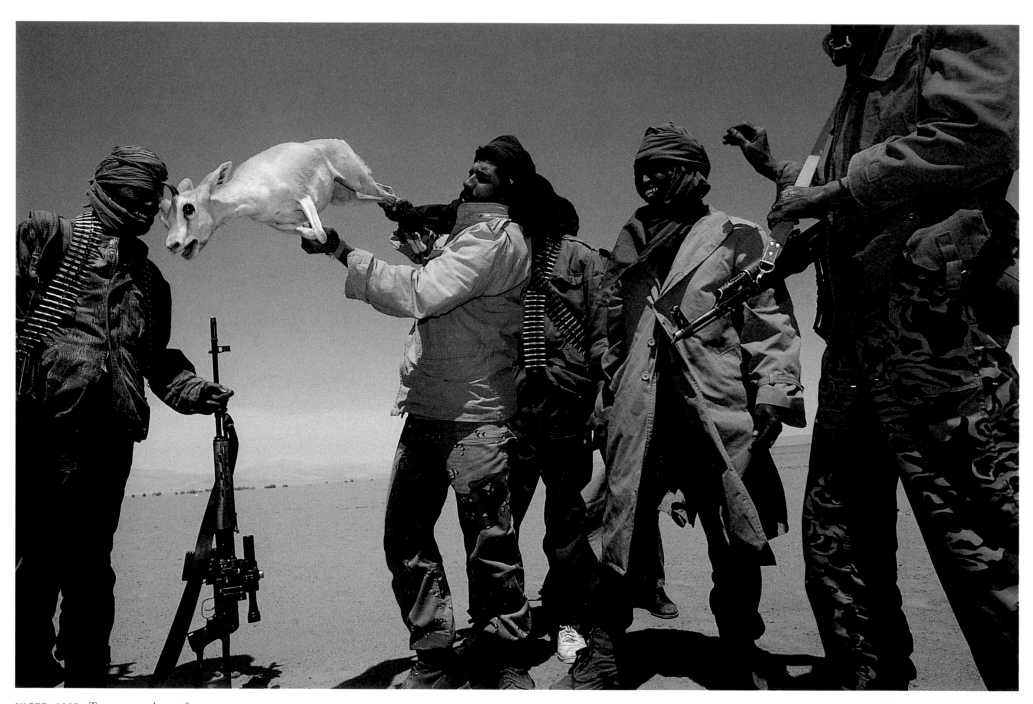

NIGER, 1993. Tuareg members of the FLT play with a young gazelle caught on the massif.

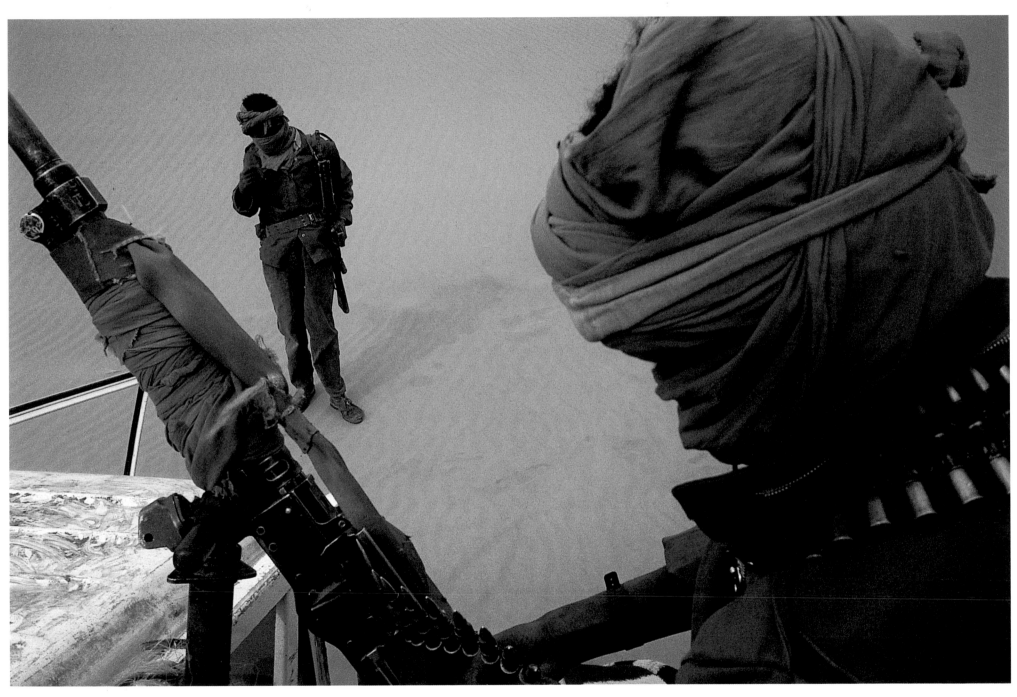

NIGER, 1993.
Tuareg FLT members, Aïr.

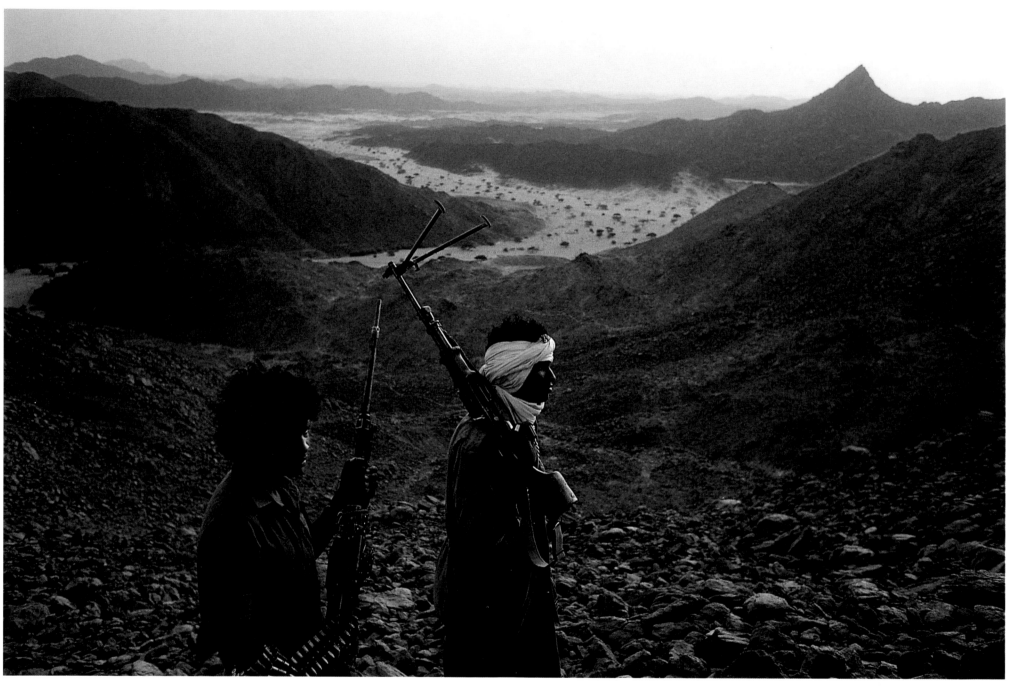

NIGER, 1993. When Maitre arrived by foot at the top of the Bogroum, the charismatic chief of the Mano Dayak rebellion welcomed him warmly—though somewhat uneasily. It turned out that the army had recently made an attack on the road Maitre had just taken from the Algerian border, but thanks to his guide's skill and familiarity with the area, they managed to elude the military.

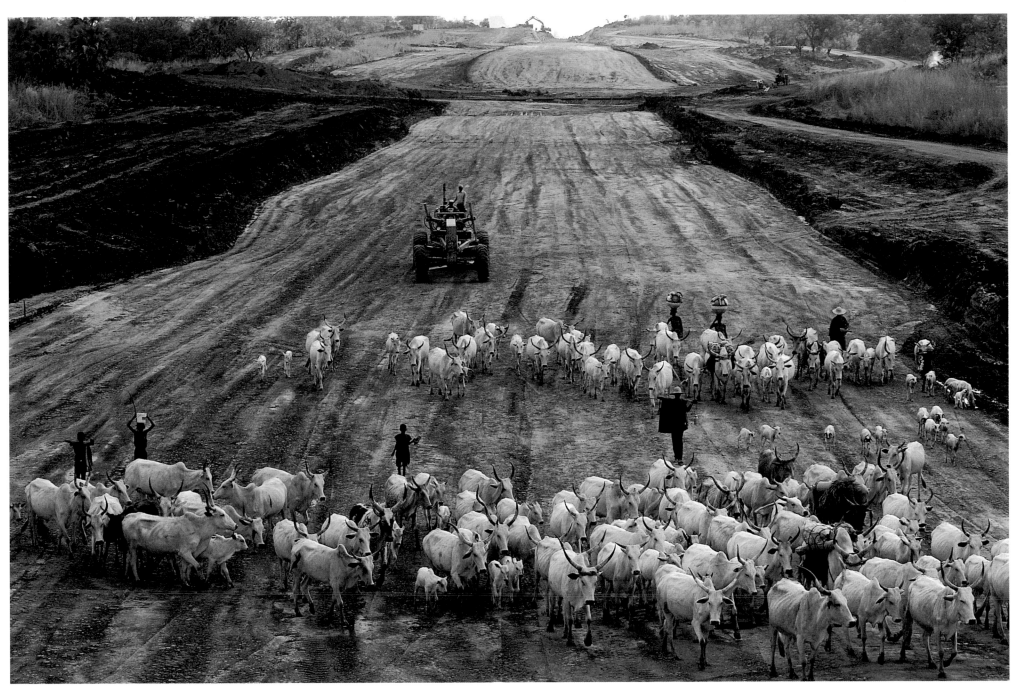

NIGERIA, 1988. For ease of travel,
Fulani shepherds follow the path of
the railway from the steel plant at
Ajeokuta.

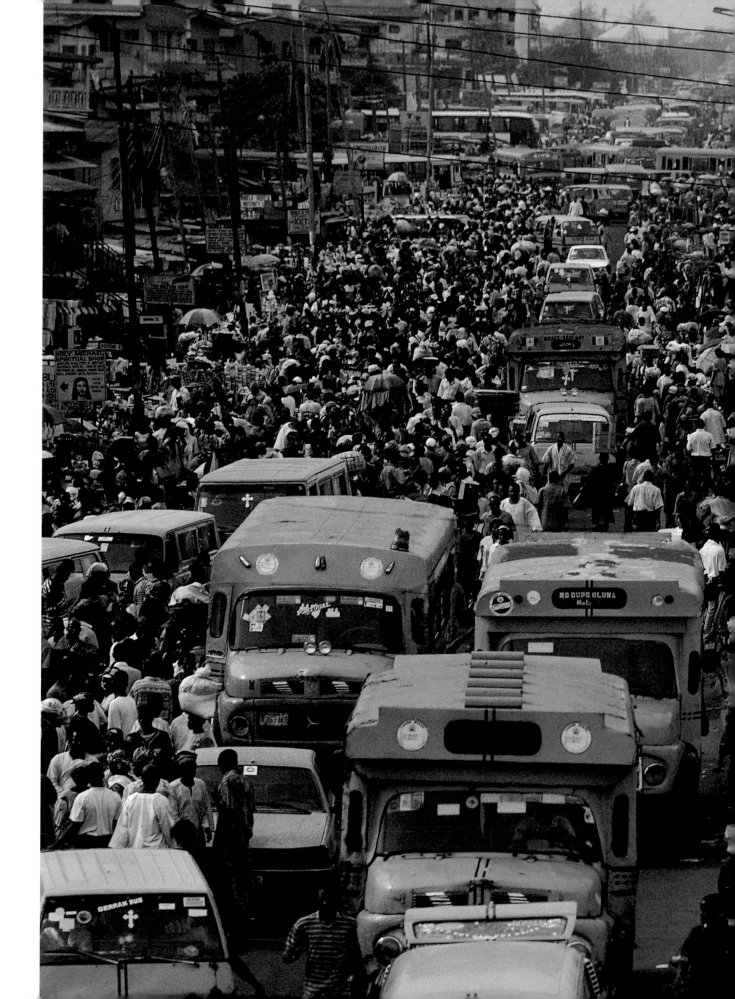

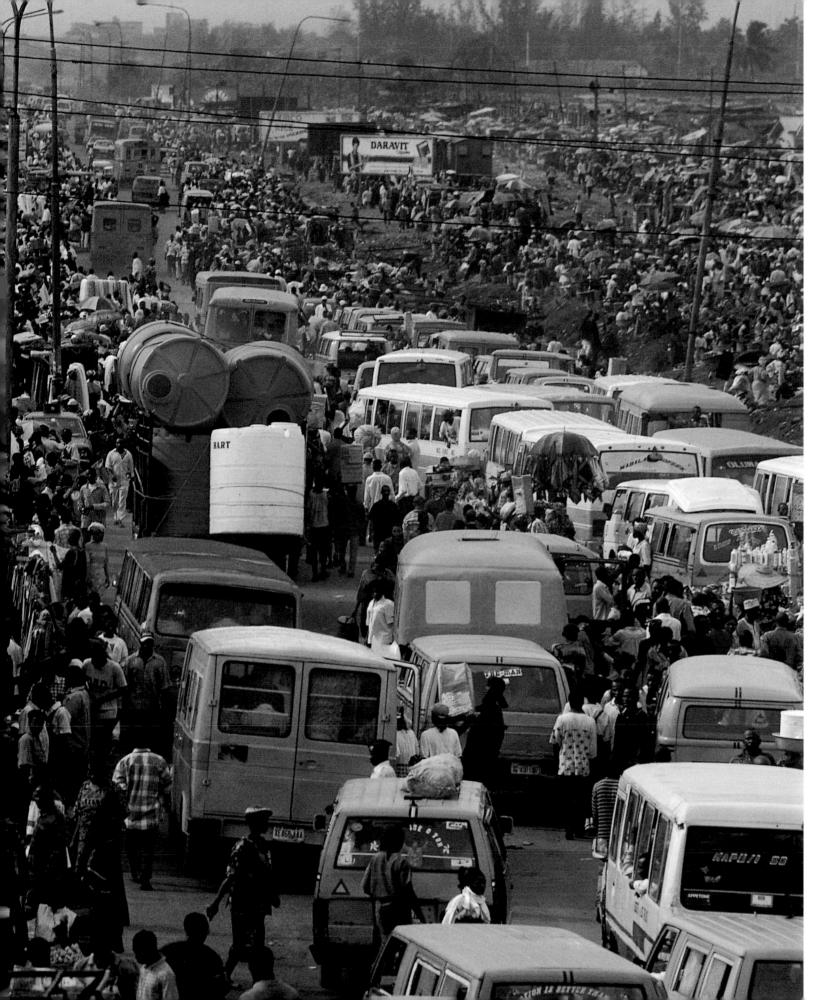

NIGERIA, 1999. Traffic in the Oshodi quarter of Lagos. Lagos is a sprawling city of ten million people. According to U.N. experts, Lagos will have a population of twenty-four million by the year 2024. It is by far the most chaotic city in Africa, and is permanently blocked by "Go Slows," or traffic jams.

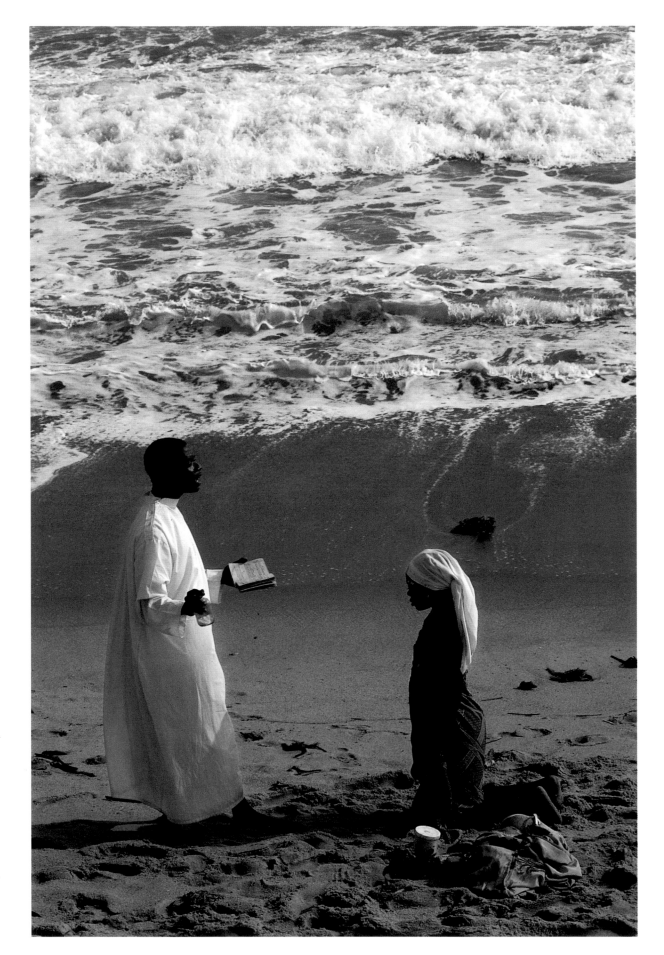

NIGERIA, 1988. On Victoria Island's "Bar Beach" in Lagos, a priest baptizes a young woman.

NIGERIA, 1988. A popular neighborhood in Ajeokuta, where many of the workers who built the local steel plant live.

The plant never produced steel and is considered to be one of Africa's biggest "white elephants."

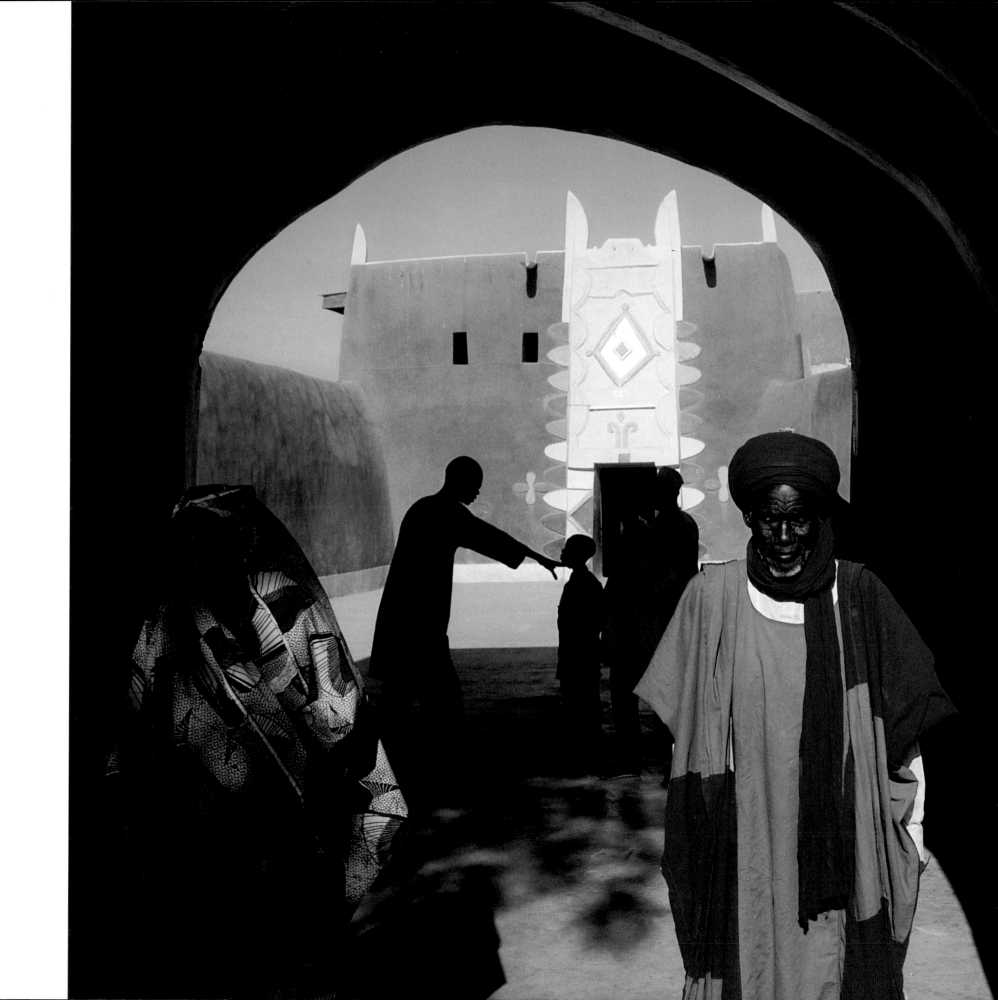

NIGERIA, 1999. The entrance to the palace of the Emir of Daura in Hausa country, northern Nigeria.

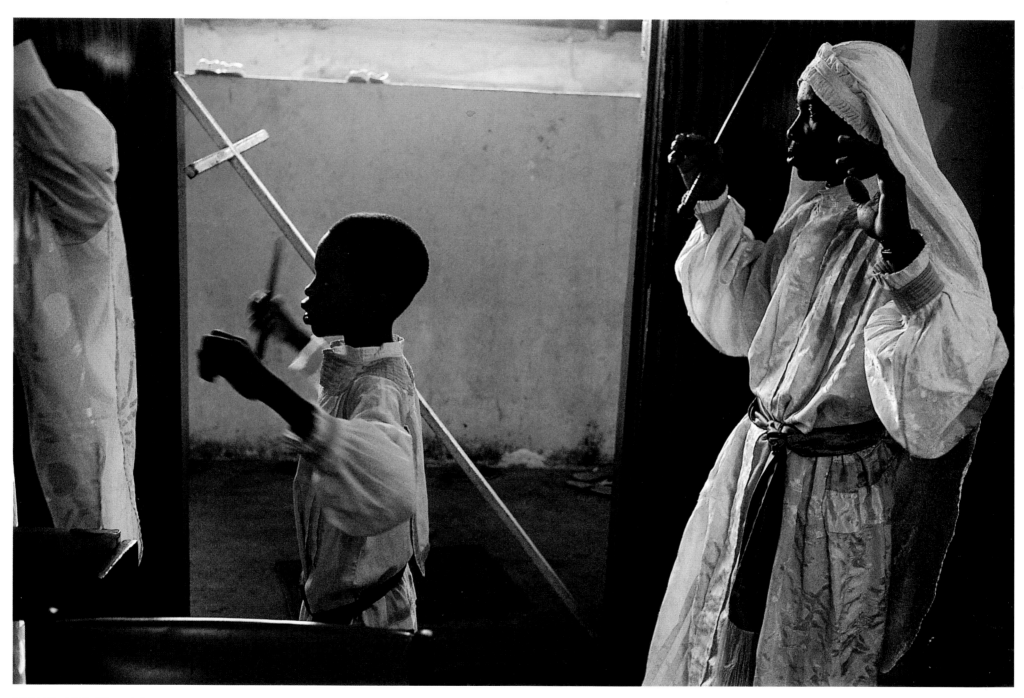

NIGERIA, 1999. Mass at the
Syncretic Church of the Cherubim
in Port Harcourt. Many Nigerian
people take refuge in new churches
in an effort to forget the troubles
of daily life.

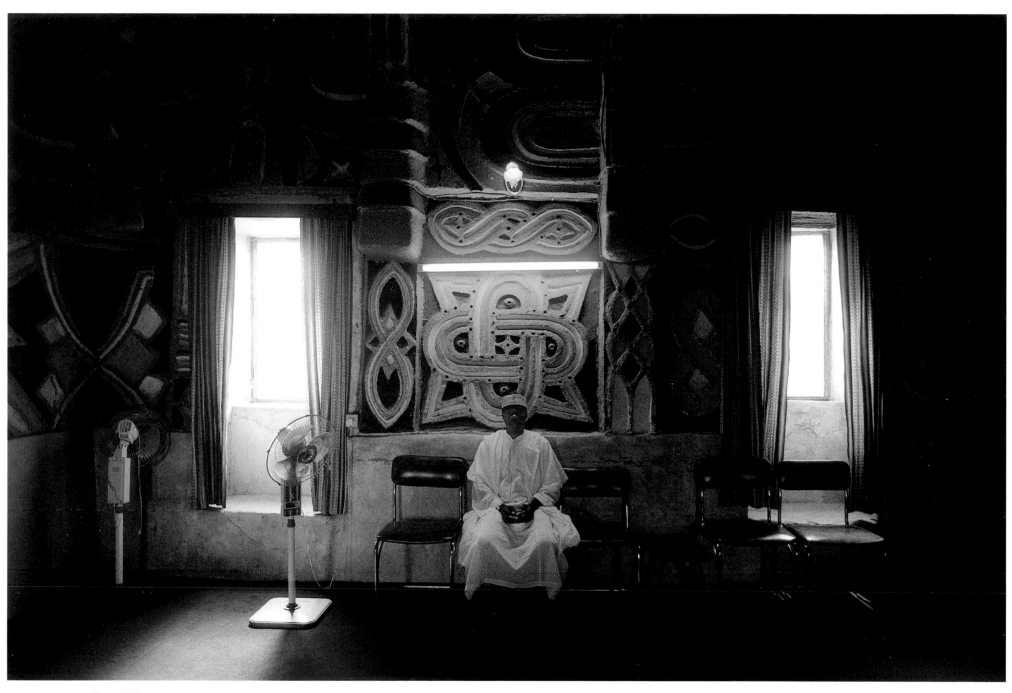

NIGERIA, 1999. One of the rooms
in a Hausa-style palace, home of
the powerful Emir of Kano.

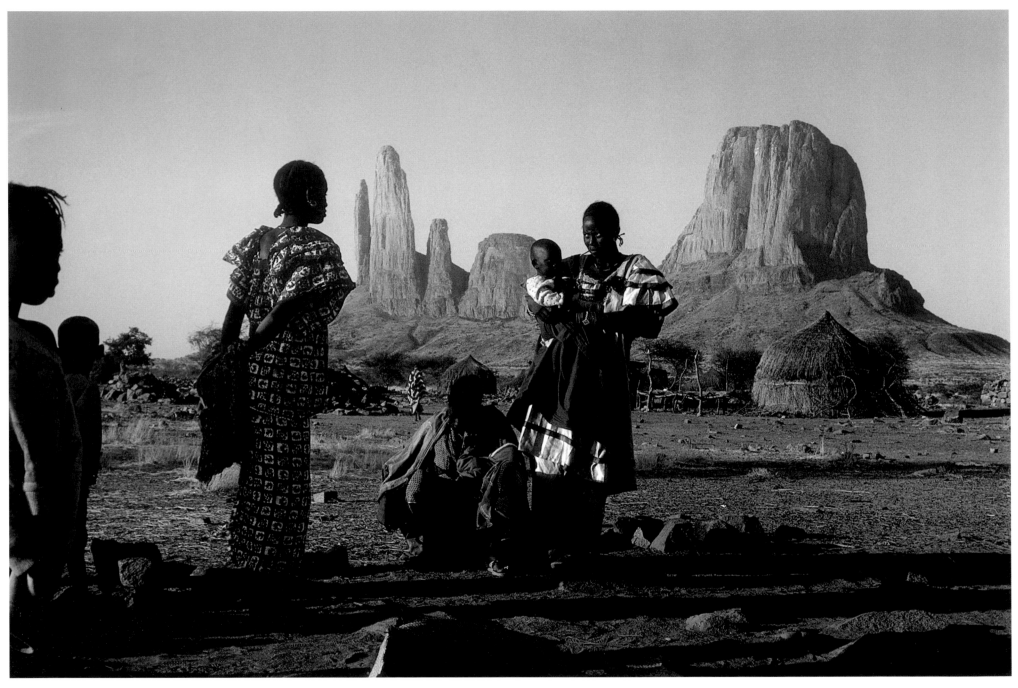

MALI, 1999. In the middle of nowhere, between Gao and Mopti in the Hombori region, is one of the most beautiful landscapes in Africa, "Fatima's Hand." At the foot of these sandstone buttes, a group of Fulani make an encampment.

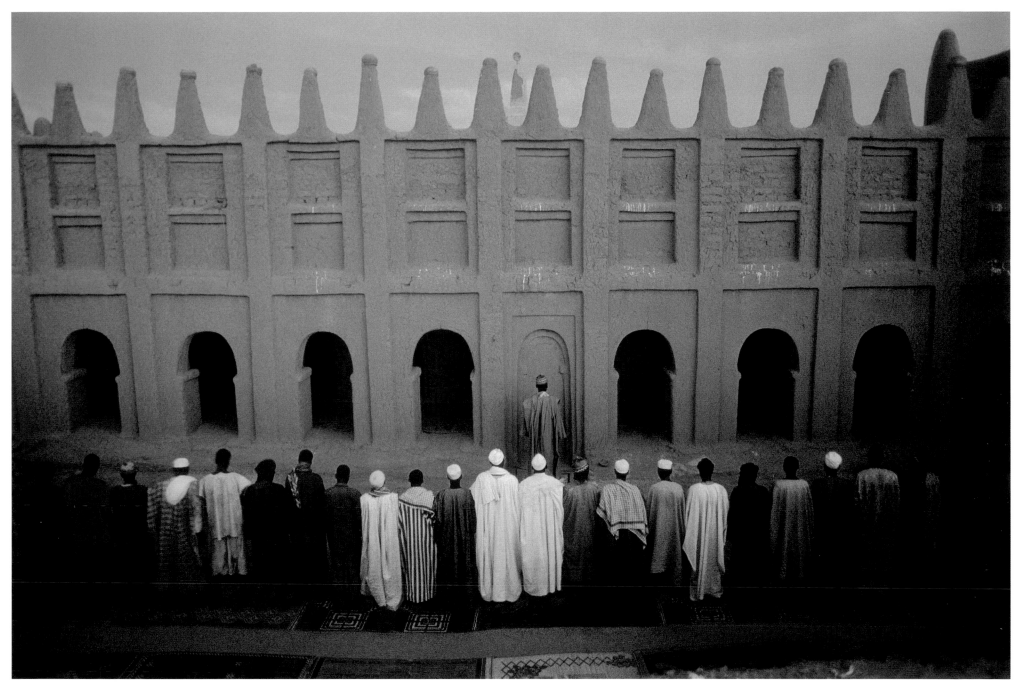

MALI, 1999. Nightfall in the village of Guidjo, on the Niger River. When breaking the Ramadan fast for evening prayer, villagers come to a magnificent mosque built of adobe by Bozo masons.

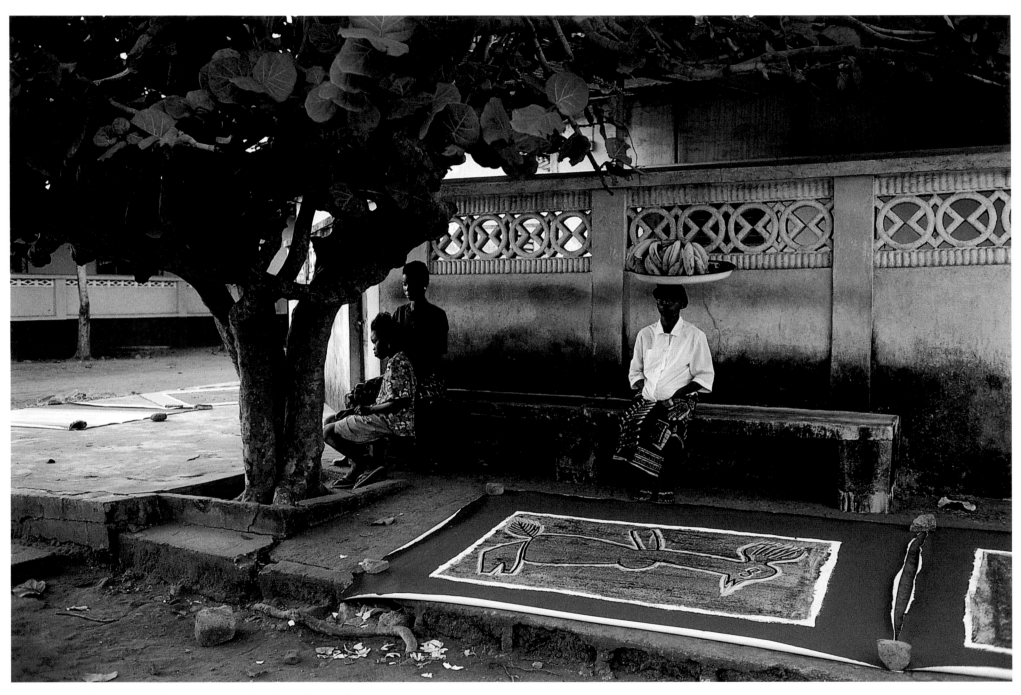

BENIN, 1997. The paintings of artist Romuald Hazoumé drying in the street. Hazoumé finds inspiration in voodoo culture. His works are made of cow dung and paint mixed with multicolored dirt from different regions of Africa.

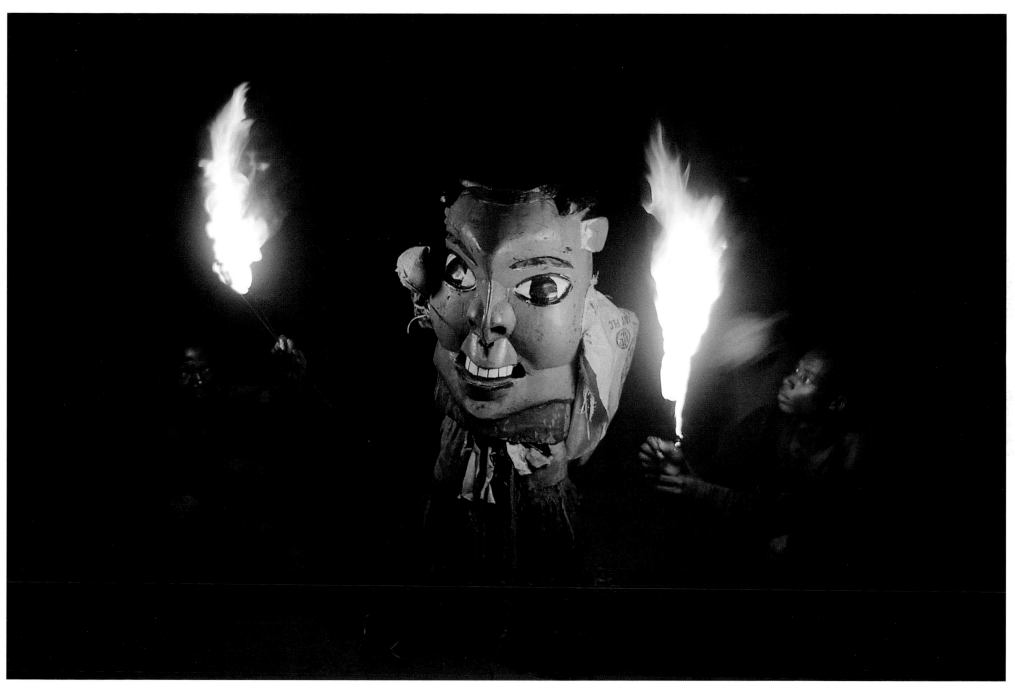

NIGERIA, 1996. Traditional celebration of Kwaghir among the Tiv in Gboko. In this celebration, life in the community is represented humorously, through costumed dances and puppet shows.

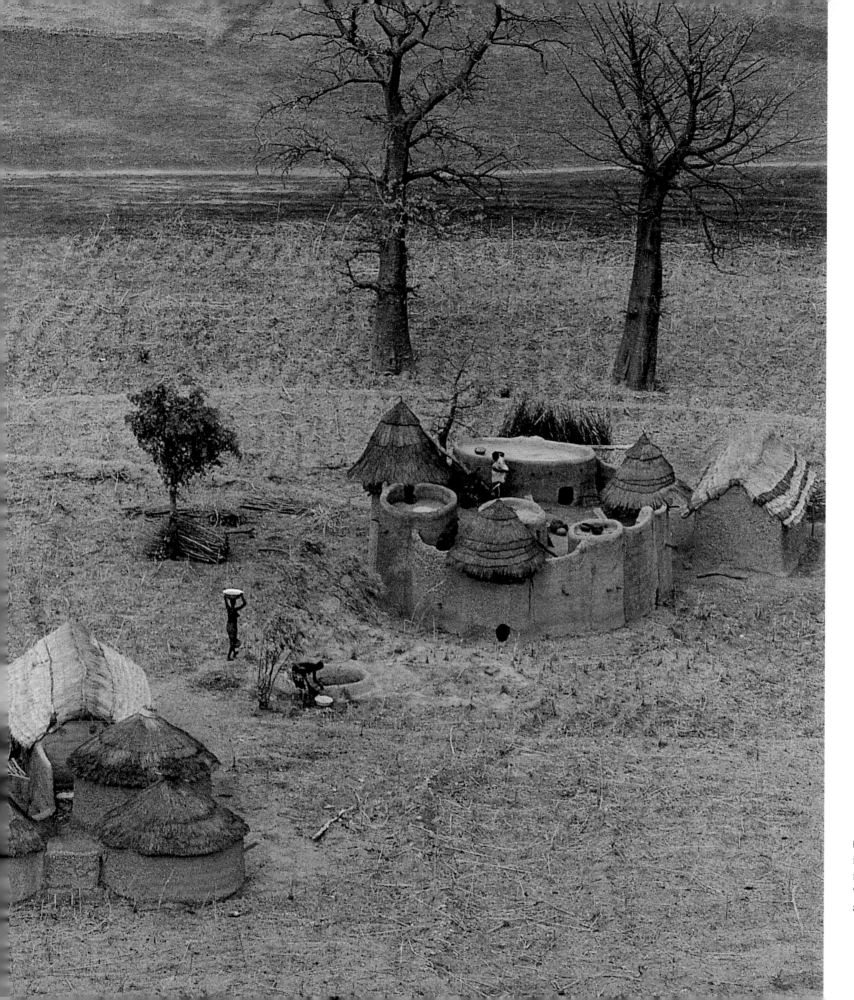

BENIN, 1999. The Somba villages in the Boukombé region are made up of dirt fortresses called "Tatas," which serve as protection against invasion.

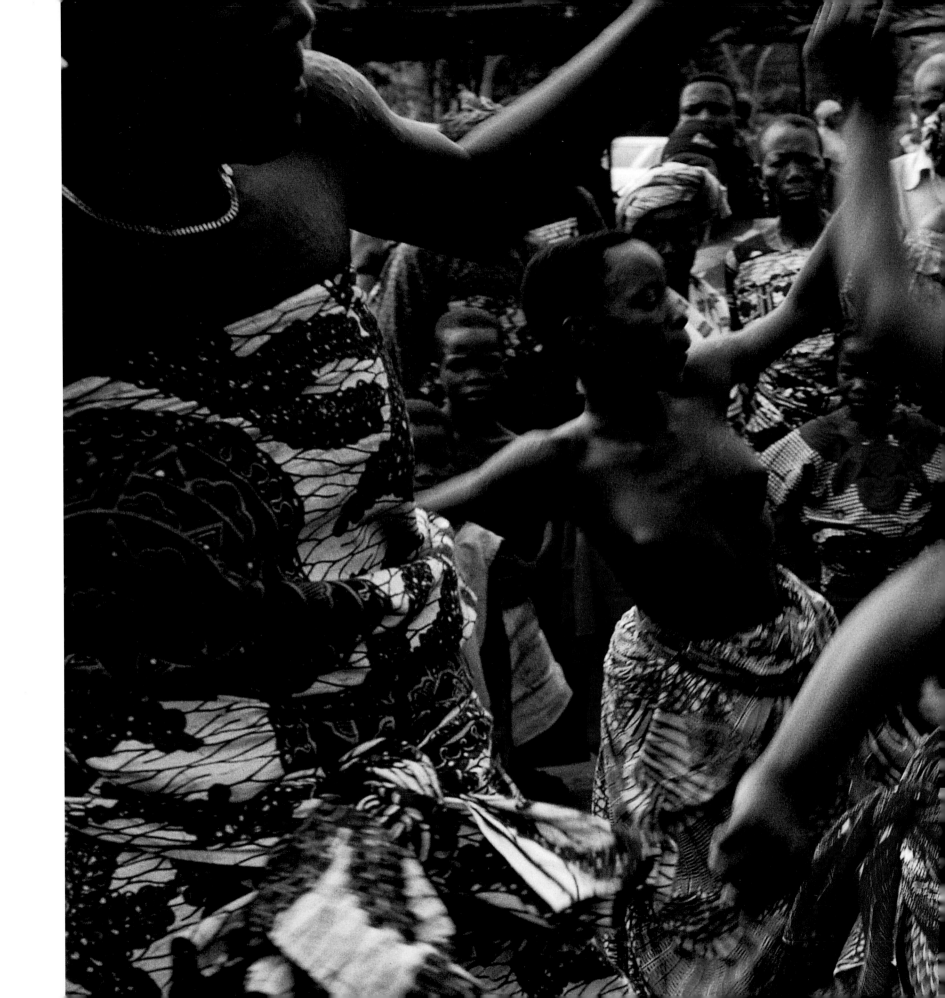

BENIN, 1997. Women dancing at the great vodun festival in Adjara.

BENIN, 1999. Every three years, for a period of nineteen days, spirits representing the dead return to dance and visit every corner of the city of Sákété.

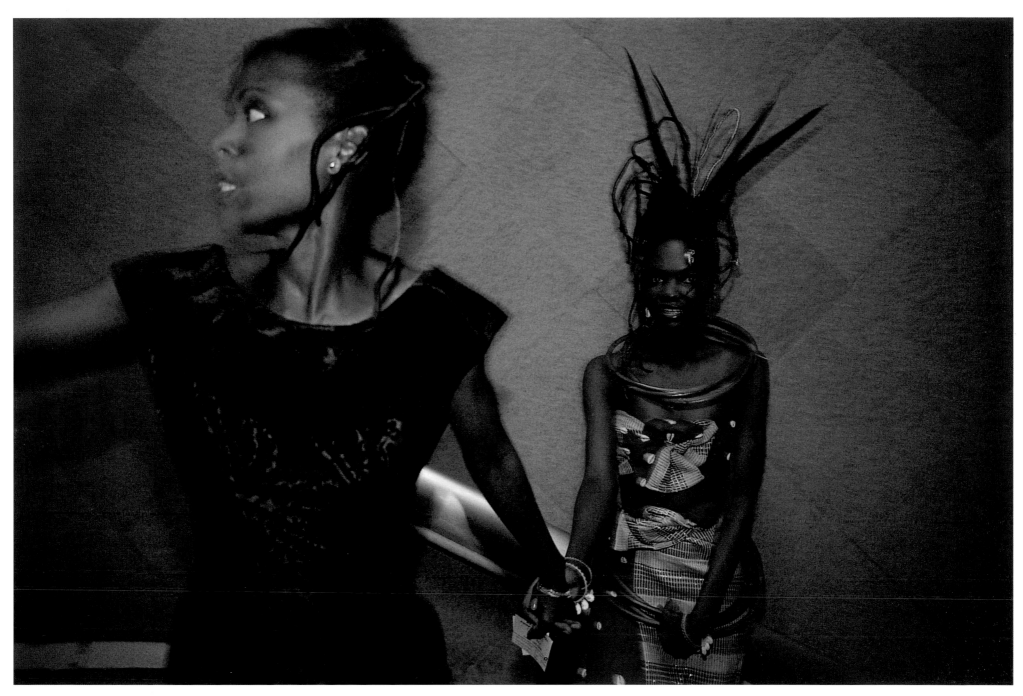

CÔTE D'IVOIRE, 1999. Young women at "Africanova," the first international hairstyling fair at the Hotel Ivoire in Abidjan.

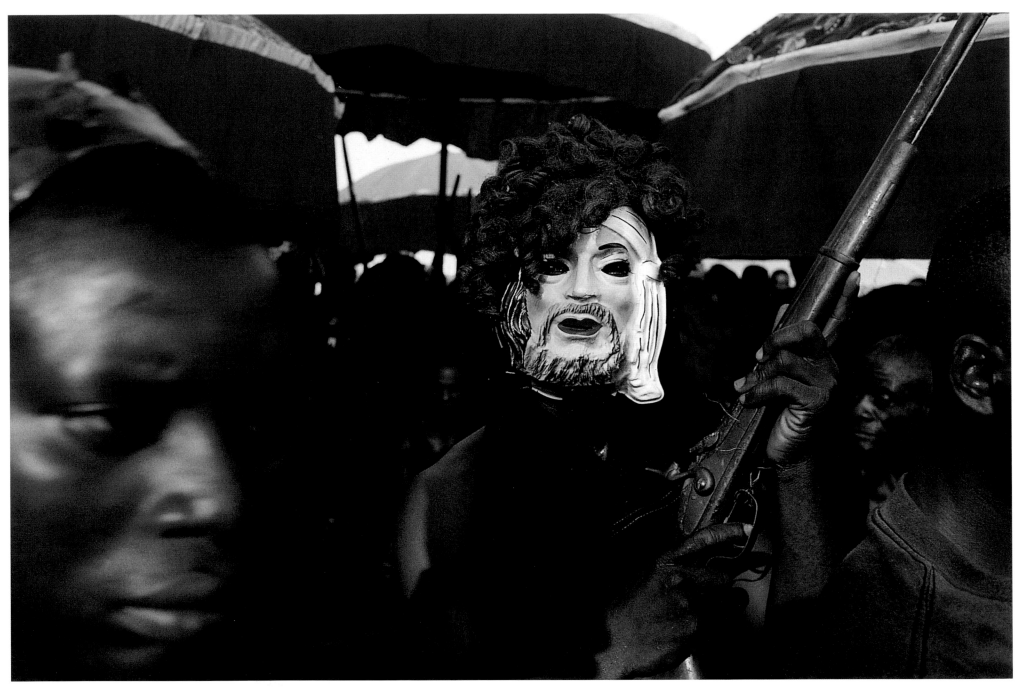

GHANA, 1999. At the funeral ceremony of King Ashanti Asantehene Otumfuo Opoku Ware II in Kumasi, an armed man represents the colonists. The gun serves to ward off evil spirits, and to demonstrate the terrifying power of the king, in spite of his death.

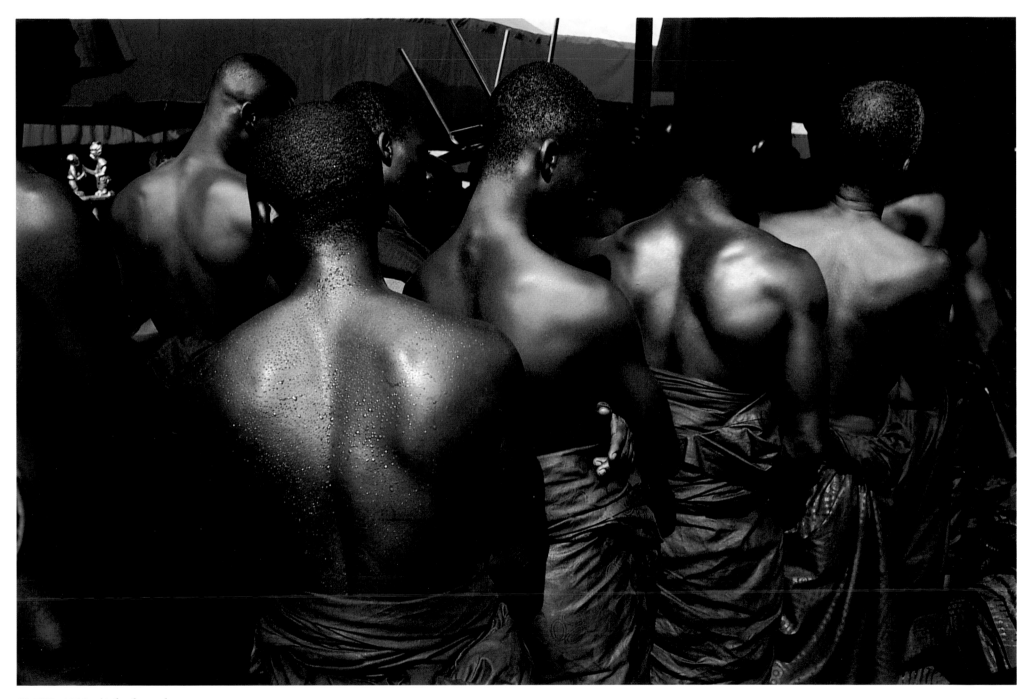

GHANA, 1999. At the funeral ceremony of King Ashanti Asantehene Otumfuo Opoku Ware II in Kumasi, all the chiefs arrive dressed in black. The funeral services last four days.

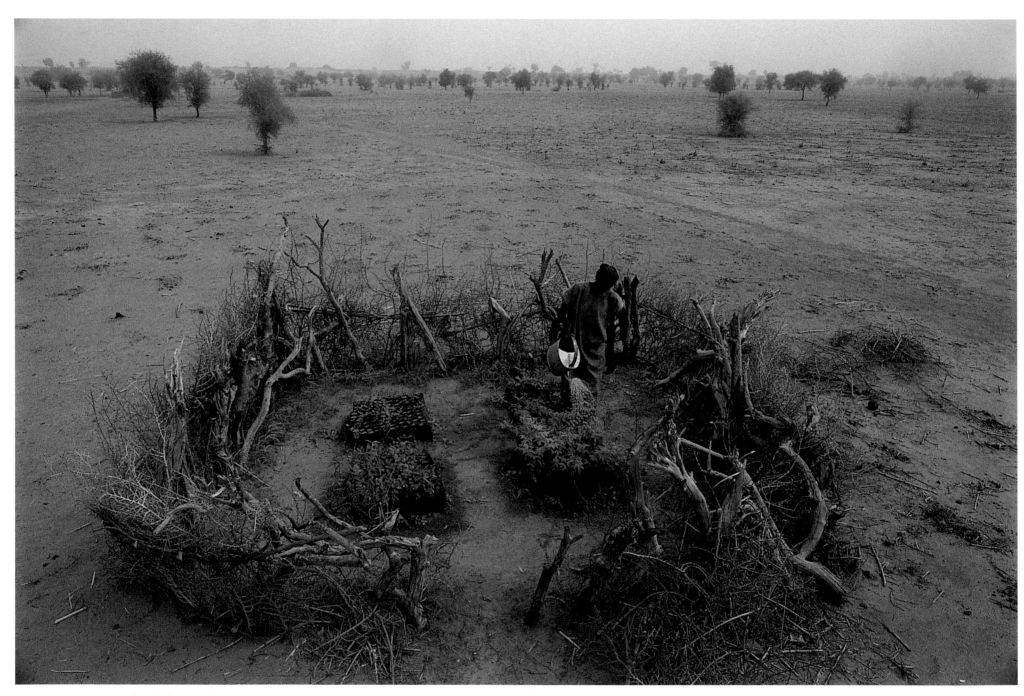

BURKINA FASO, 1991. In the heart of the Sahel, a Tilla villager waters his small nursery. Surrounding shrubbery protects it from erosion, the harmattan winds, and animals.

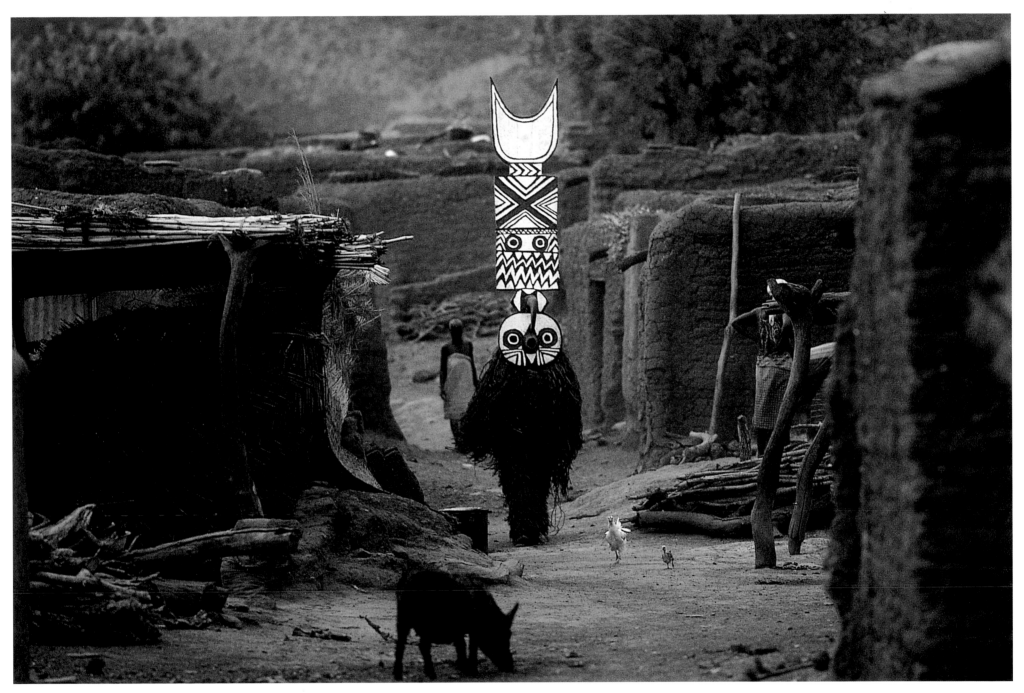

BURKINA FASO, 1993. On a small street in Boni, the Owl Mask walks to the funeral ceremony of the Chief of Masks. The owl symbolizes one who sees beyond the living–thus the mask itself is considered supernatural. It is believed that if the wearer is unmasked, he will die brutally within the year. The X represents the mark of the clan; it is also seen in the scarifications on the cheeks and foreheads of the Bwa people.

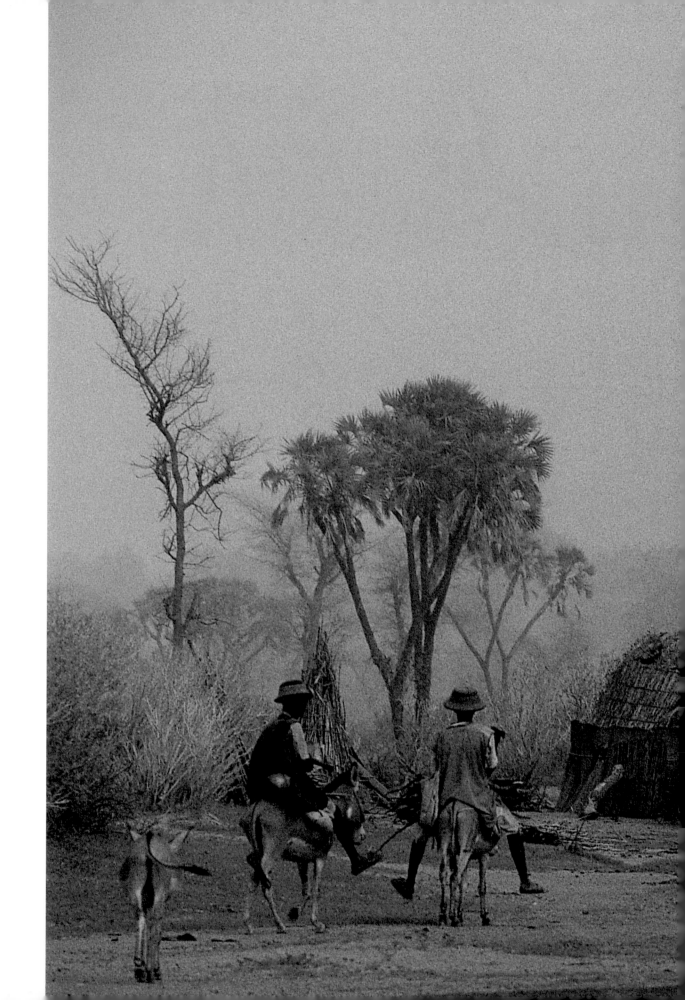

BURKINA FASO, 1991. Farmers from the village of Korea, near Diori, enter the fields on a day when the dry harmattan winds blow through a region already scarred by desertification.

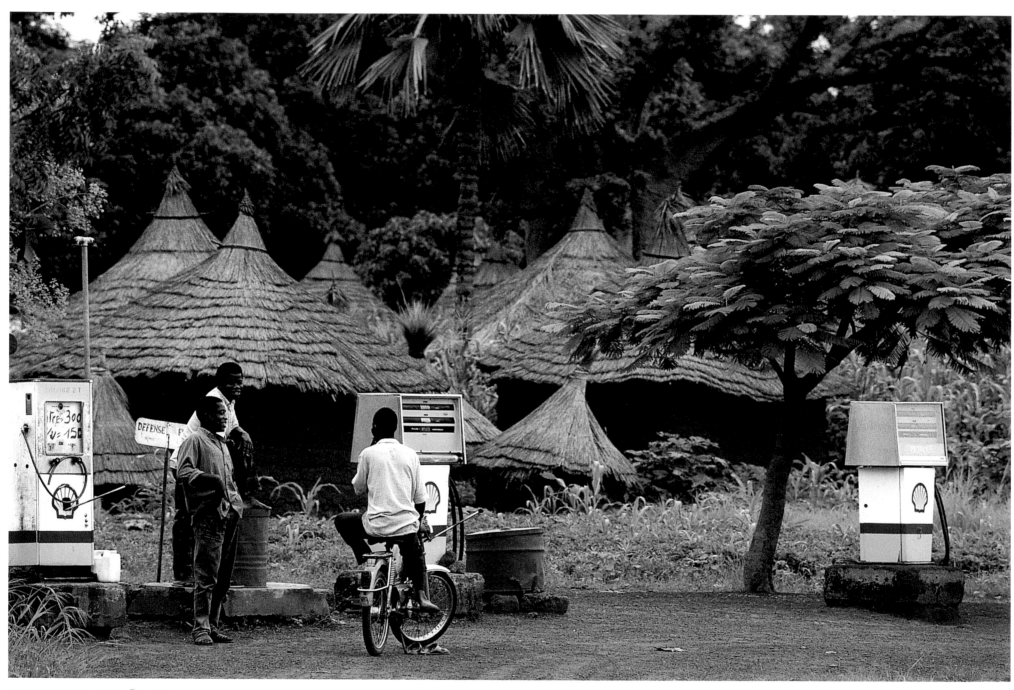

BURKINA FASO, 1991. Gas station
on the road from Gaoua in the
Lobi area.

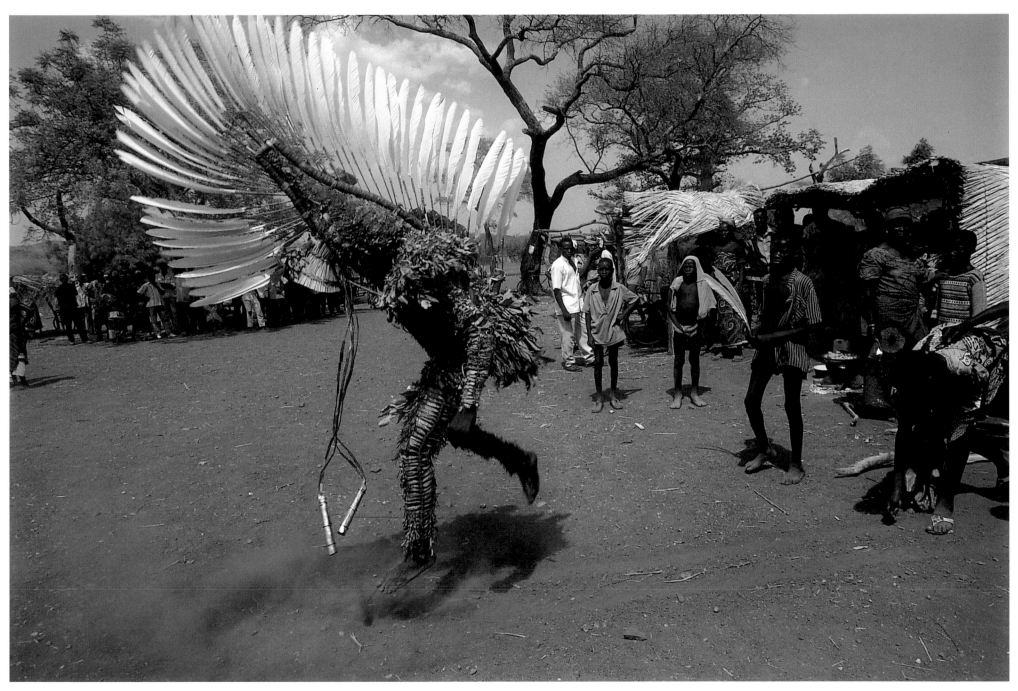

BURKINA FASO, 1993. The Leaf Mask, or Do, offspring of the creator Weni, is responsible once a year for ridding all Bwa villages of evil spirits. This is accomplished by a dance-exorcism—here, by the dance of Kopoi. This mask is made of fresh leaves and a fiber cone bristling with a woven crest of white feathers.

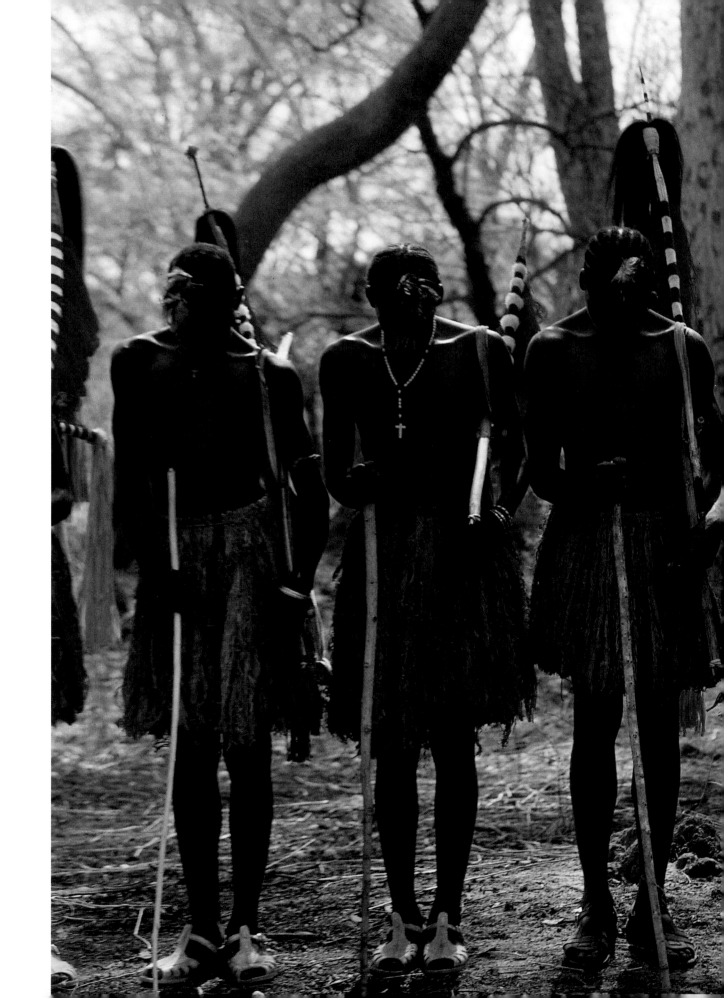

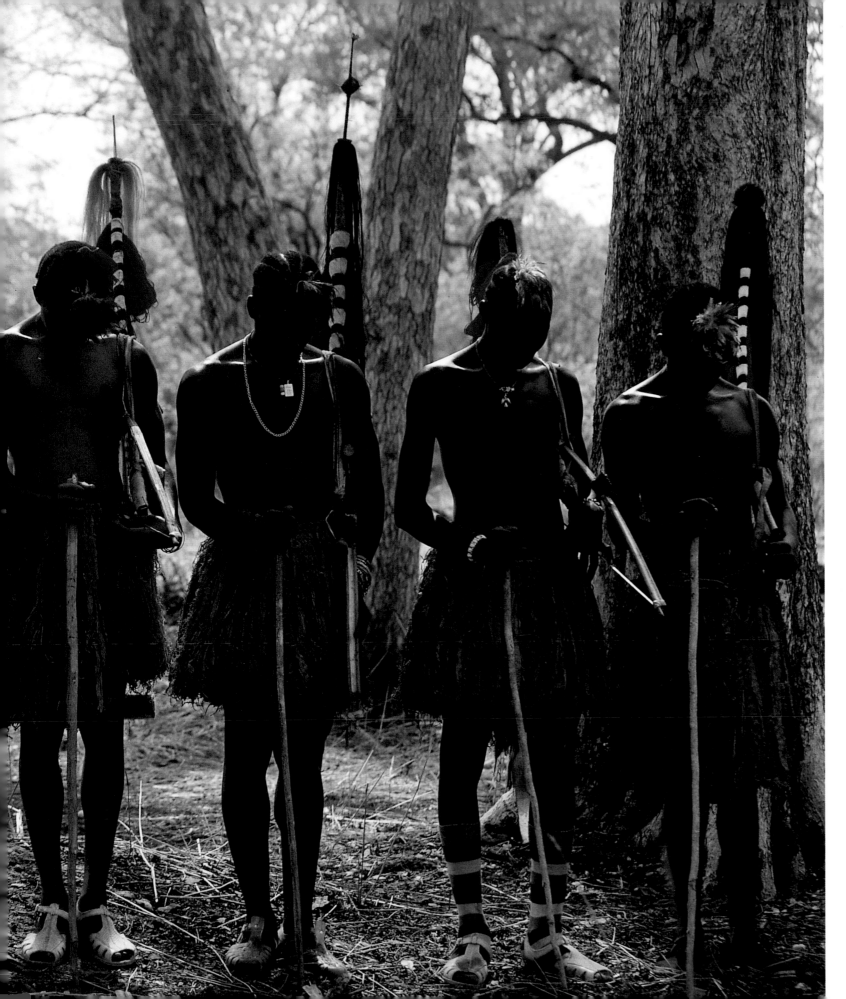

SENEGAL, 1992. Emerging from a sacred wood, young Bassari men sport the traditional outfit of initiates: grass skirts, shaved heads, bows, ceremonial swords. In this state, they are like newborn babies, incapable of holding up their own heads or expressing themselves; in fact, for them a new life is beginning.

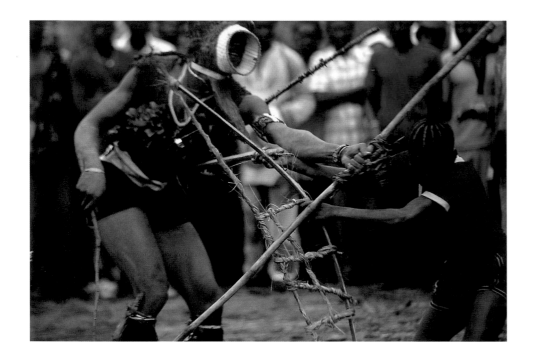

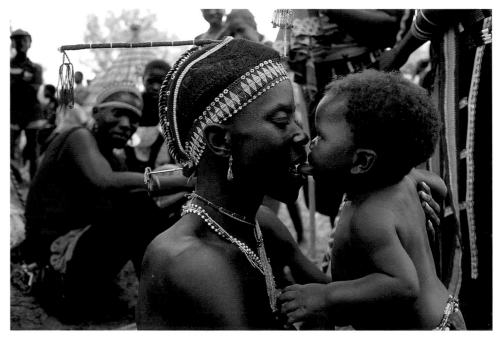

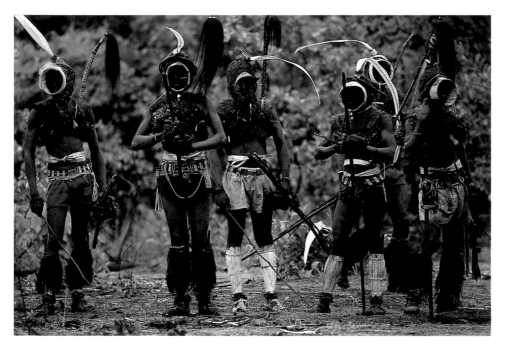

SENEGAL, 1992. *Opposite left*, a young boy plucks the entrails from a chicken's body, which will be used to foretell his future during the initiation. His closest kin attach bills to his hair on this occasion. *Above and opposite bottom right*, young mothers apprehensively watch the preparations for combat between the young initiates and the Lokouta Mask. This is the only part of the initiation ceremony in which they may assist, as the secrets of initiation must never be revealed to a woman. *Left top and bottom*, a Lokouta Mask and young initiate battle with one another. After a rough lashing, the initiate will be defeated and thrown to the ground. At this point, the initiate is on his way to adulthood.

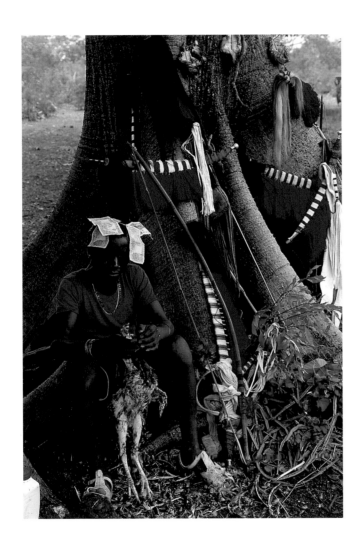

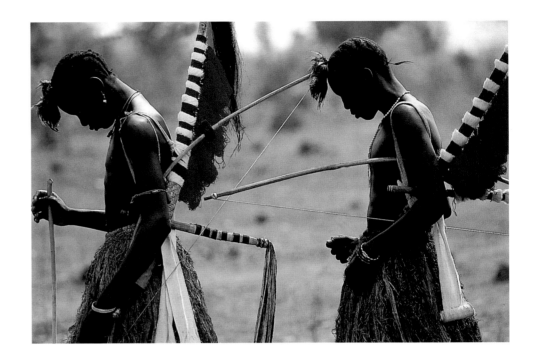

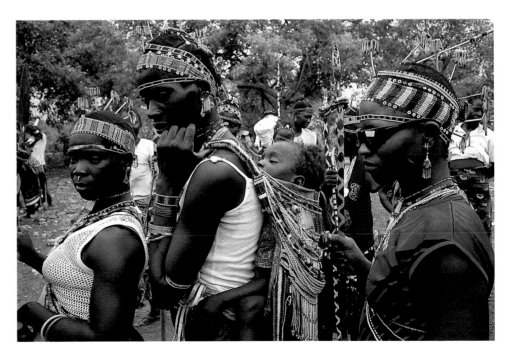

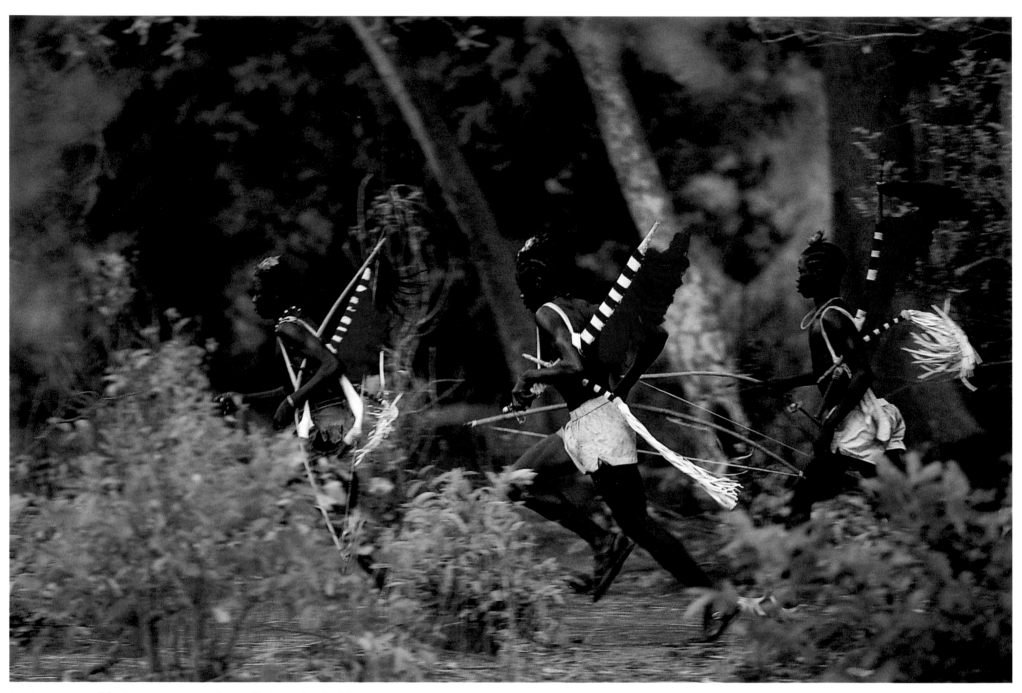

SENEGAL, 1992. Moving at a run, three Bassari initiates head toward the sacred forest where they will receive special instructions given to initiates only. During this period they will also endure bodily punishments, which are meant to toughen them and give them mastery over themselves.

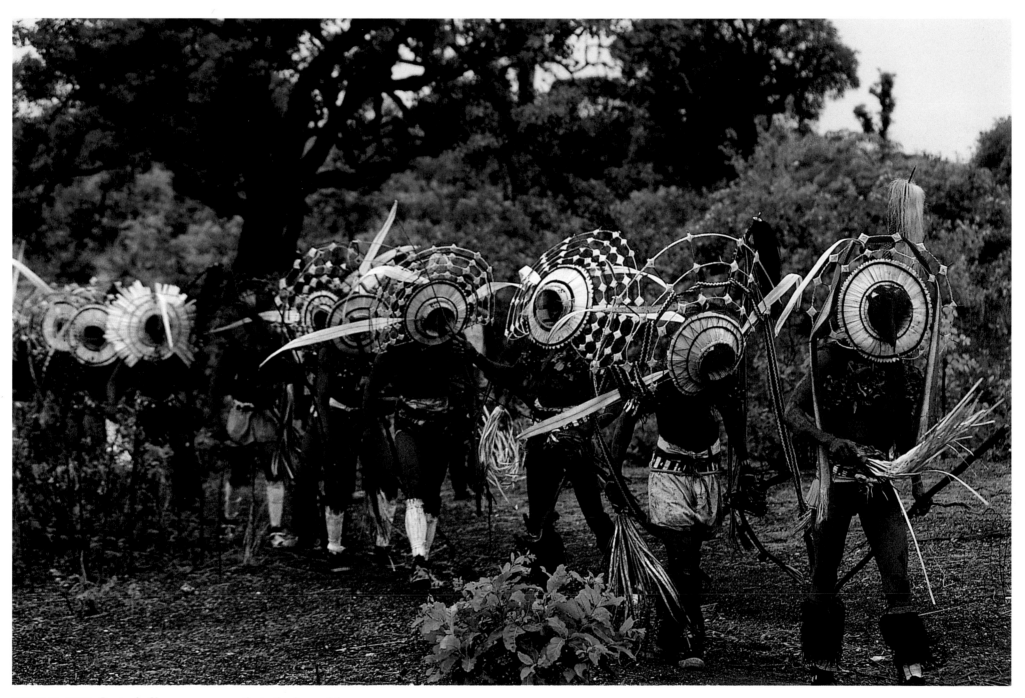

SENEGAL, 1992. In single file, the Lokouta Masks arrive at the outskirts of the Bassari village of Mako. For the Bassari people these beings—covered with ochre dirt, their heads donned in raffia wreaths in the form of the sun—are not human, but incarnations of good spirits that inhabit the nearby grottos. The Lokouta will then beat the young initiates, thus ushering them into adulthood.

CENTRAL AFRICA

The Planet's Green Lung

In the thick of the great equatorial forest that covers two-thirds of this vast area live the Binga, the Gelli, the Aka, the Tun, the Mbuti, and other tribes that most of us have come to know under the name "Pygmies," or "forest peoples." These appear to be among the first inhabitants of the African continent.

Several millennia ago, the forest peoples lived throughout sub-Saharan Africa, perhaps even in North Africa. In 2,500 B.C.E., Pharaoh Nefrikare I, of the Sixth Egyptian Dynasty, sent an expedition to find the source of the Nile. According to the Egyptians, one of the African forest people was captured and brought back to the Pharaoh's palace. They were the first to name these people Pygmies.

GREEN LUNG. At that time, the green swath of the great forest stretched throughout all of Africa. This was before desertification. The indiscriminate clearing of land by lumberjacks and successive populations of farmers has now reduced the immense equatorial African forest, which after that of the Amazon still constitutes the planet's second most important "green lung."

THREATENED FORESTS. Indeed, today the African forests are threatened from every side. European and, more recently, Asian logging companies are turning rich forest resources into rough lumber—mahogany, gaboon mahogany, limba, sipo (industrially used reddish wood), sapelli, and others—and clearing vast areas for exploitation. Similarly, mining compan-

CAMEROON, 1989. The Kapsiki Mountains of northern Cameroon are dotted with volcanic peaks. The writer André Gide considered this the most beautiful landscape in all of Africa. In this chain of extinct volcanoes, groups of fierce Kirdi seek refuge from the raids of Fulani and Kanuri armies who have been persecuting them for centuries.

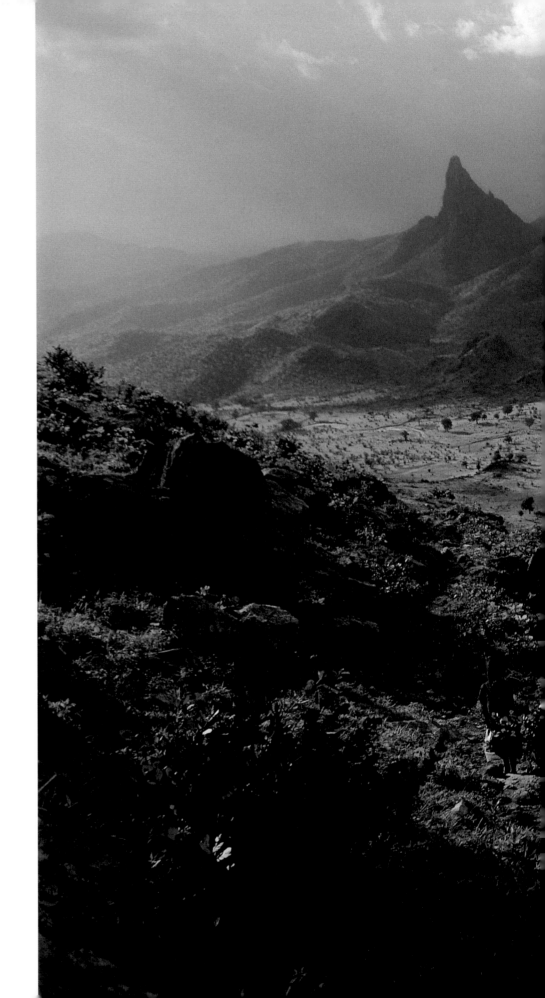

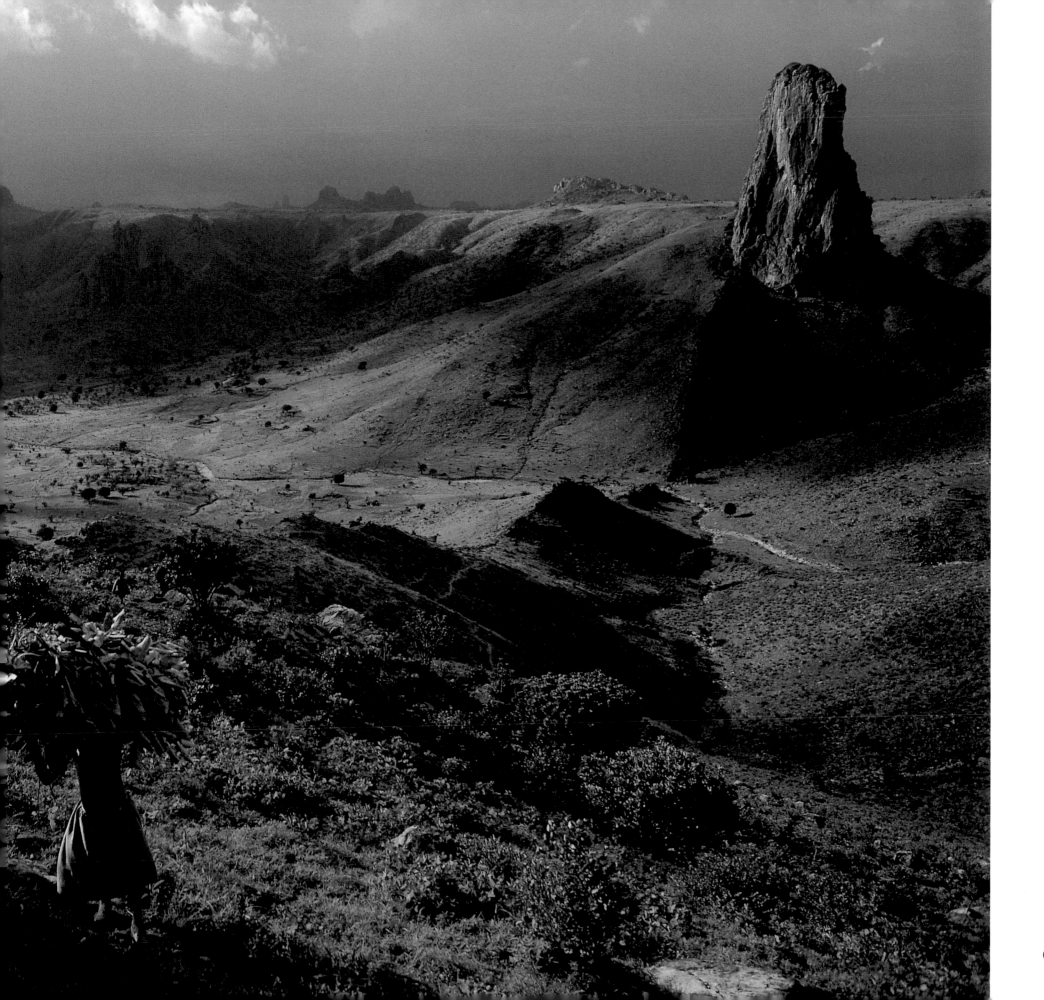

ies are digging quarries as well as carving out roads to transport their products. Finally, both itinerant farmers and planters are nibbling away at the forest's periphery; generally they grow nothing more than a single crop. This ransacking has been increasingly condemned by global ecological organizations. In contrast, the forest peoples, perfectly adapted to the dark and damp environment of the underbrush, have been very careful never to exhaust the resources offered to them by their nurturing mother—indeed, they worship the forest as one would worship a goddess.

Long before the advent of the modern world, however, other African populations had already driven the forest peoples deep into the forest. Ever since the dawn of time, Africa has been a continent on the move. Driven by hunger, attracted often by mythical riches, or propagating new religions, entire peoples, strangers to the continent—Arabs, Europeans, Indians, Malayans, and others—invaded Africa from every side and by every means of transportation: on foot, by boat, on horseback, and on camel. More frequently than not, they imposed themselves upon the original inhabitants by force, clearing land in order to establish pastures, agricultural plantations, and villages. Compelled to give up their homes, the natives in turn imposed their will upon neighboring peoples (such as the forest peoples), who were driven away and then continued to migrate. As a result, the entire demographic chessboard of Africa was called into question, one square at a time.

THE SHOCK WAVE OF ISLAM. Some countries in Central Africa, such as Cameroon and Chad, experienced the shock wave brought on by the arrival of the Arabs and the introduction of Islam in North Africa only after a delay of several centuries. Disseminated by marabouts using the trans-Saharan caravans, the religion of the Prophet Mohammed spread across the great African empires of the western Sahel (Mali, Songhay) and through Chad (the empire of the Kanem-Bornu). At the same time, in northern Nigeria, a chain of powerful Hausa sultanates was established.

In the nineteenth century, the Sokoto Peul, in the north of Nigeria, set the jihad (a Muslim holy war) in motion and instigated the invasion of neighboring Cameroon. In turn, they established sultanates, including Ngaoundere, Rey-Bouba, Garoua, and Maroua, particularly in the north of the country. But the arrival of armies also hastened the frantic flight of a large part of the local population, who were resistant to Islam. Thus, some thirty peoples, labeled Kirdi ("pagans") by the Muslim invaders, sought refuge in the Mandara Mountains in the farthest north of Cameroon. There they built villages fortified like eagles' nests. Among these ethnicities were the Kirdi Kapsiki, the Mafa, the Maba, the Mora, and the Podokwo.

BANTU MIGRATIONS. If the advance of the Islamic cavalry was stopped by the natural barrier of the great equatorial forest farther south, it did not offer a real obstacle to the great migrations of the Black Bantu. Originating in the great open spaces of northern Nigeria and Lake Chad, the Bantu diaspora migrated progressively toward the center of the continent and then, in a final stage, dispersed widely throughout southern Africa, where one of the Bantu branches—the largest and most famous one—was formed by the Zulu peoples. In Central Africa, the Bantu multiplied under the name Fang or Pahuins. In order to move from tropical Africa toward equatorial Africa. They had to traverse an impenetrable forest and its sinewy waterways. To do so, they built rafts and dugouts, and let themselves drift with the current of the innumerable rivers and streams that branch out through the forest. Thus, in order to cross Gabon, for instance, all they had to do was travel down the Ogooue and a few of its many tributaries.

THE CONGO RIVER. Today, as in the past, the Congo offers Africans an international waterway, the immense basin of

which covers almost four million square kilometers. It not only stretches across the territory of both Congos (Brazzaville and Kinshasa), but affords access to Angola, the Central African Republic, Gabon, and Cameroon. The Congo is the fifth-longest of the world's great rivers, after the Amazon, the Nile, the Ob, and the Yangtze; it is unique in that the residents along its banks, no matter what their nationality, speak a common language, Lingala. It is spoken by sailors, fishermen, and passengers on board the rivercraft; by forestry developers, villagers, civil servants on assignment, and foreign traders.

RIVER CONVOYS. It is an unforgettable spectacle to see the enormous river convoys of thirty to forty barges, overflowing with passengers and miscellaneous merchandise (from smoked fish to black monkey, from live crocodile to stale baguettes), as they travel upriver against the current, powered by nothing more than a minuscule motorboat. Along the way, they are met on either side of the river by hordes of locals in dugouts offering their wares to the passengers, some with balls of manioc, some with bunches of plantains, or else liters of thick cabbage-tree oil, the color of fresh blood.

THE MIGRATION OF THE FANG. The Fang claim to have given the continent its name, since *Africa* is a distortion of *Afiri Cara*, the name of one of the Fang's earliest ancestors. As with the majority of the peoples of Central Africa, their migration presumably occurred in waves in the direction of the Equator. Once arrived in southern Cameroon, Equatorial Guinea, and Gabon, they are supposed to have divided into many groups before they settled down in the great forest regions, having been stopped in their thrust toward the south by Spanish, German, and French settlers.

BANTU MIGRATION AND METALLURGY. Among all the great peoples who have crisscrossed Africa, the Bantu occupy a special place, for, according to the daring hypotheses of archeologists, they are supposed to have contributed widely to the expansion of metallurgy throughout the Southern Hemisphere. It is known that metalwork was invented in Mesopotamia one or two millennia before our time. Supposedly it spread along the Nile during the time of Egypt's pharaohs. Going up the "god-river," blacksmiths and steelworkers brought the secret of iron manufacturing to the kingdom of the Kush in the sixth century B.C.E. From this "African Birmingham" the iron road would merge with the path of the Bantu migrations. Having left Lake Chad and central Nigeria (the region of the Benue River), where one can still see high mounds of iron ore, the Bantu created a new residence in Angola and Congo-Kinshasa before reaching South Africa. Here kingdoms developed that were to have brilliant cultures. Whether among the Baluba, the Bakuba, or the Balunda, even today many traditional ceremonies still survive; art forms developed in African courts, such as superb furniture and sculptures, are collected by the finest museums of the world. Unfortunately, the kingdoms of Central Africa, including the former Tutsi monarchies of Rwanda and Burundi, have always cultivated the art of war. This explains the difficulties in stopping the famous "Conflict of the Great Lakes," which at the end of the twentieth century culminated in genocide, and continues to cause unrest throughout the region. It is a fire that is difficult to extinguish—the great powers would like to run off with the enormous riches of the mines in the region (offshore oil, diamonds, gold, copper, tungsten) and are too divided by their rivalries to seek resolution.

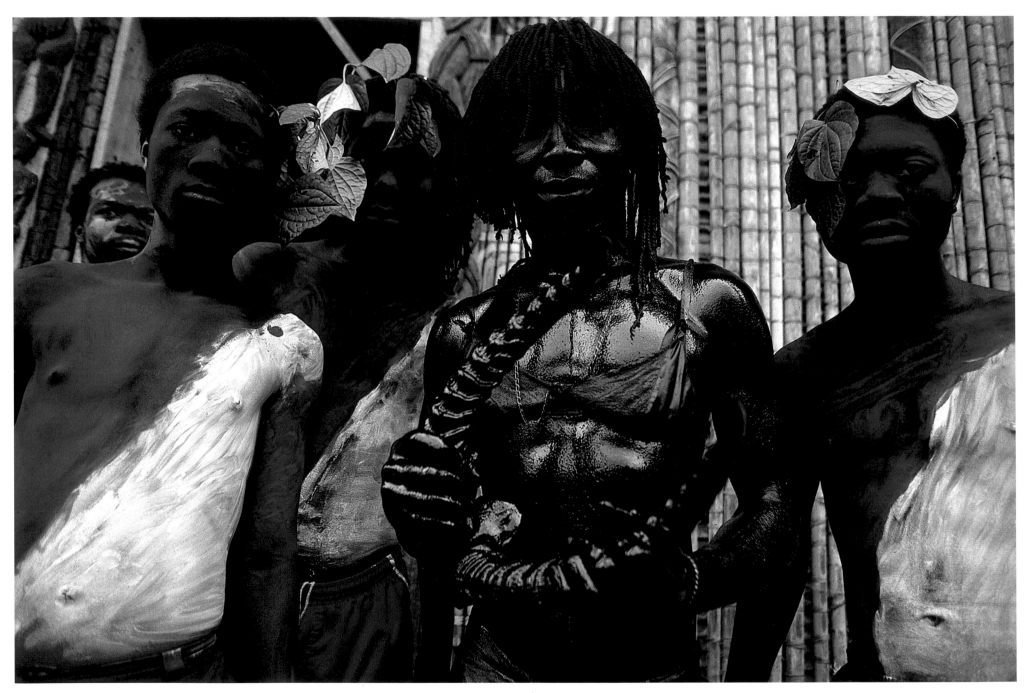

CAMEROON, 1989. During the initiation ceremonies of the Bamiléké, in the Bafoussam chiefdom, the men paint themselves black with tar and blue with methylene; they then growl, roar, and howl frighteningly.

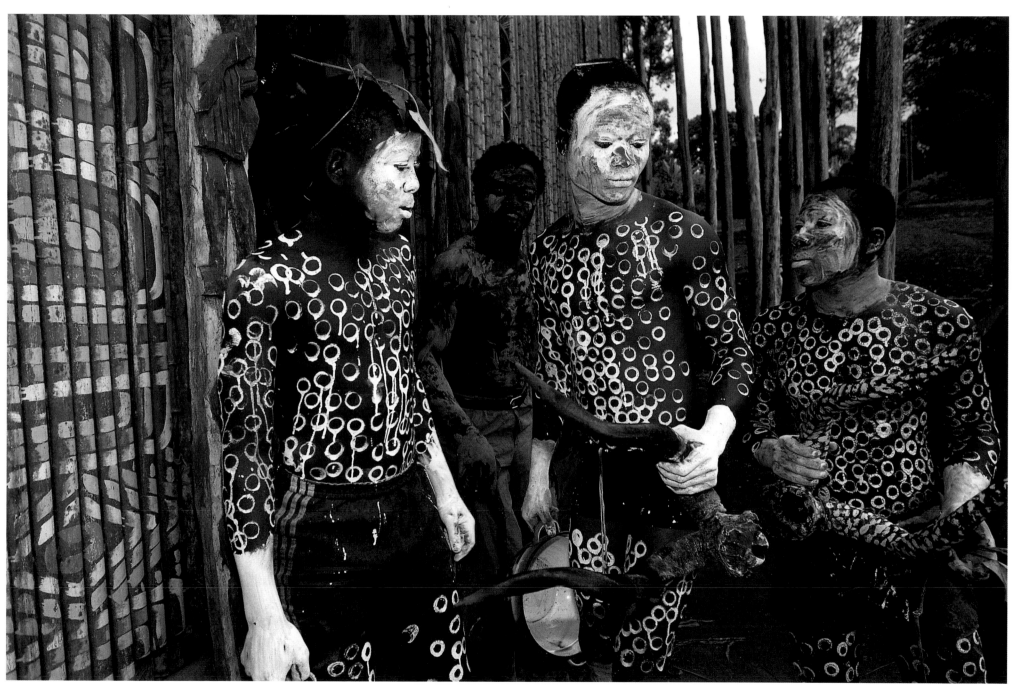

CAMEROON, 1989. During the ceremonies, young men are painted with white spots representing the leopard and its strength.

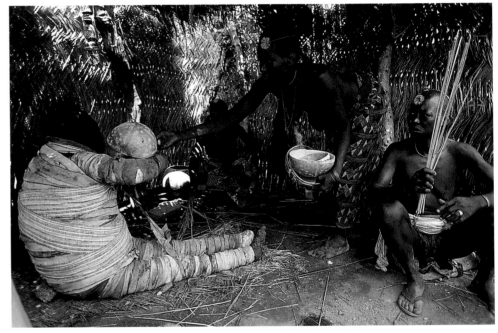

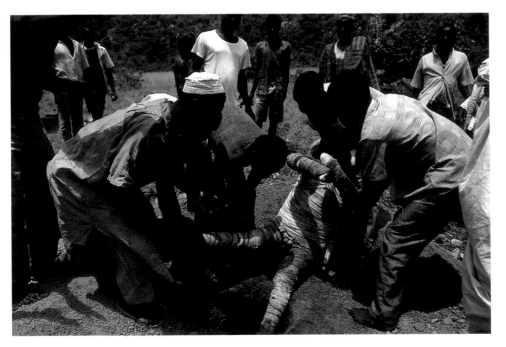

CAMEROON, 1989. The Fali of Ngoutchoumi have practiced certain ceremonial traditions for centuries. *Top left*, the body of a dead woman, wrapped in strips of cloth like an Egyptian mummy, is carried through all the places she has lived for a final good-bye before being buried in the fields where she worked her whole life. *Above*, the body of the deceased receives last rites before being carried to her final resting place. *Left*, the body of the deceased is slid into her last resting place—a narrow, deep hole. The body is thus returned to the belly of the earth. In a traditional funeral rite, the skull of the dead woman is kept in an urn, among the pantheon of her ancestors. It is believed that these ancestors protect the living.

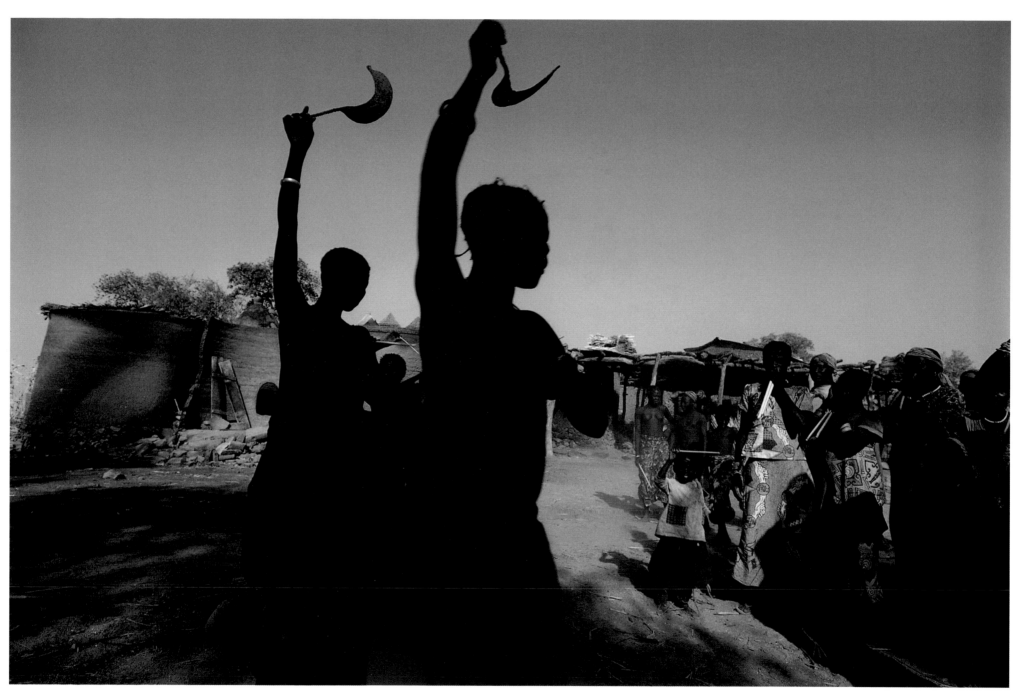

CAMEROON, 1983. The dance of the scythes is performed by Kirdi women of Oudjila at the end of the harvest. This is a dance for fertility and abundant harvests to come.

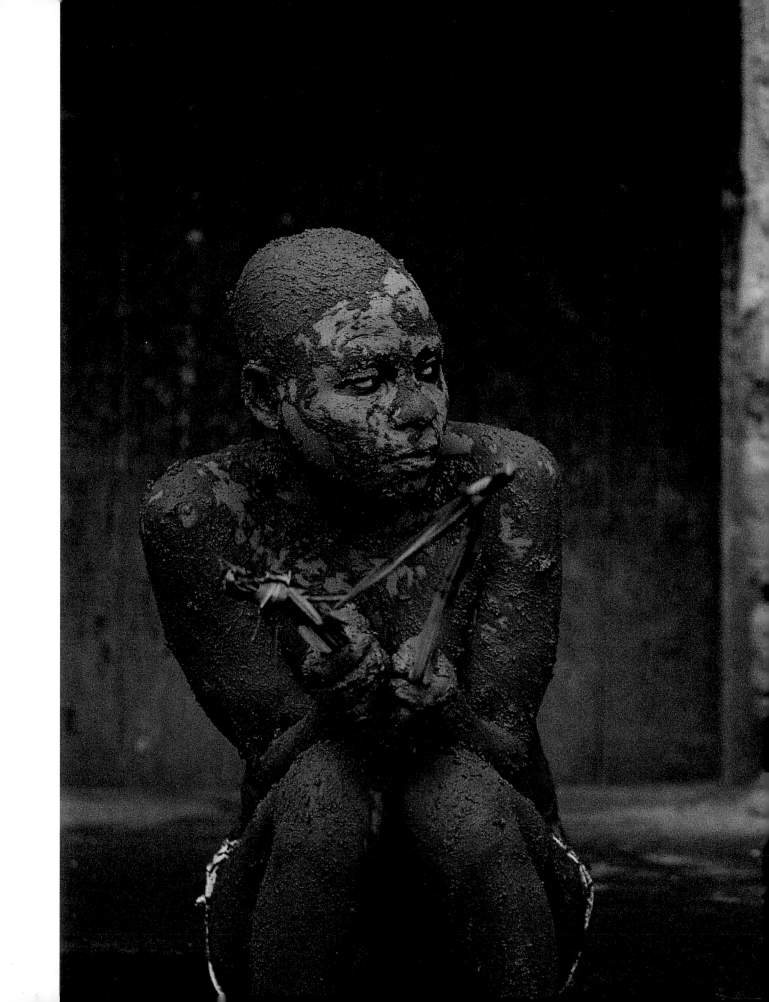

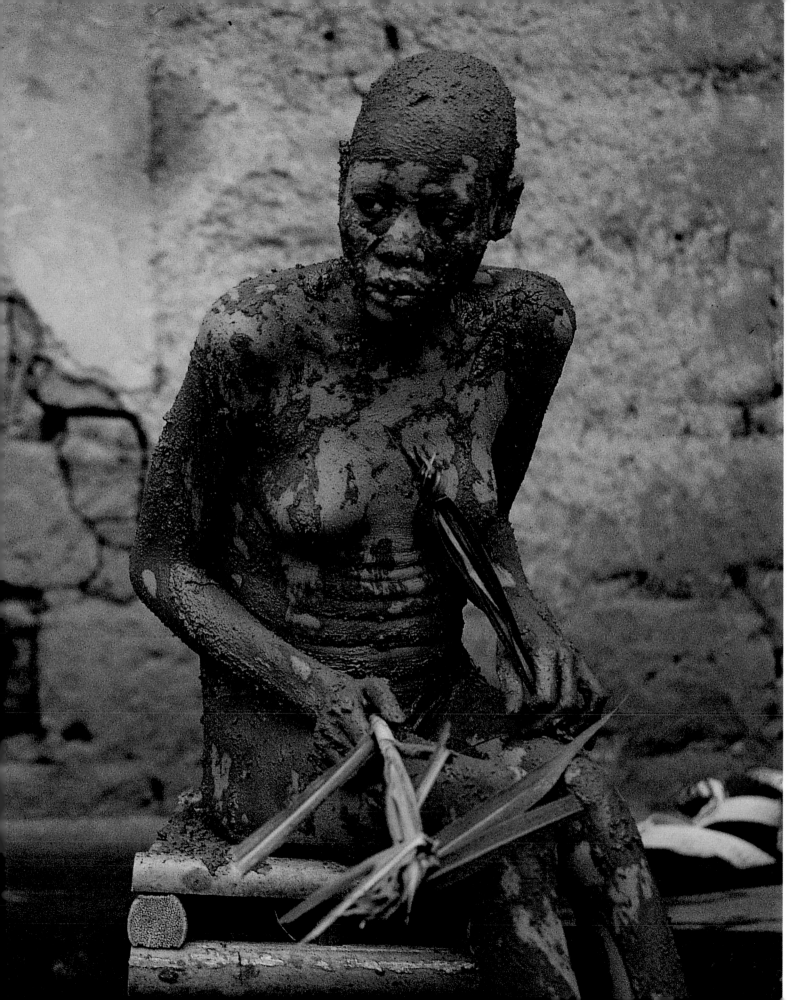

CAMEROON, 1995. These female patients stay naked and covered in mud for two hours every day. They must wait until the evil spirits that possess them have left, according to the treatment of healer Tadoh Fomantum of Bamenda.

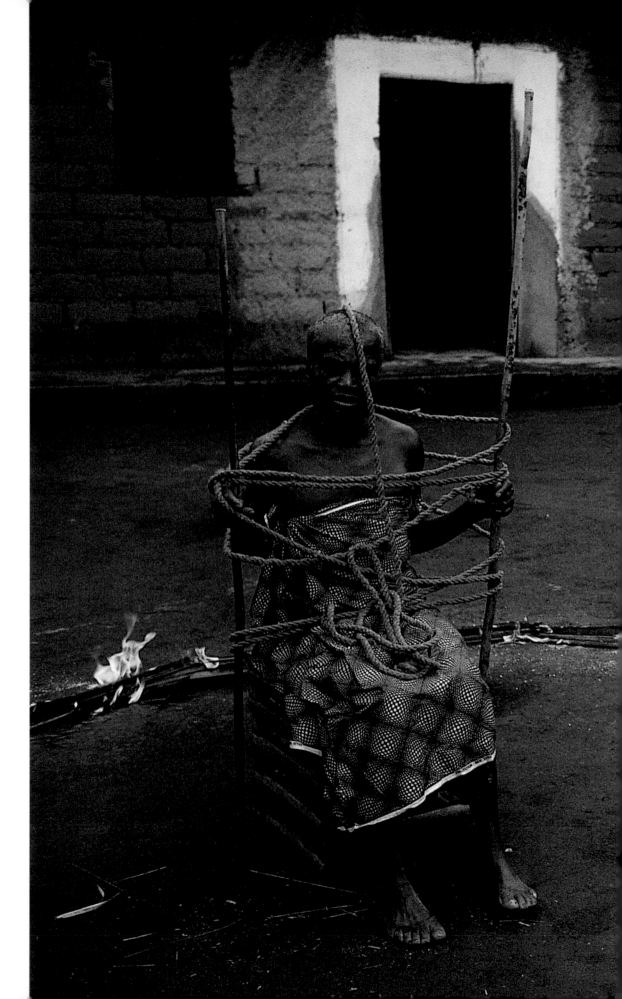

CAMEROON, 1995. In his Bamenda clinic, healer Tadoh Fomantum attempts to cure a patient who has been driven mad by sorcery. This treatment is considered a "traditional therapy" by Western psychiatrists. It relies on ancient cultural beliefs that have been mastered by men of great spirituality. Some patients from the region are brought to Tadoh's clinic by medical doctors.

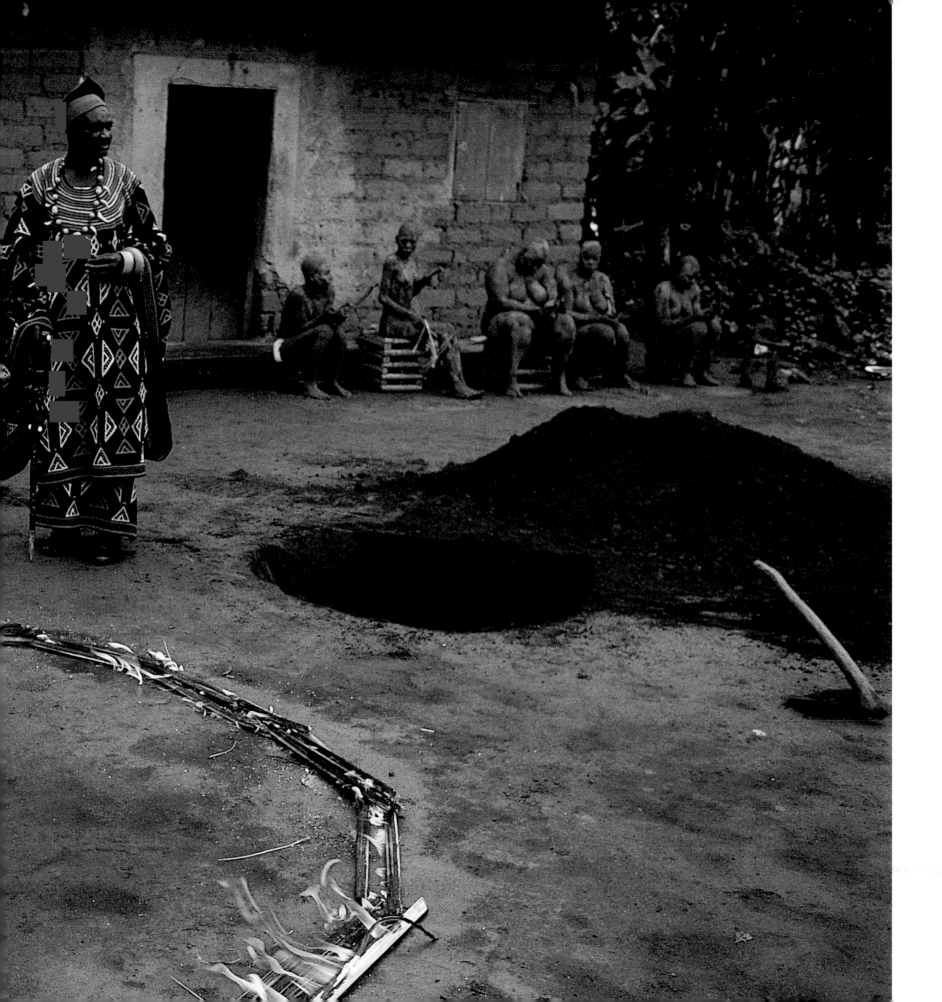

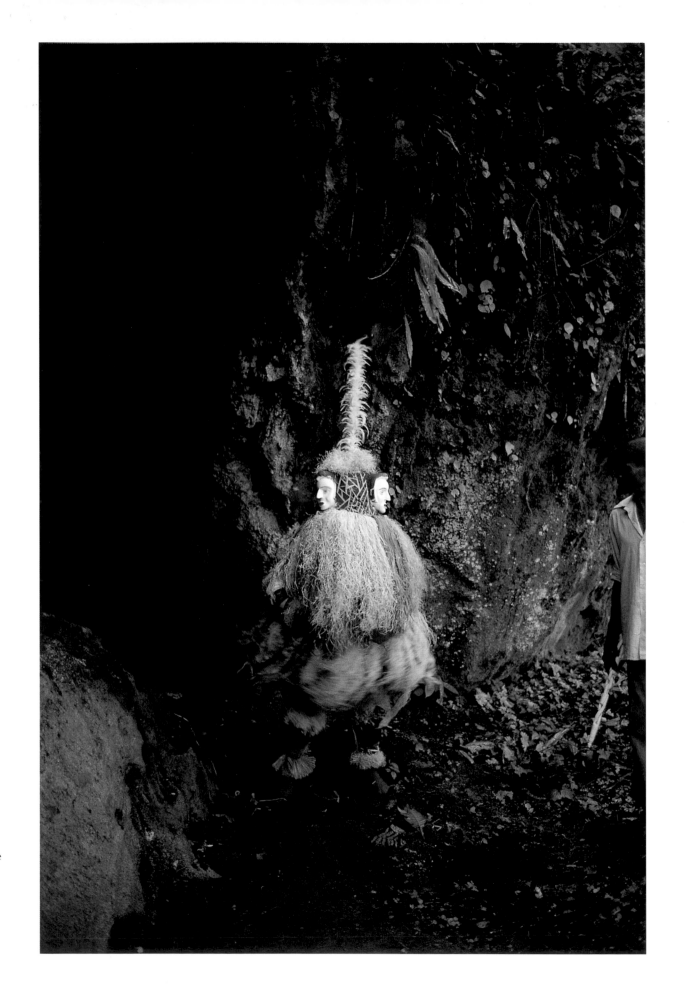

EQUATORIAL GUINEA, 1988.
In the Mongomo region, the "Okak" Fang people use the White Mask in the cult of the dead. From the time of the white people's first appearance among them, the Fang have believed that they were their ancestors returning.

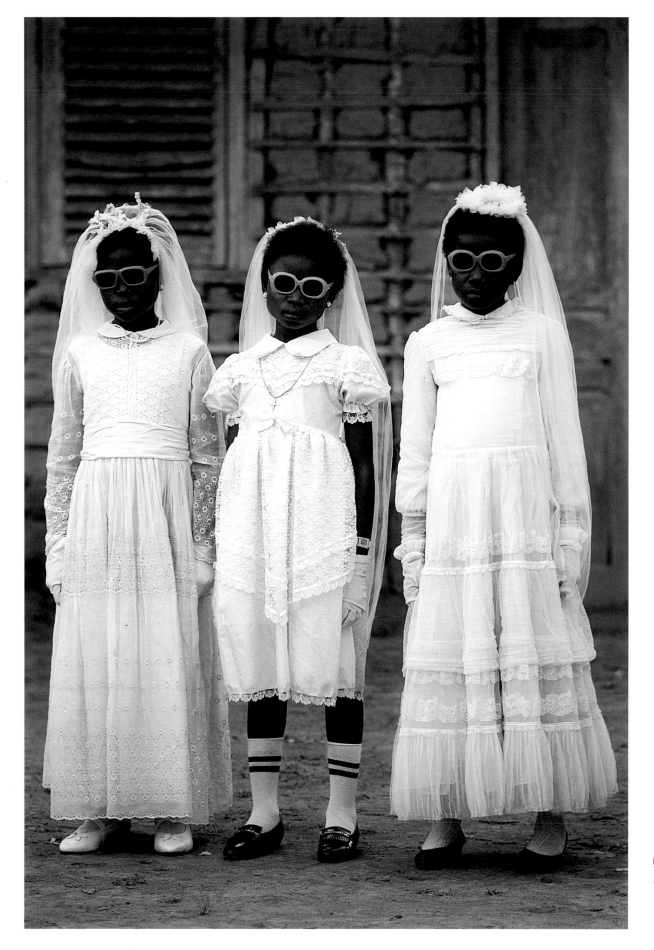

EQUATORIAL GUINEA, 1988.
After First Communion in Bata.

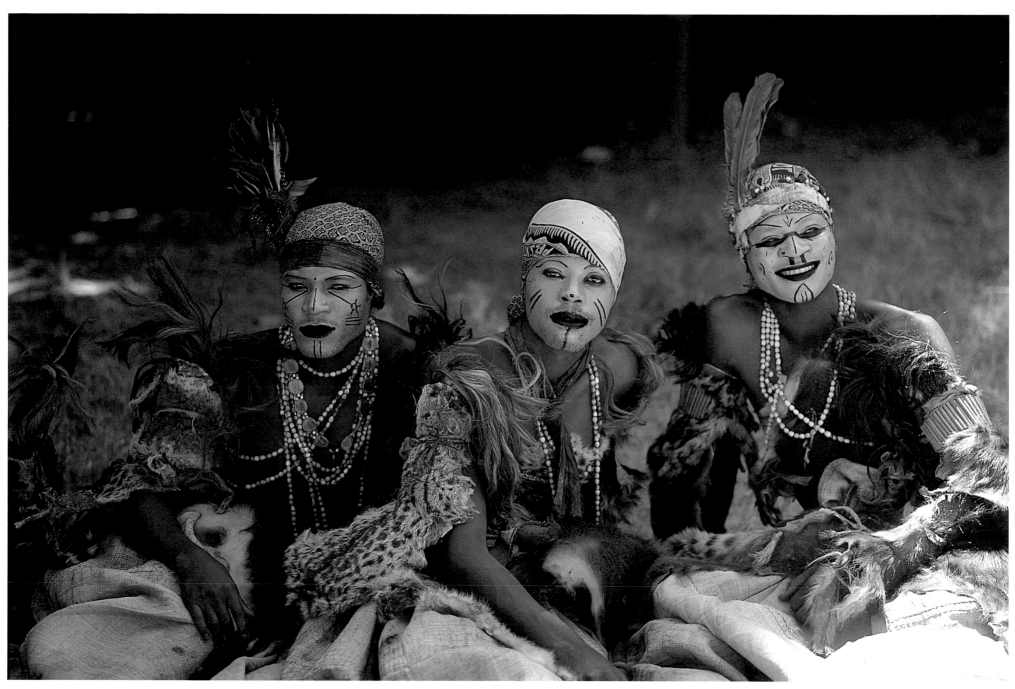

CONGO, 1985. In the Shaba region, Mbudje dancers of Luba ethnicity rest in the shade after dancing at initiations, funeral services, or birth celebrations. For these dances, they paint their faces. Once this was done with natural colorings; today more modern materials, such as paints, are used.

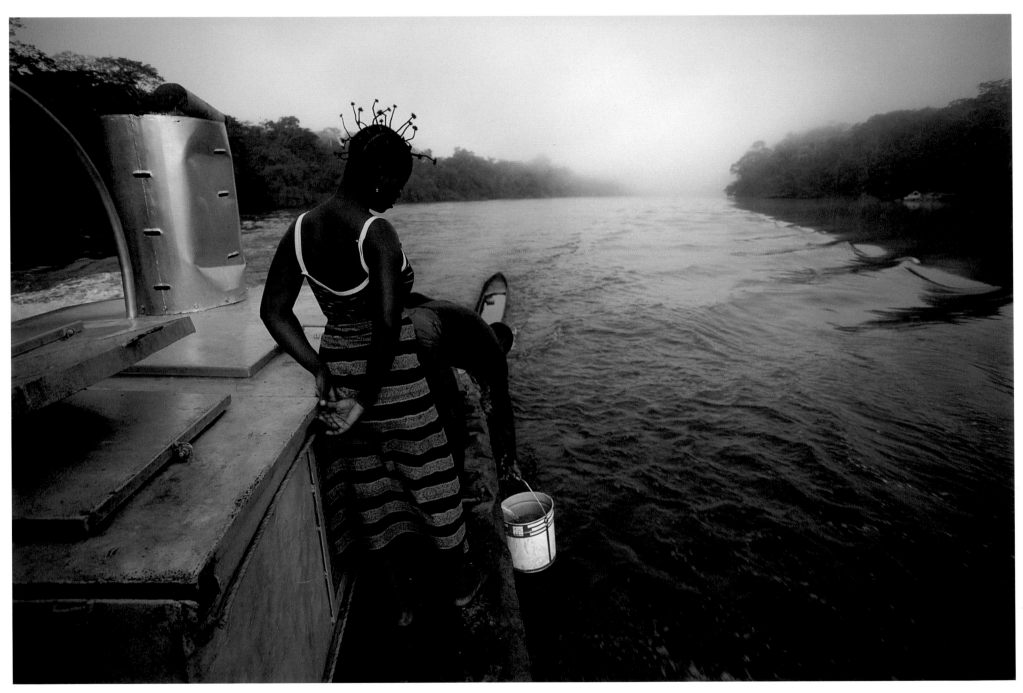

CENTRAL AFRICAN REPUBLIC, 1983.
In the early morning, passengers travel up the Lobaye River, deeper into the heart of the virgin forest in Pygmy territory. This boat is the "taxi of the jungle" for the inhabitants along the riverbanks.

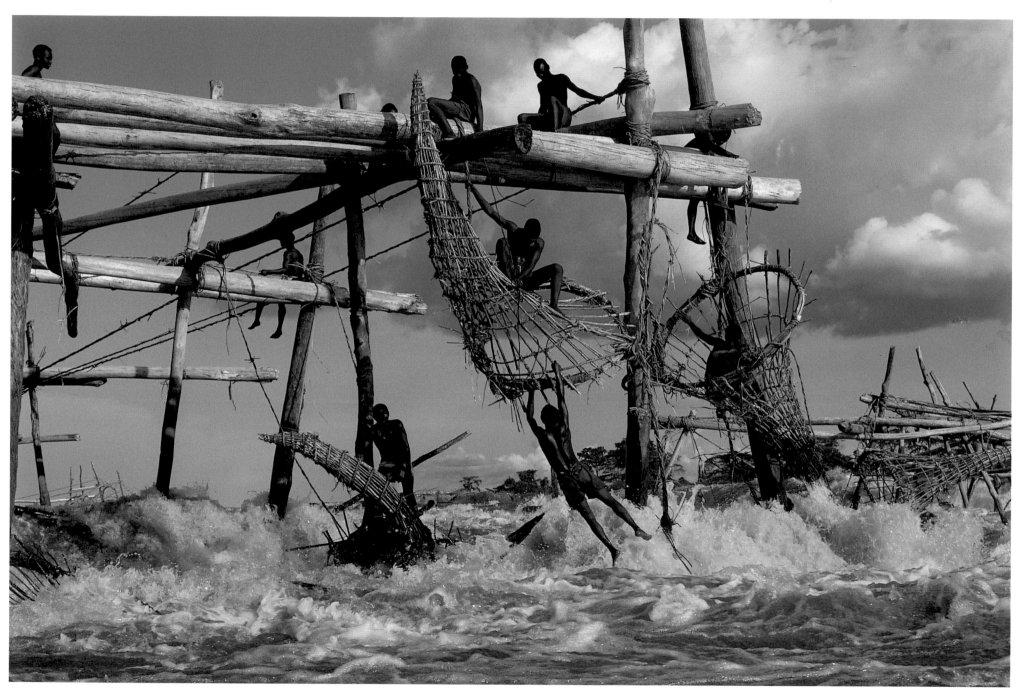

CONGO, 1995. At Boyama Falls, near Kisangani, Wagenia fishermen pull in their giant hoop-nets from the river's rapids. In 1877, the explorer Henry Stanley remarked upon the virtuosity of these fisherman, as they were at great risk of falling into the cascading falls.

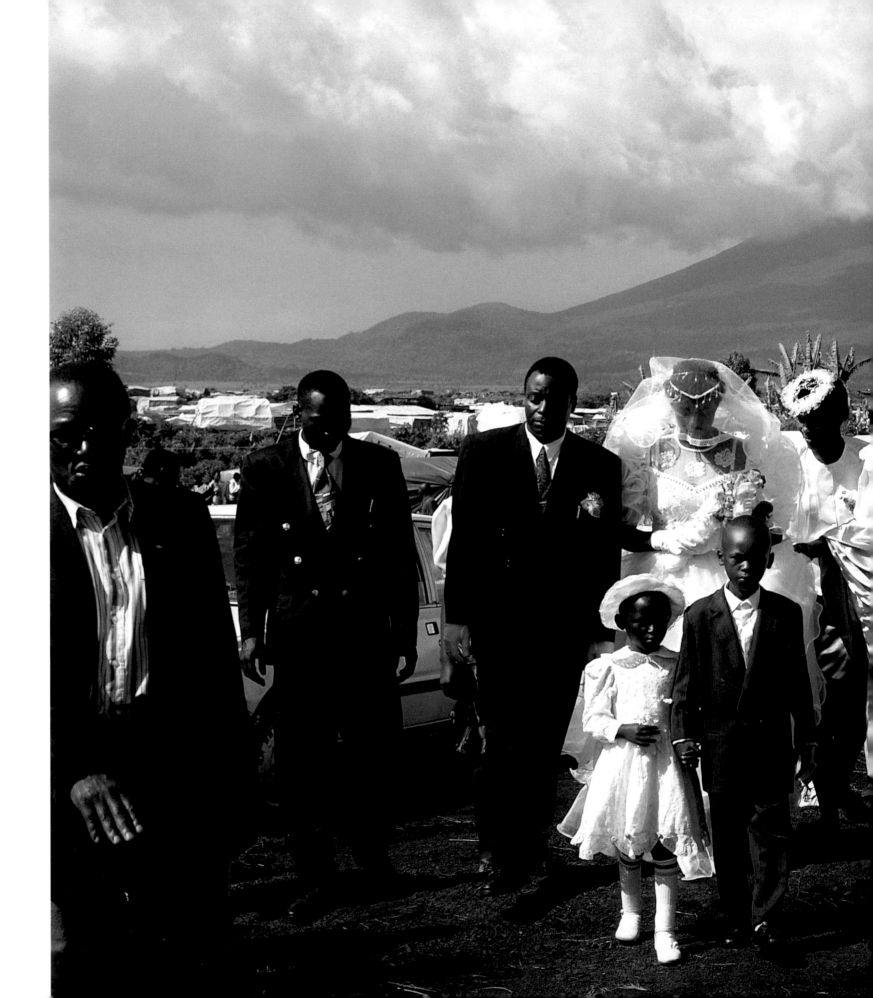

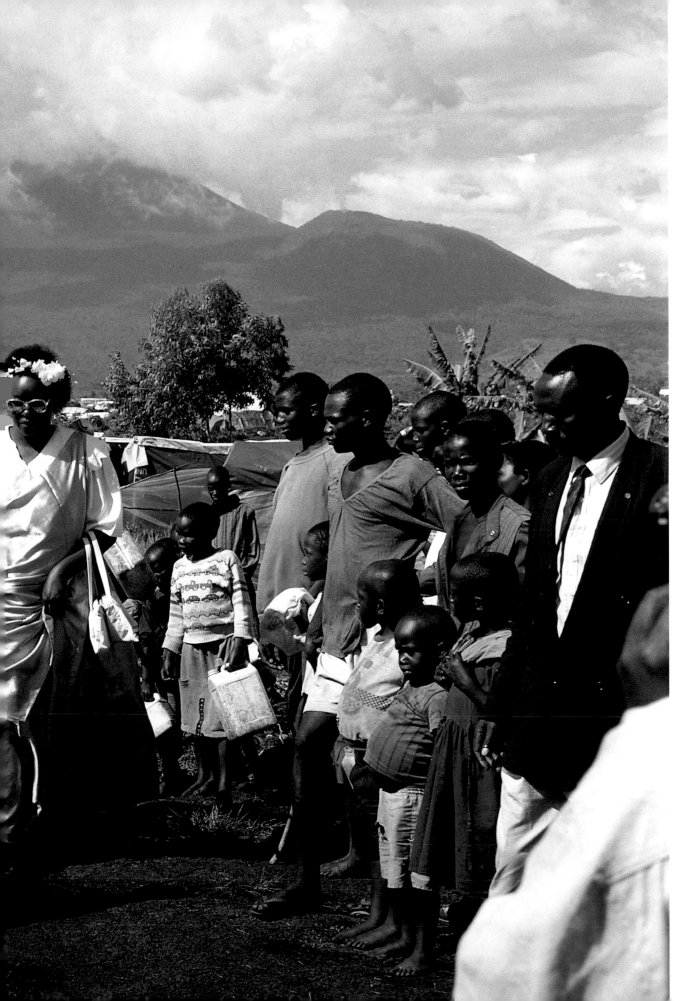

CONGO, 1995. On the shores of Lake Kivu, the Mugunga refugee camp, filled with nine hundred thousand Rwandans, extends as far as the eye can see. Here, between precarious tents, a solemn marriage takes place. All of the participants belong to the now-deposed Hutu elite who ordered the ethnic massacre in the summer of 1994. This ceremony is a testimony to the exodus that has touched every layer of society in the country.

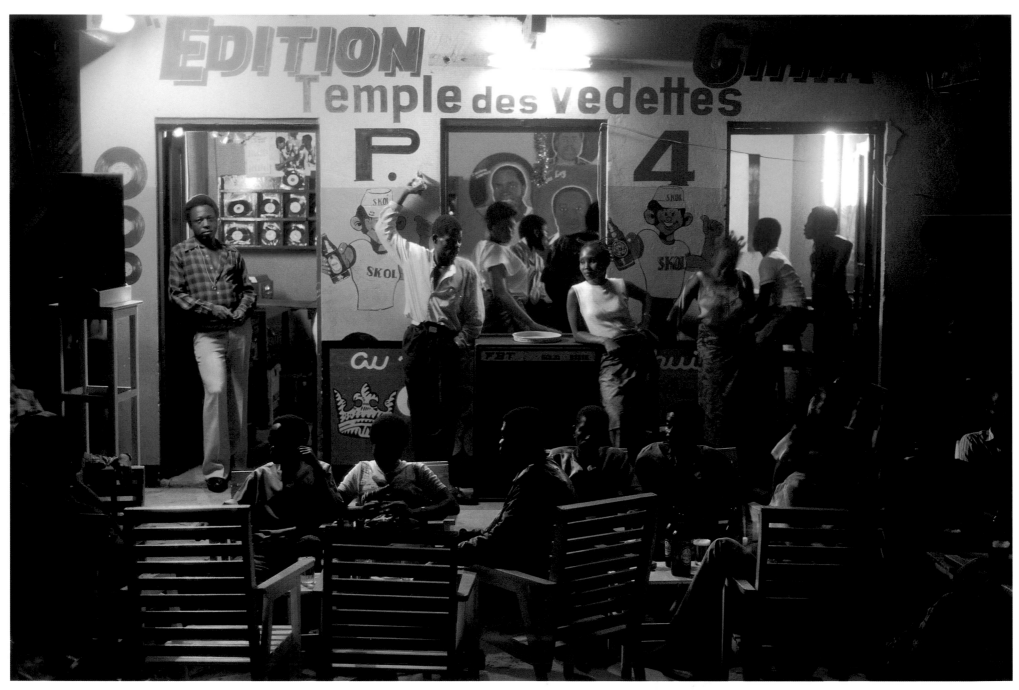

CONGO, 1986. When darkness falls in Kikwit, loudspeakers are brought out onto the terraces of bars and nightclubs, blaring a bewitching music. Music is central to Congolese life. Most of Central Africa's greatest musicians have come from Congo.

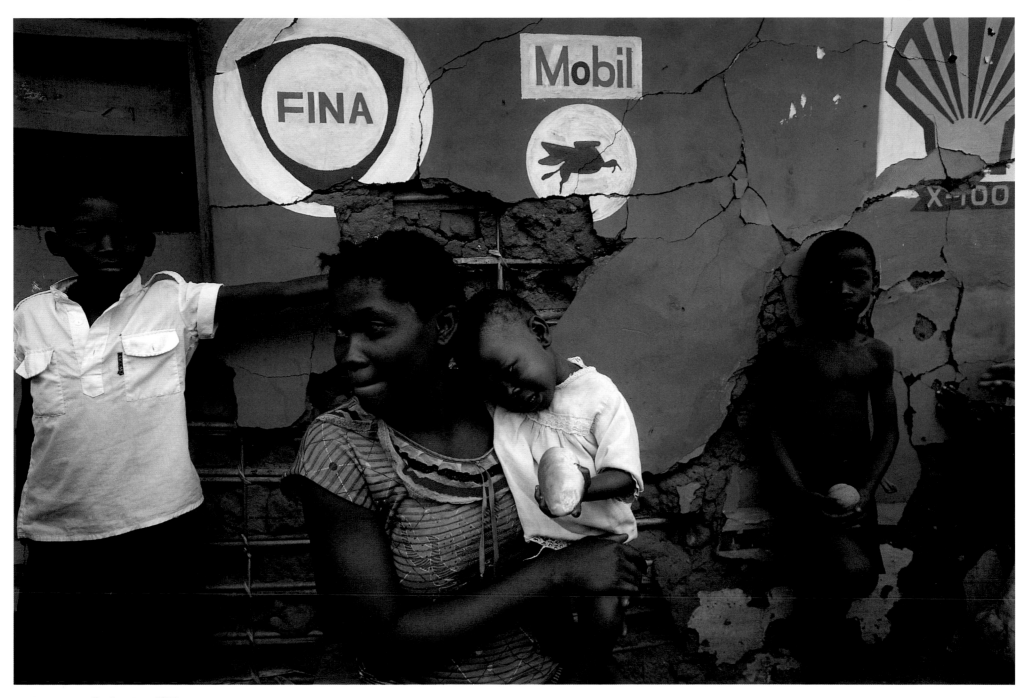

CONGO, 1986. In the city of Kik-
wit, advertisements are plastered
on the *poto-poto* (dirt) walls of
houses. Kikwit city was hit severely
by the EBOLA virus.

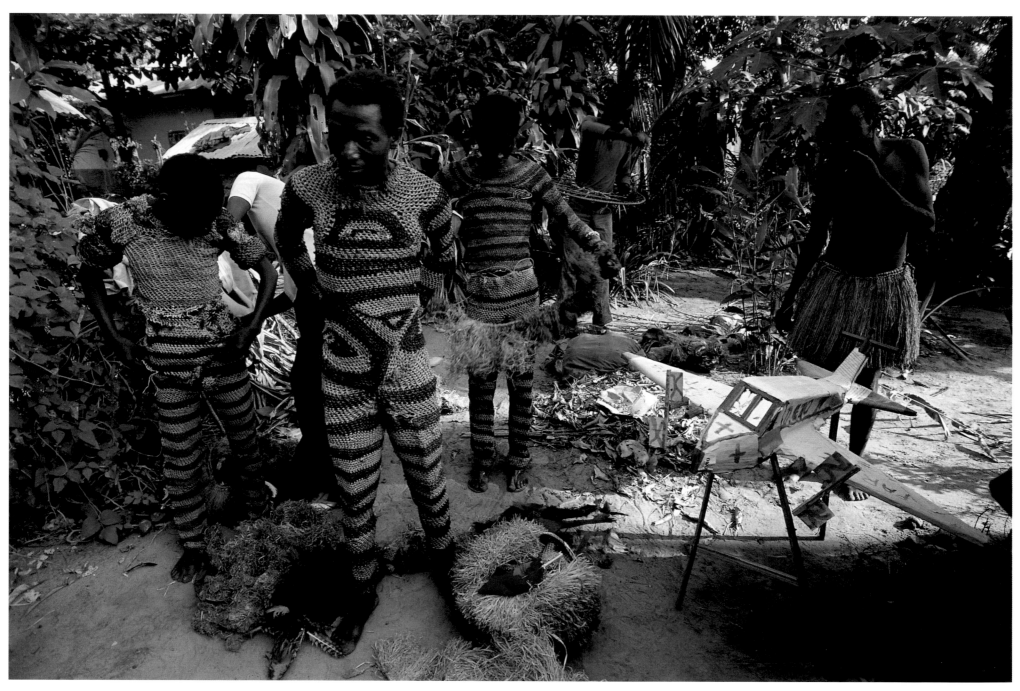

CONGO, 1986. More than 450 ethnic groups share the Congolese land, and practicing animists are prevalent among them. Here in Kikwit, among the Bapendé of Bandundu, the cockchafer has been replaced by the airplane. In former days, insects were used to transport spells and curses sent by sorcerers. Today, with the extension of the Congolese community into Europe and throughout the rest of the world, insects have been exchanged for airplanes, as their magic energy has not been strong enough to reach believers who live far away.

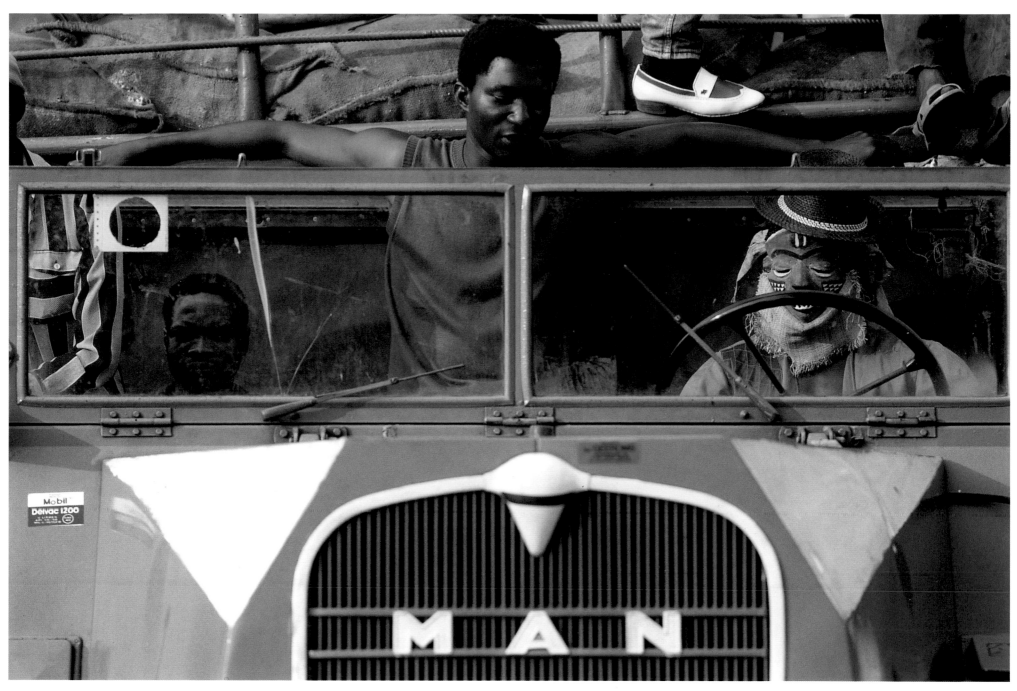

CONGO, 1986. In the streets of
Kikwit, a driver shows off
his power and fearsomeness.

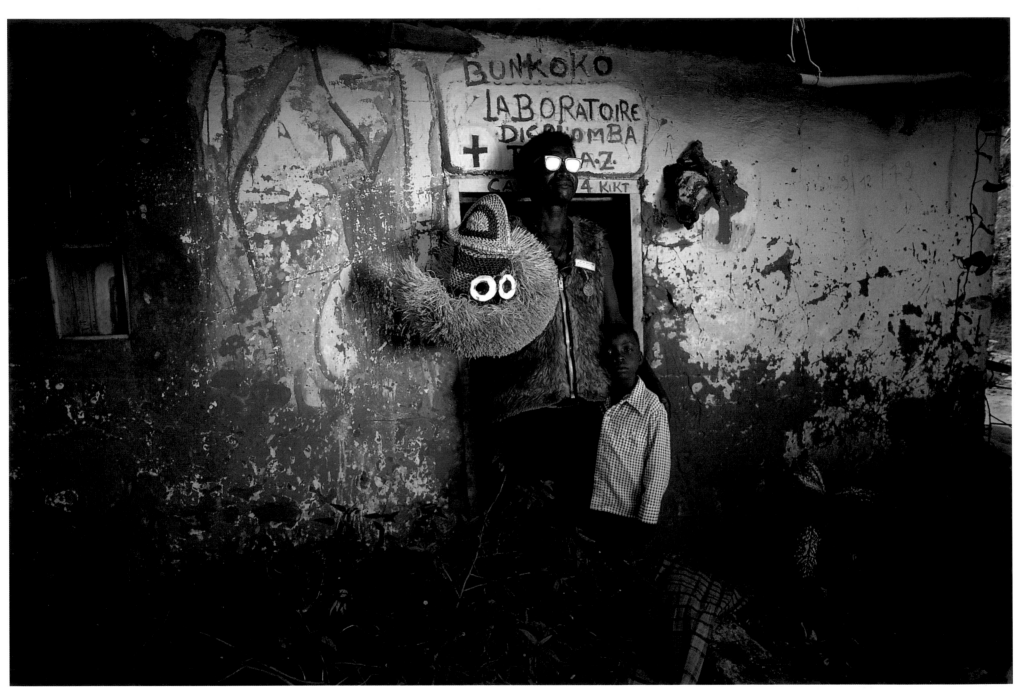

CONGO, 1986. In Kikwit, a healer of Bapendé ethnicity stands at the entrance to his laboratory, with his son and his traditional mask. The healers of Bandundu are highly renowned. Traditional healing methods are widely practiced in Africa; in many countries, Western-style medicine is failing, and traditional methods are the only medicine used.

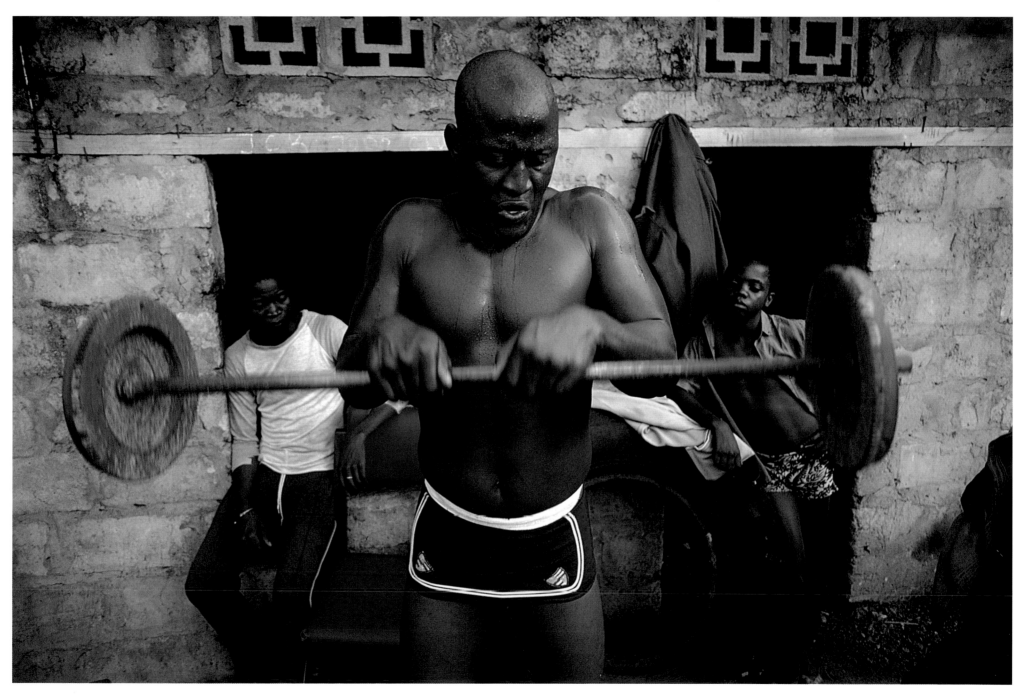

CONGO, 1986. The wrestler Samson trains in the popular Matonga quarter of Kinshasa. Soccer, wrestling, and boxing are the most popular sports in Congo. It was in Kinshasa that Muhammad Ali won his world-championship fight against George Foreman in 1974.

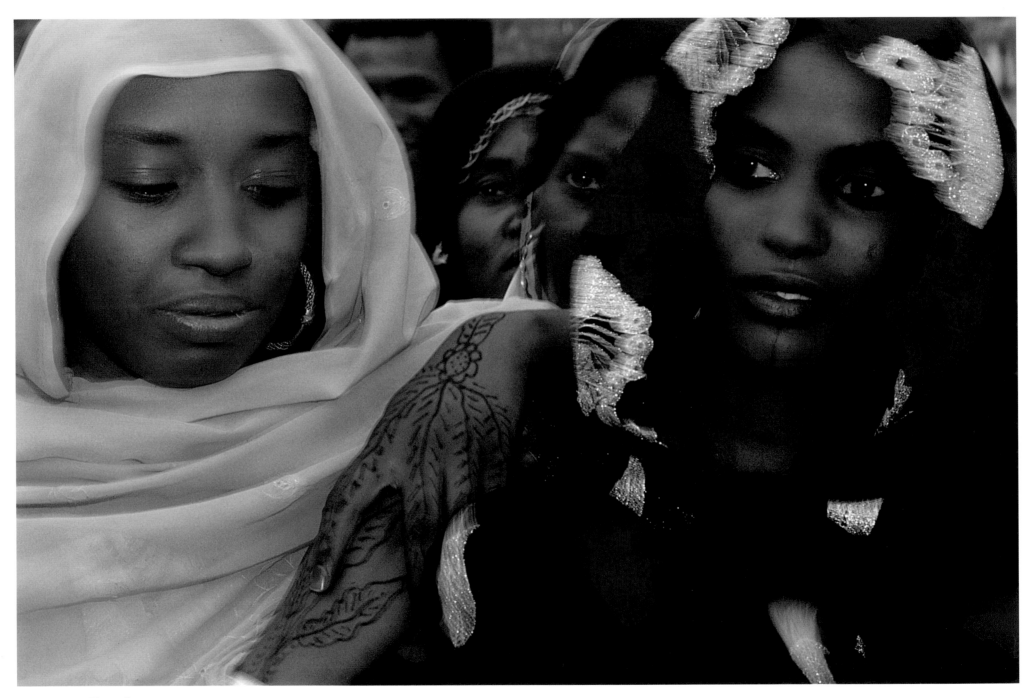

CHAD, 1987. These Gouranes women, members of a semi-nomadic Muslim tribe, attend a festival to celebrate Chad's reclaiming of the city of Faya-Largeau from the Libyans.

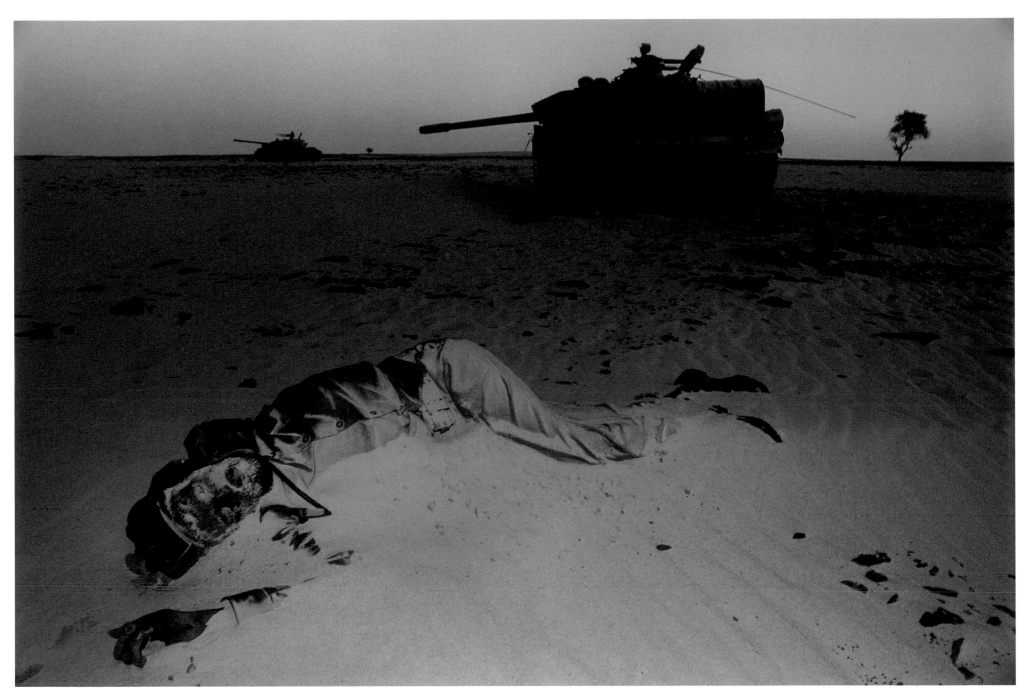

CHAD, 1987. This Libyan tank driver, yet another casualty of the terrible battle of Ouadi Doum, died at the foot of his own tank.

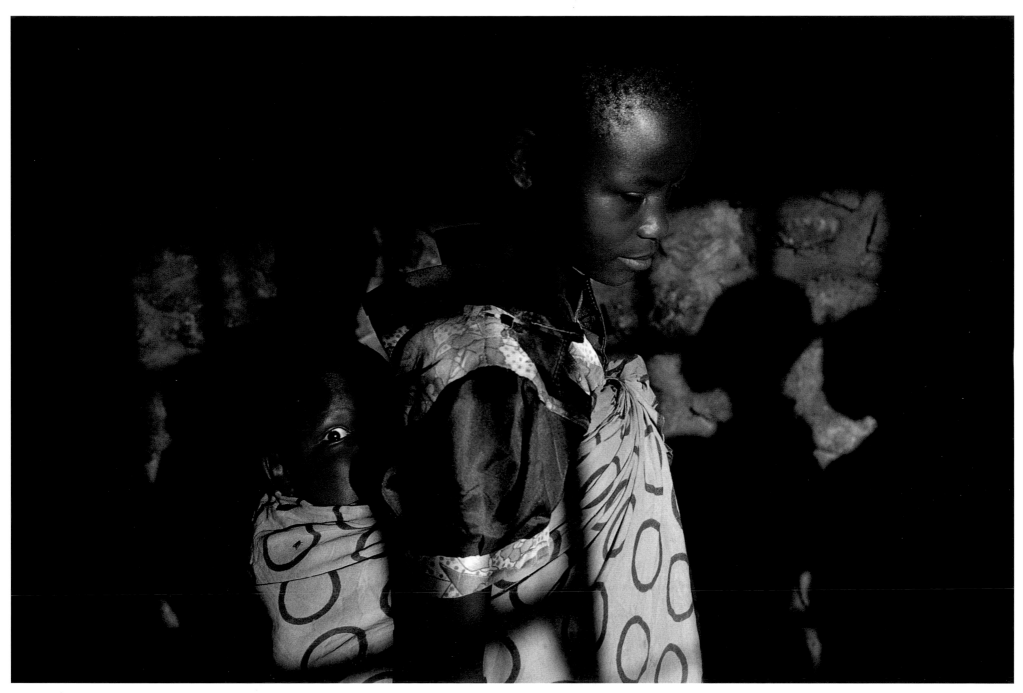

BURUNDI, 1997. The "Shalom House" is an orphanage where Maggy, a Tutsi from Burundi, teaches Hutu and Tutsi children how to live together, and that solidarity is the moral code. Here, a young Tutsi takes care of a Hutu baby.

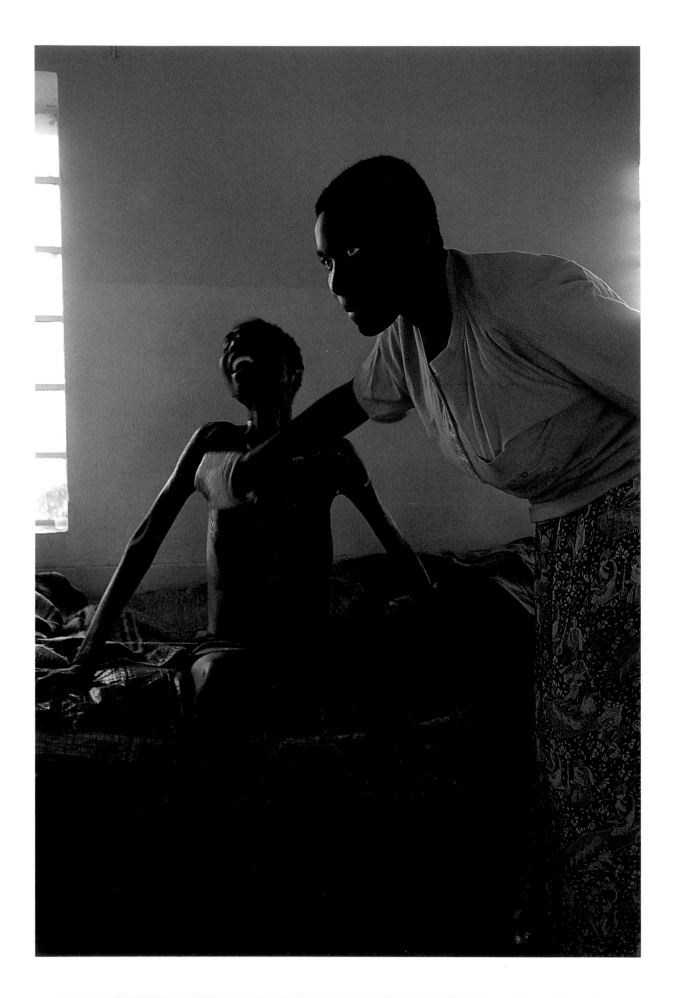

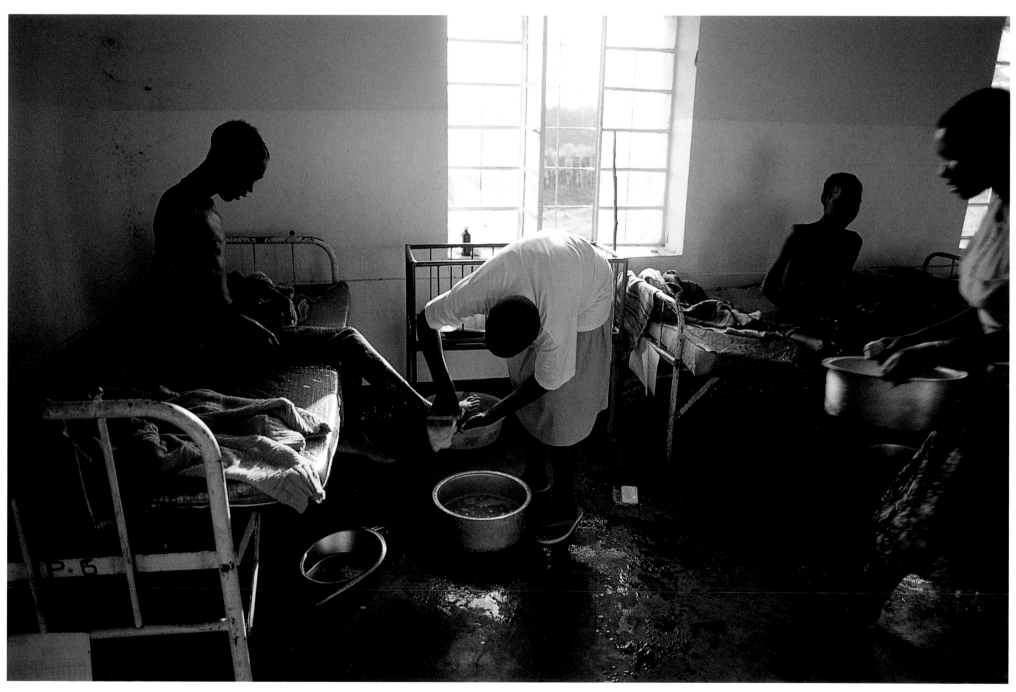

BURUNDI, 1997. *(opposite and above)* The penitentiary administration and primarily Tutsi medical personnel refuse to take care of dying Hutu prisoners when they reach the terminal stages. Maggy and the orphans of the "Shalom House" surreptitiously enter the penitentiary on Sundays to care for them, wash them, and bring them food.

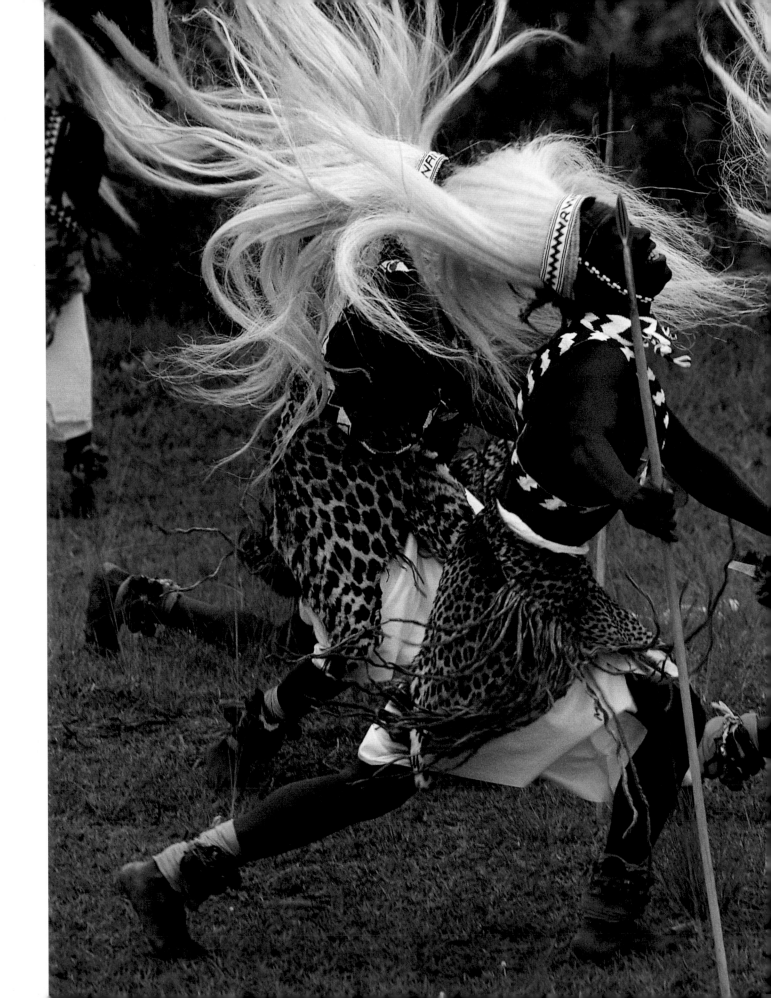

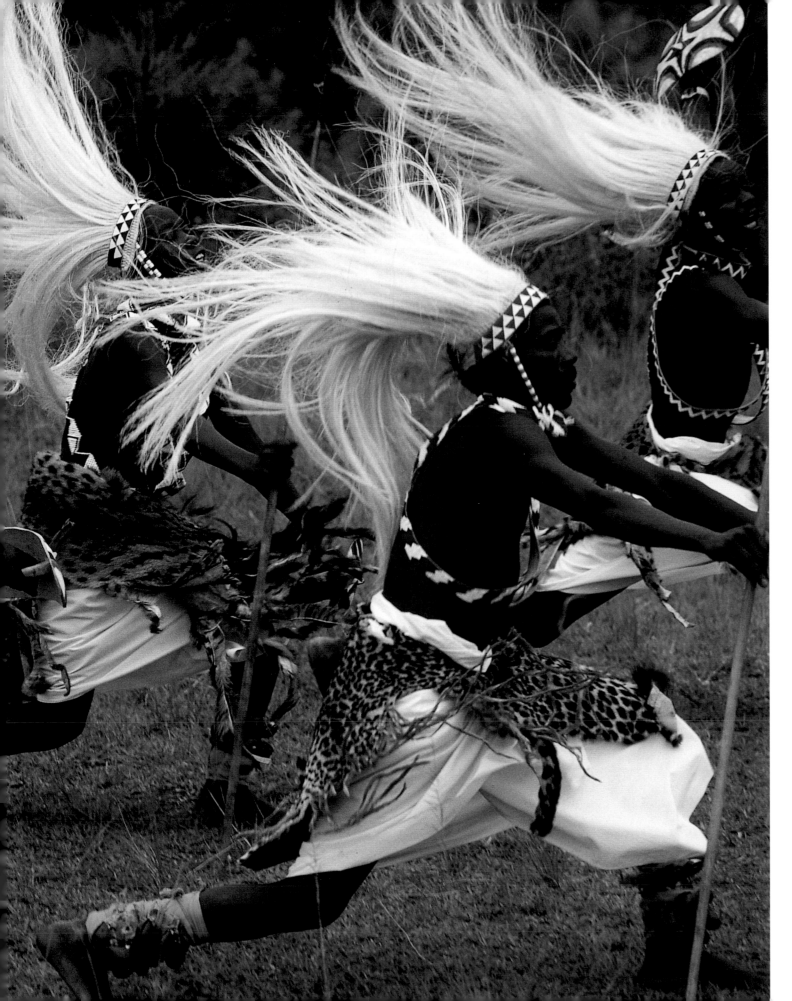

RWANDA, 1990. The Intore ("Chosen Ones") are Tutsi dancers who were once elite warriors. As they dance, they leap and whirl their long raffia manes.

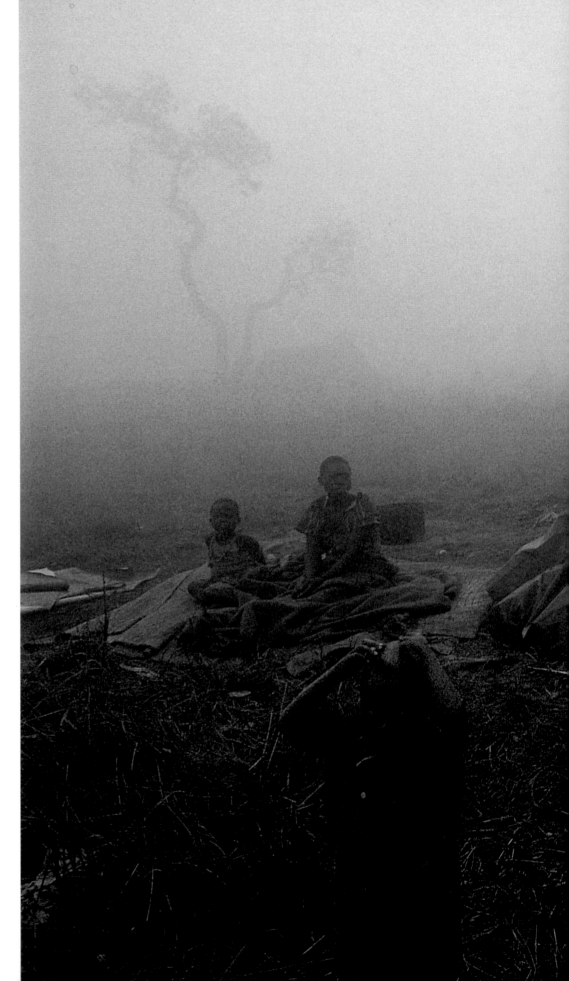

TANZANIA, 1994. At the Benako camp, more than 350,000 Rwandan Hutus are crowded with their animals into U.N. tents. They often walk for days and nights before reaching the "apocalypse camps."

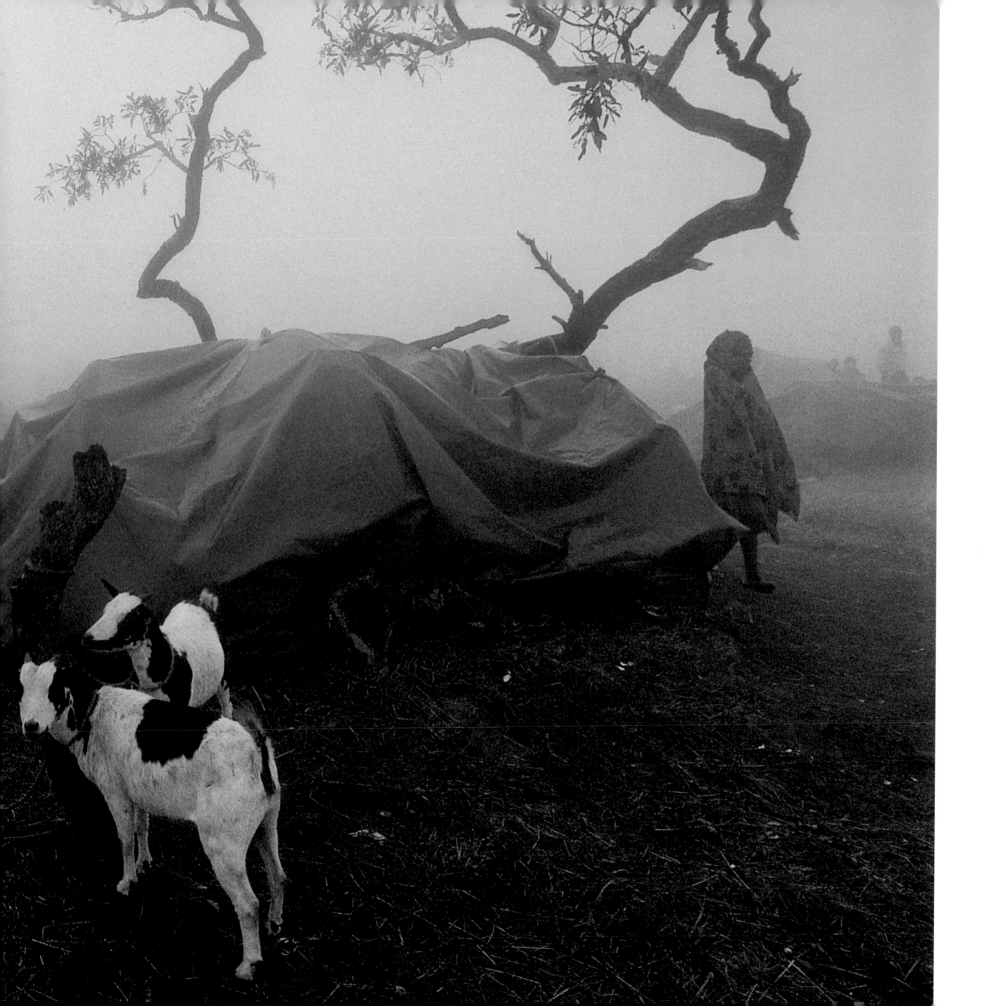

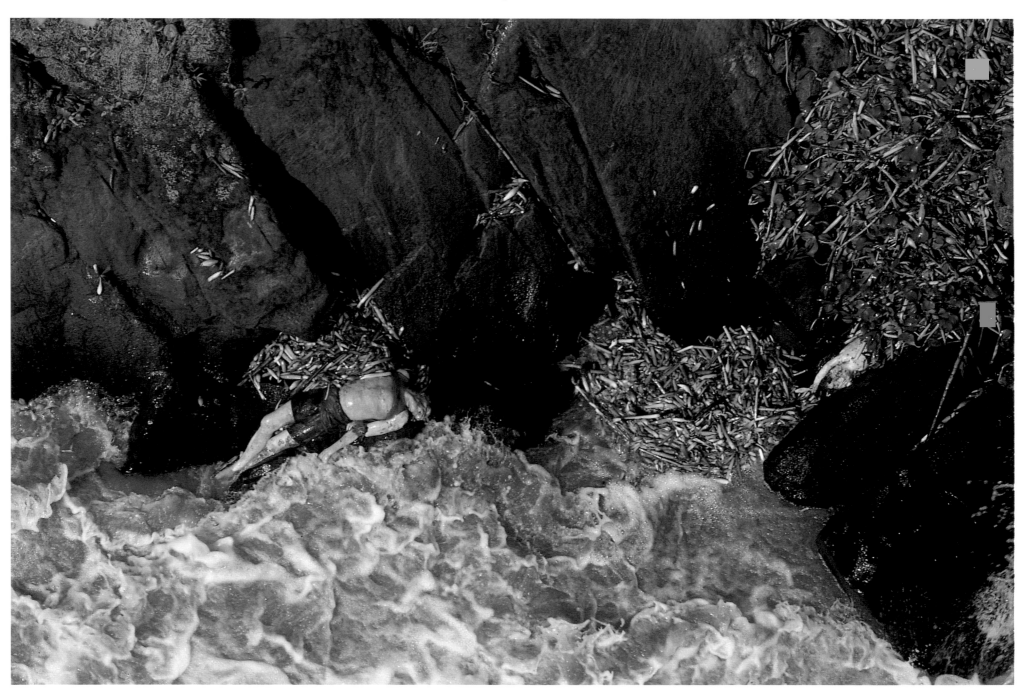

RWANDA, 1994. Tens of thousands of bodies float in the Kagera River—also known as the "Red River" because of the blood that has been spilled into it.

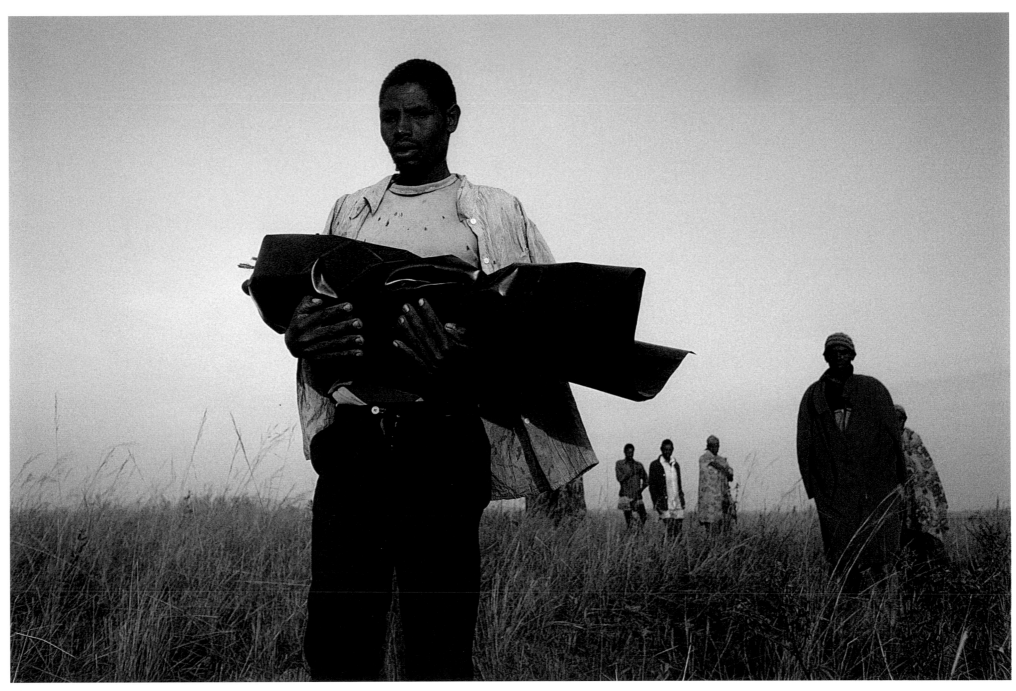

TANZANIA, 1994. In the absolute silence of morning, a father carries his child, who did not survive the cold night, to the grave. At Camp Benako, this procession is continually repeated by the refugees. The grave becomes the final resting place for these children.

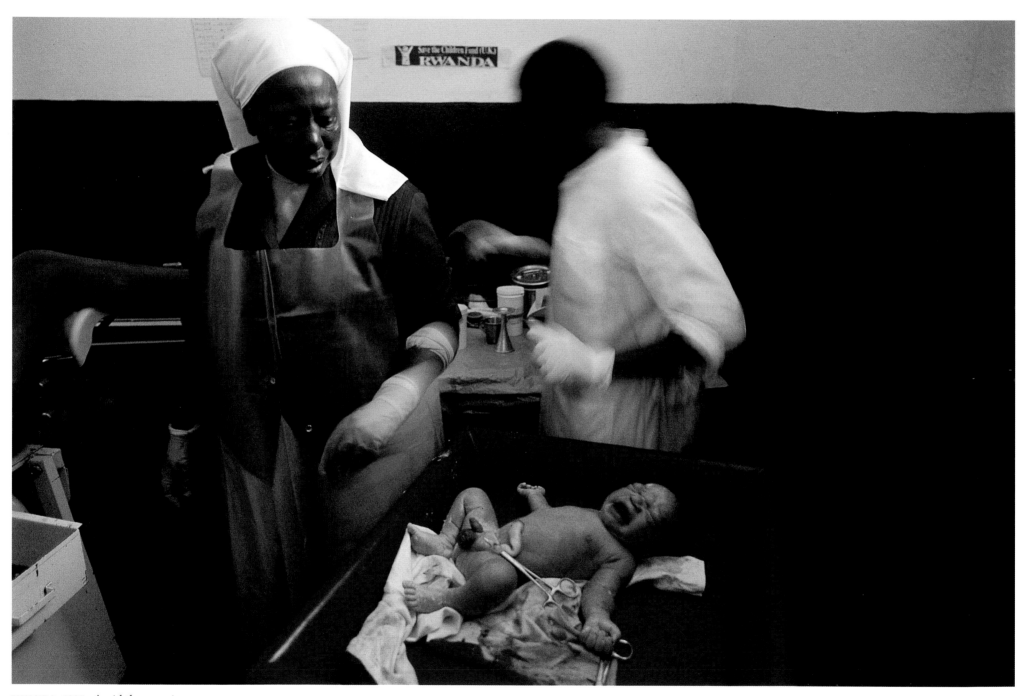

RWANDA, 1995. Amid the ongoing horrors of daily life in the village of Rwaza, a baby boy has just been born.

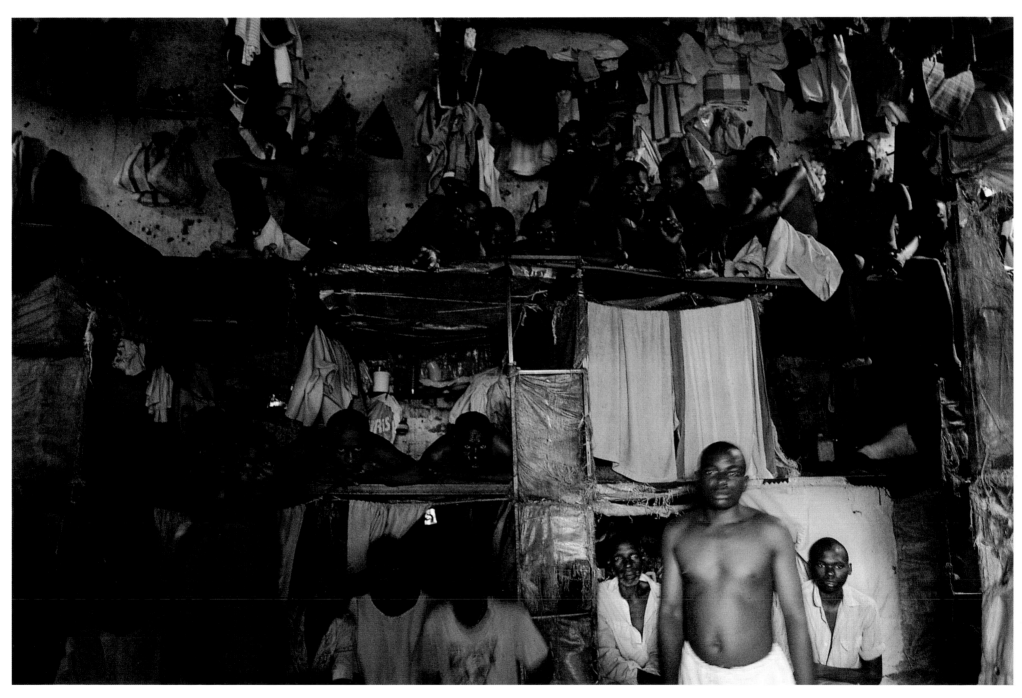

RWANDA, 1995. Eight thousand alleged murderers are crowded into the Kigali prison, where they are held in dismal midsize cells. The prisoners—old farmers, school-teachers, priests, and doctors—are all accused of genocide by the government of the Rwandan Patriotic Front.

EASTERN AFRICA

The Garden of Eden

If, several million years from now, we were given the opportunity to return to Africa, we would be surprised to find East Africa "missing" from the continent. Like pieces of a dismantled jigsaw puzzle, Kenya, Ethiopia, Eritrea, Somalia, and Tanzania would be drifting slowly into the Indian Ocean toward Australia, just as the island of Madagascar, once attached to the mainland, did 65 million years ago. This prediction comes not from Nostradamus or some prophet of doom, but from the modern scientific community. To be convinced of its accuracy, one need only look at a relief map of Africa, or at one of the many satellite photographs of the region. Notice a gigantic, badly healed scar—the famous Great Rift Valley. Extending southward from Eritrea, on the shore of the Red Sea, to the delta of the Zambezi in Mozambique, it consists of a series of large clefts, delineated by volcanic mountain chains and a string of immense lakes, including Rudolf, Victoria, Tanganyika, and Malawi. Completely fractured in the eastern part of the African continent, the earth's crust has begun to crack on all sides, sometimes showing glimpses of its bowels. There are many active African volcanoes (such as the Nyiragongo in the Virunga Chain, shared by Rwanda, Uganda, and Congo-Kinshasa). Others, such as Kilimanjaro in Tanzania, the white and ghostly peak of which recalls Japan's Mount Fuji, are extinguished and covered with snow, a fairly rare phenomenon in Africa.

SULFUR LAKES. Adventurous spirits who care to visit the "dead" regions of Djibouti or Dankalia in Eritrea may witness the hellish spectacle of volcanic eruptions, when smoke, ash,

TANZANIA, 1995. Unable to migrate since the implementation of huge agrarian projects by former president Julius Nyerere, the Masai have now been forced to settle. The Masai live principally on the blood and milk of their herds. Today they say that Enkai, the divinity that created the earth and the herds, is dead and has abandoned them.

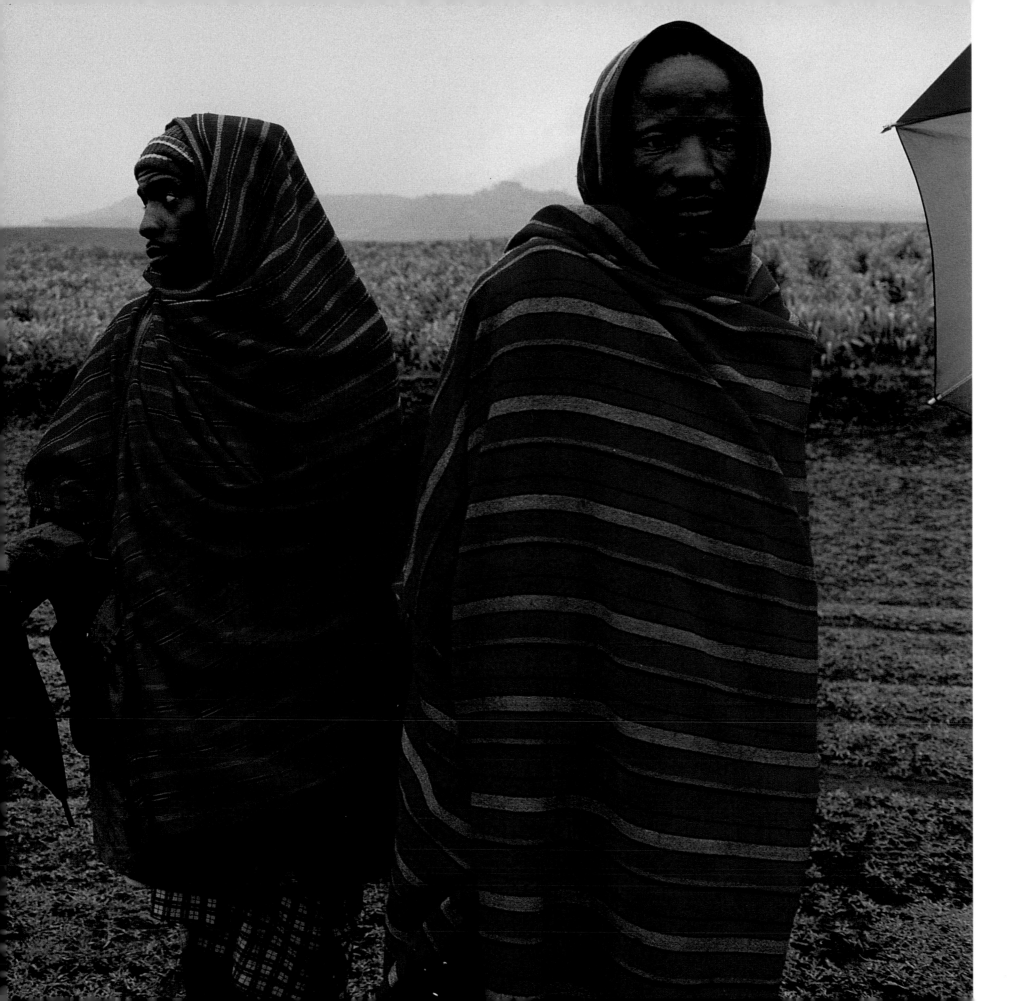

and flames spew and glowing lava is discharged. Across thousands of acres, strange lakes of sulfur have formed, bordered by statues of salt that have been sculpted by the wind, an unusual setting resembling a lunar landscape on earth.

LUCY. The Great Rift Valley is of interest not only to geologists but also to students of prehistory. In fact, without having to move mountains of rubble, paleontologists were able to access the most ancient layers of earth, which natural movements had caused to rise to the surface over time. The result: bones belonging to our earliest ancestors, the "men of the south" (*Australopithecus*), were exhumed here. It was in Ethiopia that the almost complete skeleton of "Lucy," a woman of approximately twenty years old, was found. It is said that she owes her name to the scientists who enjoyed excavating to the famous Beatles' song "Lucy in the Sky with Diamonds." This discovery revolutionized the scientific world in the late 1970s, confirming as it did the existence of our distant forebears in eastern and southern Africa three to four million years ago, earning Africa the sobriquet "the cradle of humanity." Subsequently and in waves, *Homo erectus*, the probable descendant of *Australopithecus*, populated the rest of the African continent. Eventually this pre-human reached the Near East, in all likelihood via the Sinai peninsula, and then went on to populate the other continents.

AFRICA, LAND OF TRADE. Africa has been occupied many times, by innumerable foreign peoples, since the dawn of history. The earliest invasions, along the coast of the Indian Ocean in East Africa, date back to the Dravidians, who came from the Indus Valley and presumably moved on several millennia ago without leaving any significant record of their presence. Plying the coast from port to port, from the Far East to eastern Africa, the Malayans and Indonesians are believed to have taken over at the end of the first millennium B.C.E. Exchanging silk for African ivory, they are thought to have traded in Kenya and Somalia, and then settled in Madagascar. Finally, starting in the eighth century, the Arabs established a chain of trading posts on Africa's eastern coast, which turned into competing principalities, the most powerful being Zanzibar.

"THE COASTAL PEOPLE." As all of these various non-African peoples settled along the shores of the Indian Ocean, they began to intermingle, giving rise to a language and a people

which came to bear the same name: Swahili (from *swahil*, meaning "the coast"). For centuries, the region's economy, dedicated to maritime commerce, flourished: Asian products were traded for African products. Unfortunately, the profitable slave trade was also conducted there.

BLACK PHARAOHS. The interior of eastern Africa was not devoid of people, although both European and Arabian nautical charts showed them to be either empty or populated only by lions (*hic sunt leones*). For several millennia, the dazzling civilization of the pharaohs had developed along the banks of the Nile. On the Upper Nile in Nubia (the area of today's Sudan) another civilization, that of the Kush, had benefited extensively from the influence of ancient Egypt, but also from that of Mesopotamia. From the former they learned to build pyramids (as in Meroë), and from the others they obtained the secrets of metallurgy. The Kush's power, which reached its peak in the first millennium B.C.E., enabled them briefly to dominate ancient Egypt, giving rise to a dynasty of black pharaohs. The Kush also were responsible for introducing iron to the Bantu, who then went on to propagate its use in their migrations through central, eastern, and southern Africa.

SOLOMON AND THE QUEEN OF SHEBA. Tradition has it that Amharic speakers in Ethiopia are descended from the legendary kingdom of the Queen of Sheba (today's Yemen), while their former sovereign, the Negus (or "king of kings"), is believed to be a direct descendant of the Hebrew King Solomon and Balkis, Queen of Sheba. From this story, perhaps verging on the legendary, Ethiopians have preserved several fascinating religious traditions. As members of the Coptic church, like some Egyptians, Ethiopians practice an original form of Christianity known as Monophysite (after the doctrine which claims that the nature of Christ is one—in other words, that he is at once both divine and human). Their many religious holidays feature huge processions, displaying opulent objects of devotion, as worshipers make their way into the extraordinary subterranean churches.

THE ARK OF THE COVENANT. Each year, on the occasion of the *Timket* (Epiphany, or the Feast of the Three Magi), the entire Ethiopian community follows its priests, in their large white

albs, to the place of worship where the *tabot* is displayed—the Ark of the Covenant containing the Holy Scriptures. Once the ceremony is over, people indulge in worldly pleasures: dances, huge banquets, and sports demonstrations. But these few festivities should not overshadow the austerity of everyday life. Not only does religion call for ritual fasts, which, when totaled, represent an incredible 160 days of the year, but the specter of famine, too, is intermittently present.

DROUGHT AND FAMINE. In Ethiopia, Eritrea, Somalia, and Djibouti, the thermometer reaches record-high levels, bringing waves of drought that cause the death of herds and crops and disastrous cyclical famine. To make the picture darker still, one cannot forget the civil wars that plague Somalia and Sudan, or the wars between neighboring countries like Eritrea and Ethiopia.

A LOVE OF FIGHTING. Paradoxically, these wars are also part of tradition and assume an almost festive quality as one moves southward toward Kenya and Tanzania. In these two countries, the Masai, who at first sight seem to be peace-loving cattle herders, assert their nature as born warriors. From their earliest years, they are inculcated with a love of war and fighting. Thus, during their rites of initiation young men are cut off from the community and treated harshly so as to rouse their courage and combativeness. In each age group, the most intrepid ones are encouraged to kill a lion; those who do are celebrated as heroes and are allowed to display a crest made from its mane.

Once they have reached adulthood, the Masai warriors are permitted to fight their neighbors in order to steal their women or herds of cattle. Since the neighbors are also trained for warfare, it is not unusual for this type of fighting to result in several deaths. Daily life among the Masai is more peaceful, as they only kill their cattle for food in exceptional cases, content instead to take only a little milk, or sometimes blood from the jugular vein of one of their cows. They always take every precaution to avoid causing discomfort to their cattle. The Masai revere every animal as if it were a family member.

The Nuba of Sudan are combative as well, devoting themselves periodically to their favorite pastime, traditional wrestling. It is a spectacle of rare beauty to see these athletes fight, their sculpted bodies painted with white lime.

THE STRESSFUL LIFE OF THE SHILLUK KING. Among the Shilluk of south Sudan, being king is not an enviable position. Indeed, tradition has it that the sovereign should be strangled by his successor when the family council judges that his reign has lasted too long. In order to escape the sentence and lead his possible assassins astray, the king instructs each of the women in his harem to prepare dinner. At the last moment, he chooses the conjugal bed that offers the least risk of his passing from life to death in the night.

THE PEACEFUL HUNT. The wealth of East African's fauna has always lured Western hunters. Great safaris were organized for affluent braggarts, who would then return home to Europe or America with their trophies—antelope or lion heads, or elephant tusks. In the past few decades, though, the hunters have largely been replaced by environmentally conscious tourists. Traveling by minibus, Jeep, or even balloon, they come to indulge in the more peaceful hunt of the photographer, for East Africa has perhaps the most abundant wildlife on the continent. Rigorously protected against poachers, great natural parks have been established in the savannas of Kenya and Tanzania. Safari tourism has become a true godsend for these countries. From around the world people come to photograph herds of zebra bounding out of the bush, families of lions napping in the shade of a thornbush, groups of giraffes moving with slow strides, and bands of monkeys playing tricks on visitors. With a little luck, they might even see a lone rhinoceros.

THE TREK OF THE GNU. The eastern African bush also has a grand annual event, the great migration of the gnu. Since time immemorial, these huge antelopes have made the same journey every year, from Tanzania to Kenya. To either side, the lions patiently wait along the path for the laws of natural selection to be applied: the earth will provide them with a gnu that is too old, too young, too enfermed or distressed as it passes through a muddy pool.

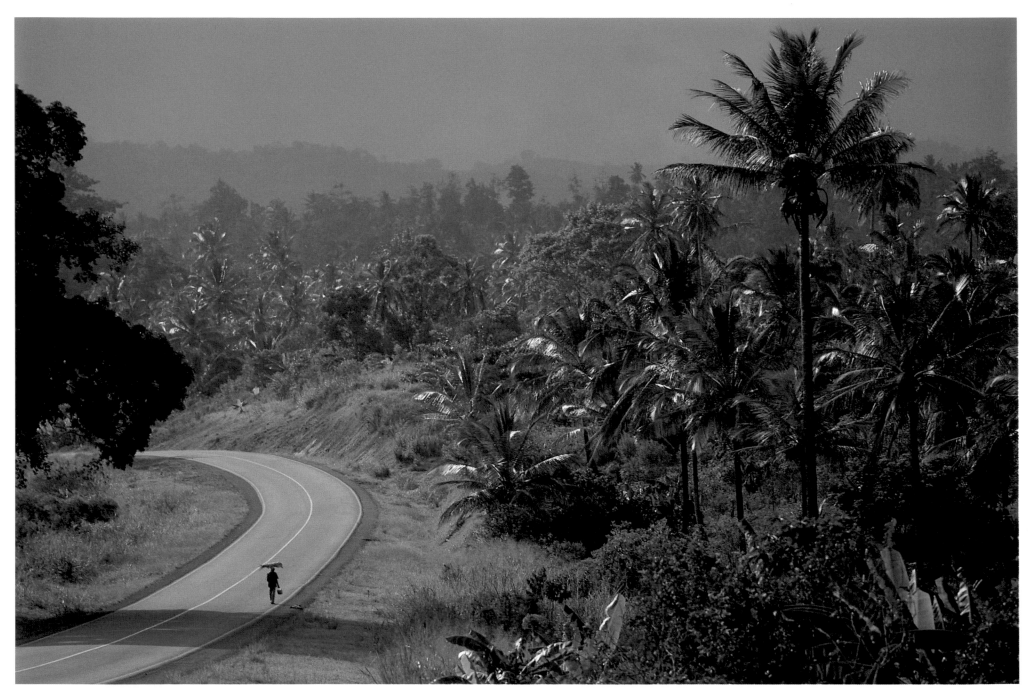

TANZANIA, 1995. Near Muheza, on the Tanzanian coast, a beautiful road passes through lush greenery. There is little traffic; only a few pedestrians take this route.

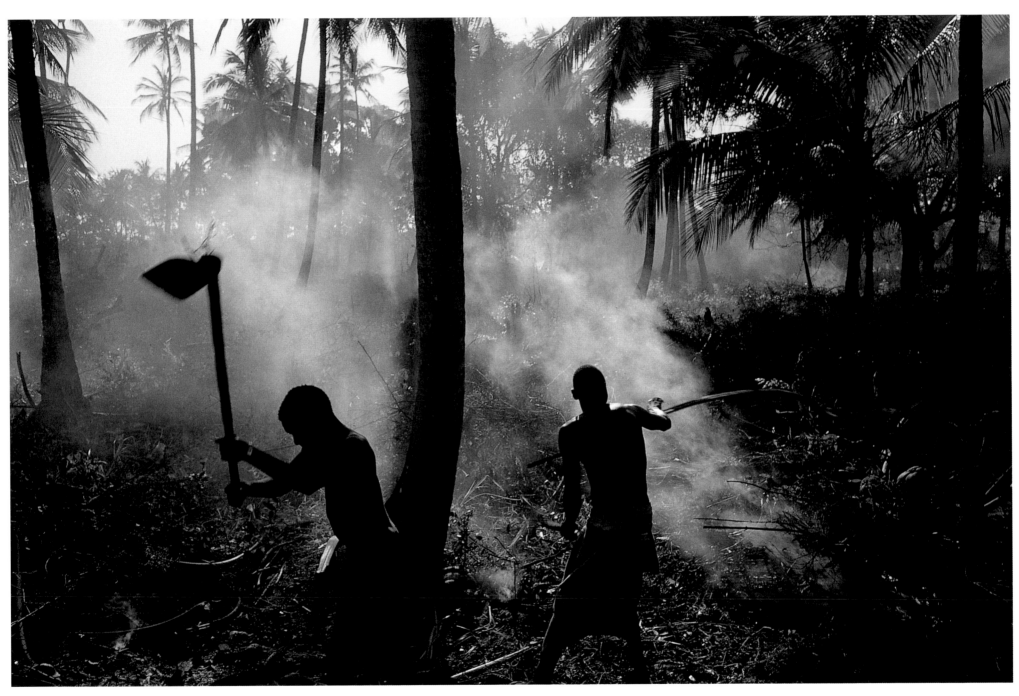

TANZANIA, 1995. Near Tanga,
peasants cut down a forest for
slash-and-burn cultivation.

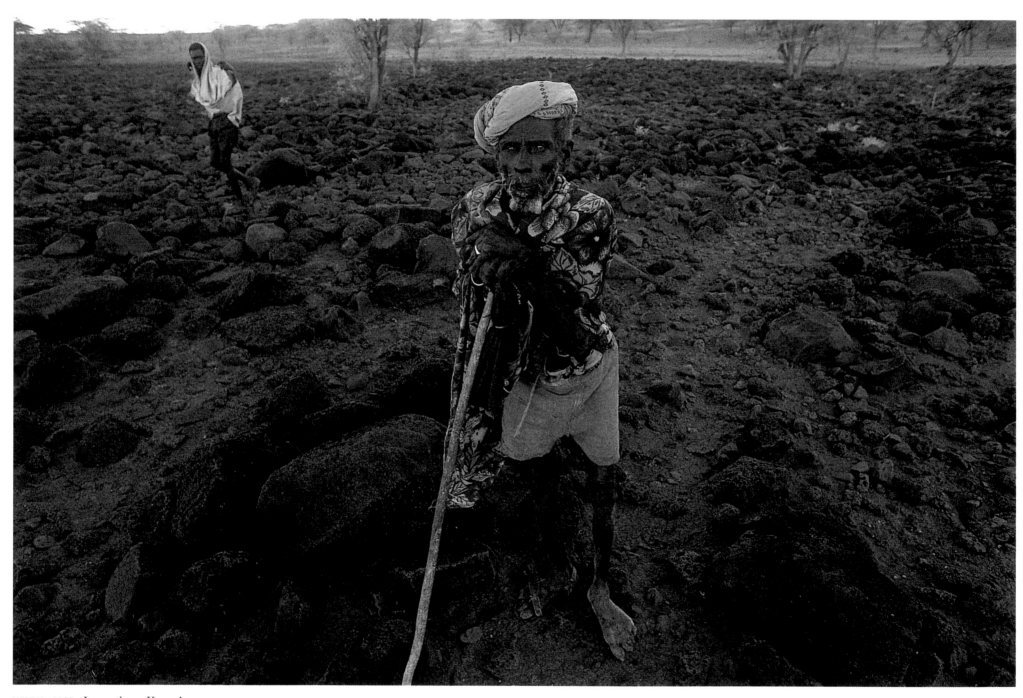

KENYA, 1993. In northern Kenya's Lake Turkana region, one of Africa's harshest areas, live the Gabbra. They are nomadic, and migrate in families.

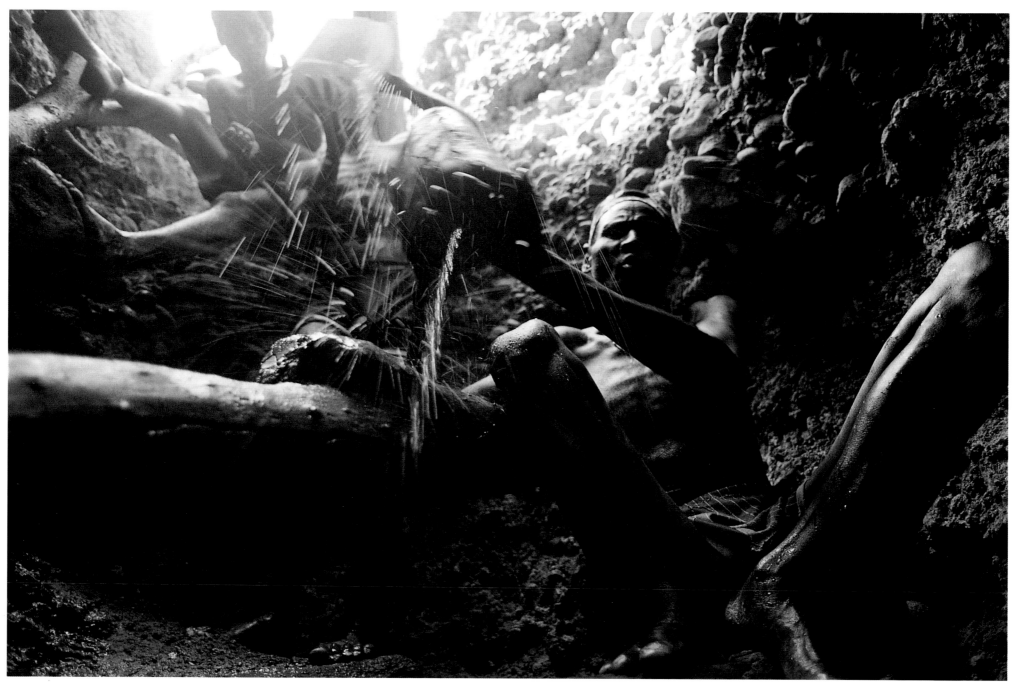

KENYA, 1993. To collect water from wells, the Gabbra make a chain of five or six people and pass along goatskin containers filled with water. As they work they sing songs describing the love they have for their cows, which all but disappeared in the great droughts of 1984. They have continued to practice particu- larly aggressive war tactics, that is, the tradition of cutting off their enemies' genitals.

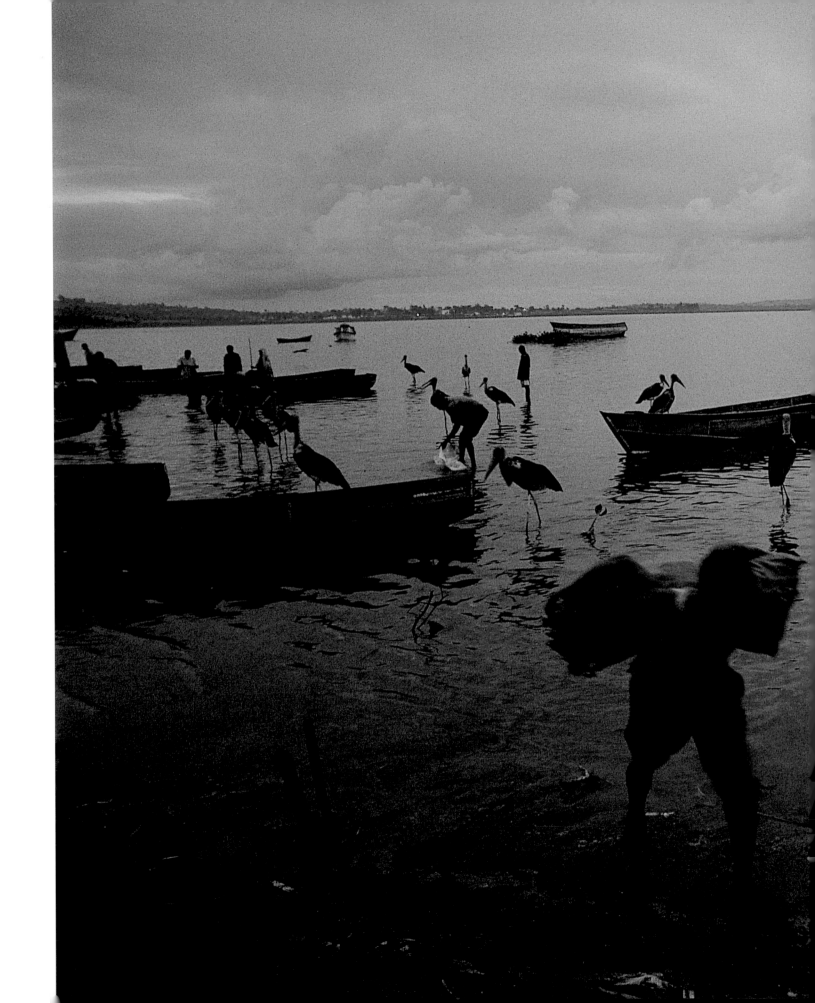

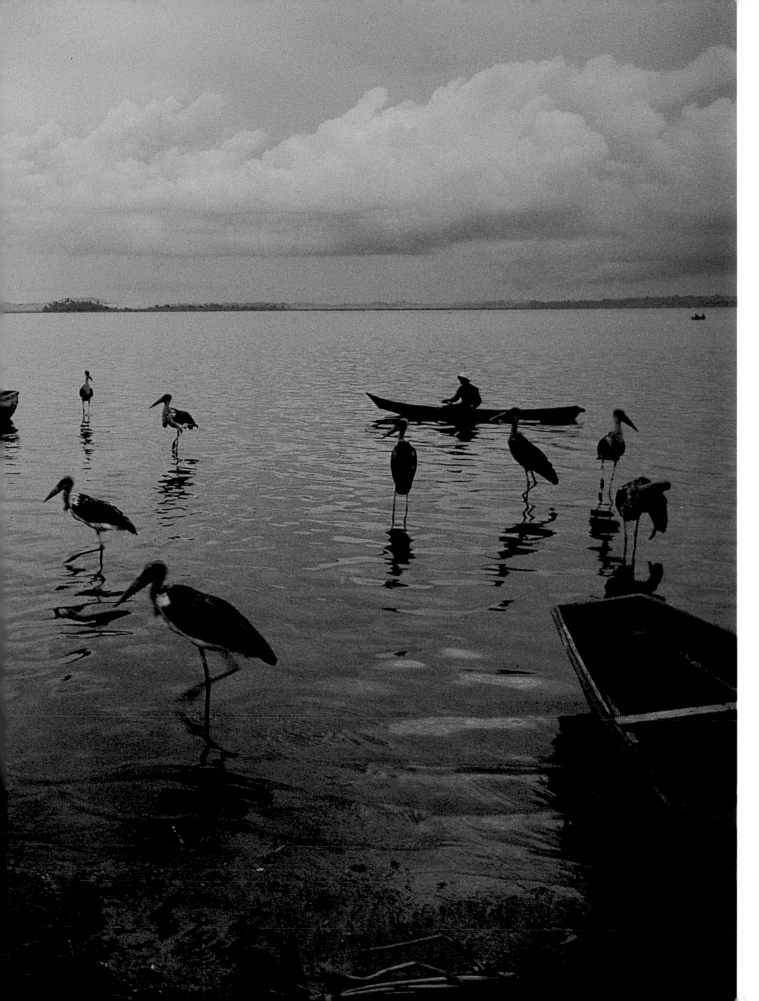

UGANDA, 1995. Just before dawn, marabouts await the return of fishermen to the village of Ggaba.

UGANDA, 1995. Magala Gombe is one of two million HIV-positive people in Uganda. He lives along the infamous "AIDS route" that links Mombassa and Bujumbura.

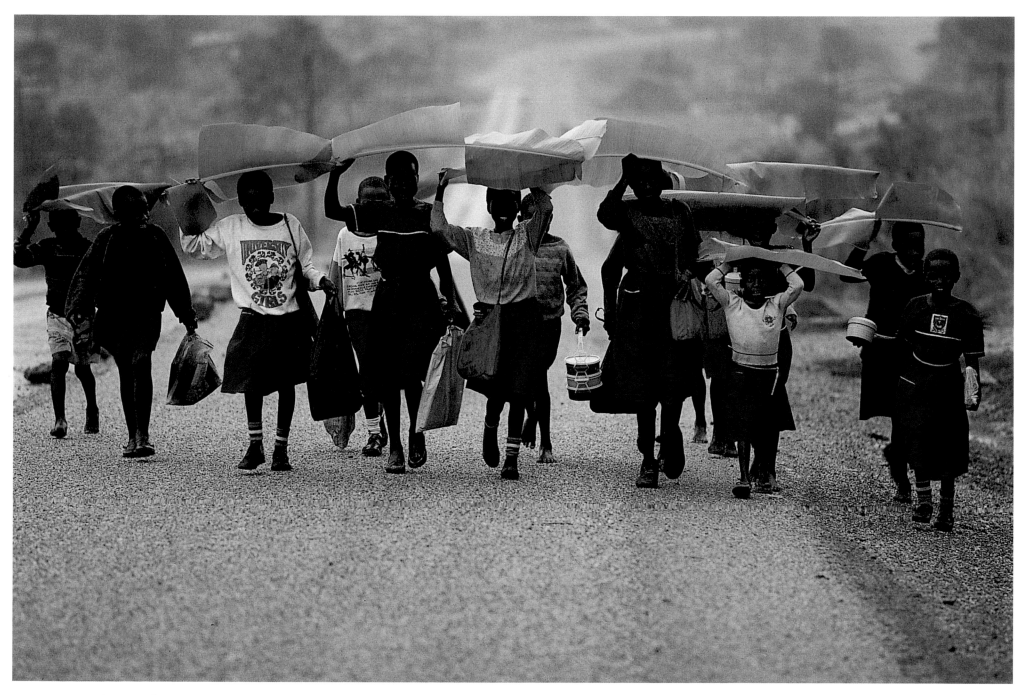

UGANDA, 1995. A group of schoolgirls in Fort Portal shield themselves from the rain with wide banana leaves.

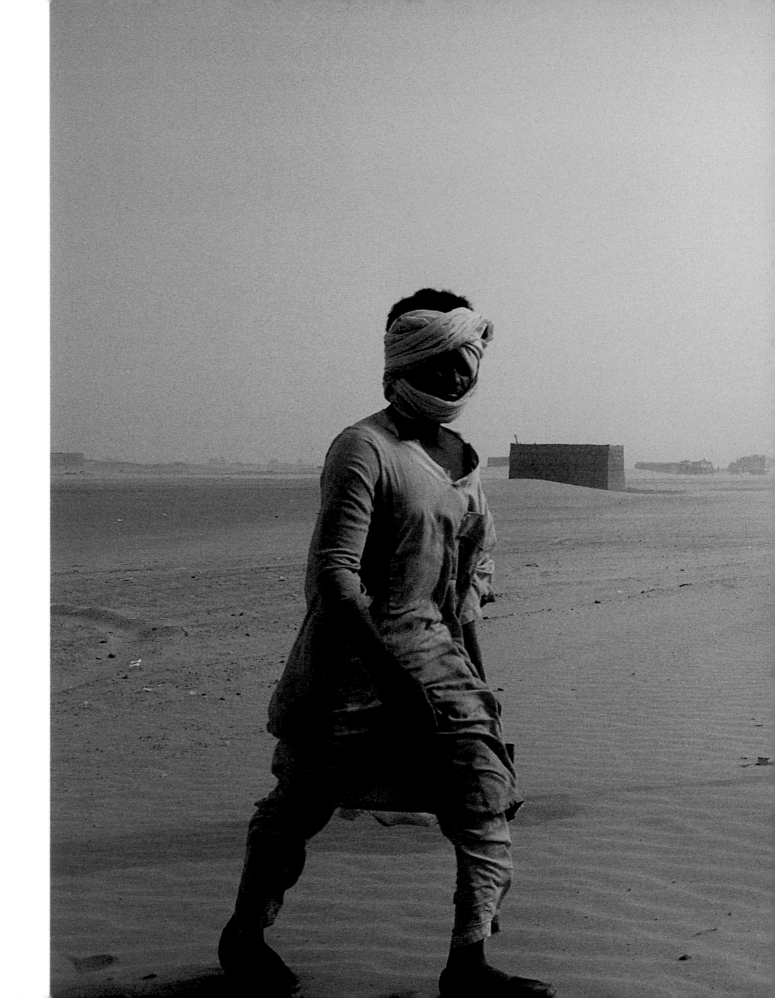

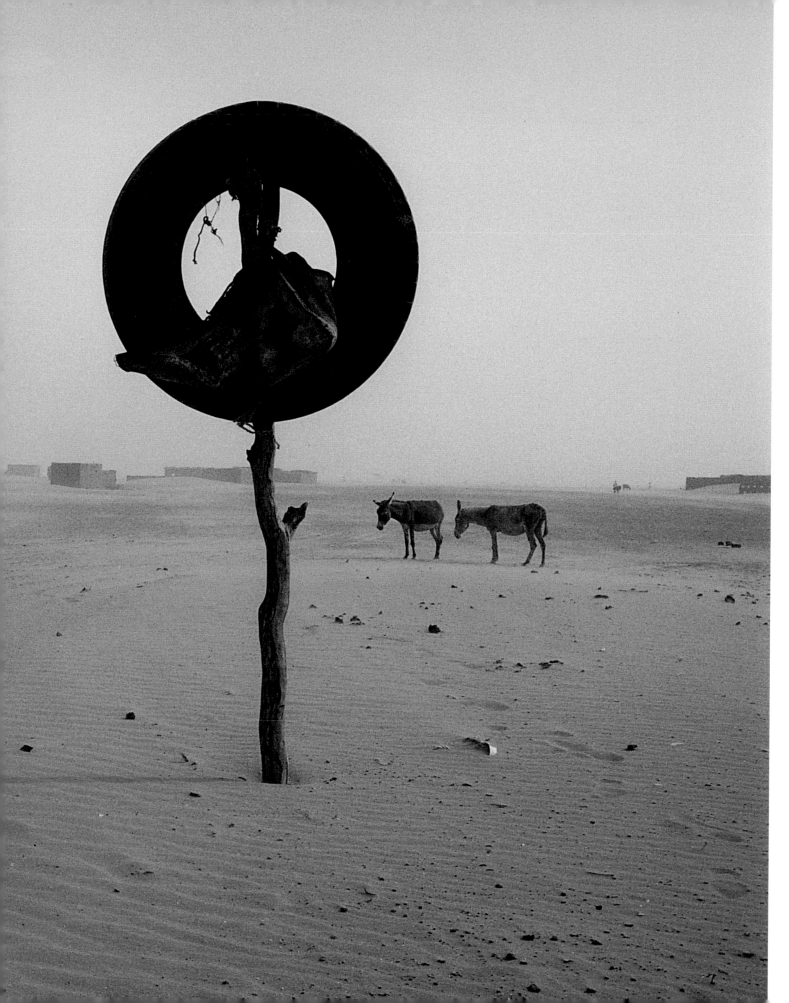

SUDAN, 1995. An old tire and a goatskin form the sign for a car mechanic and a restaurant in the village of Goomuk along the road to Dunqulah, or Dongola, three hundred kilometers from the Egyptian border.

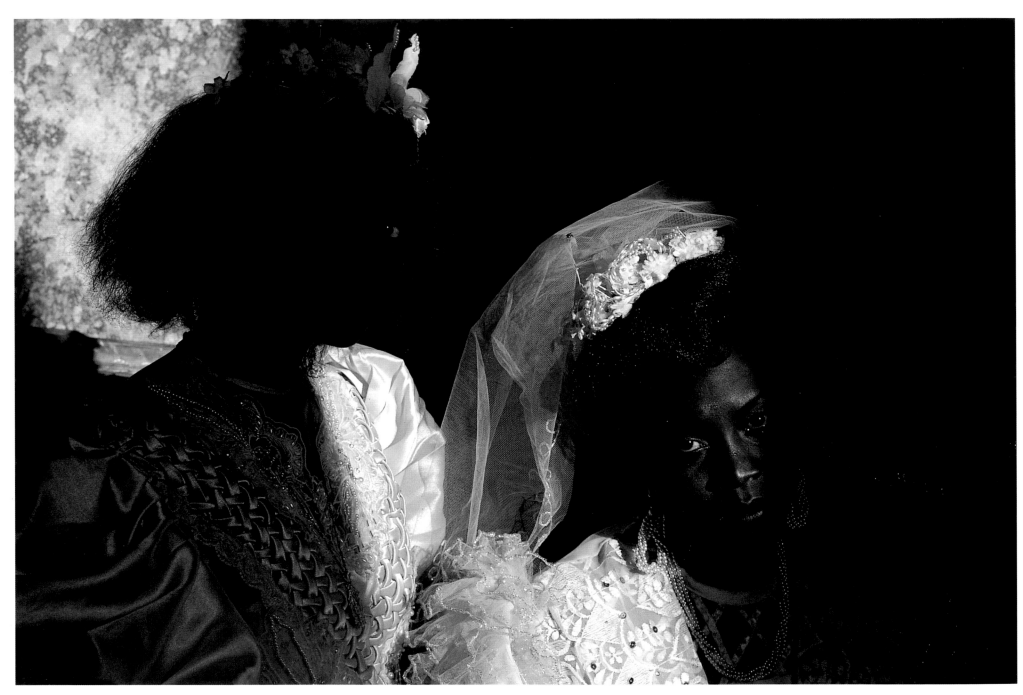

SUDAN, 1995. A wedding among the Nuba in the outskirts of Omdurman. The Nuba fled their mountain home to escape the war. The photographs of Leni Riefenstahl made them famous in the West.

116

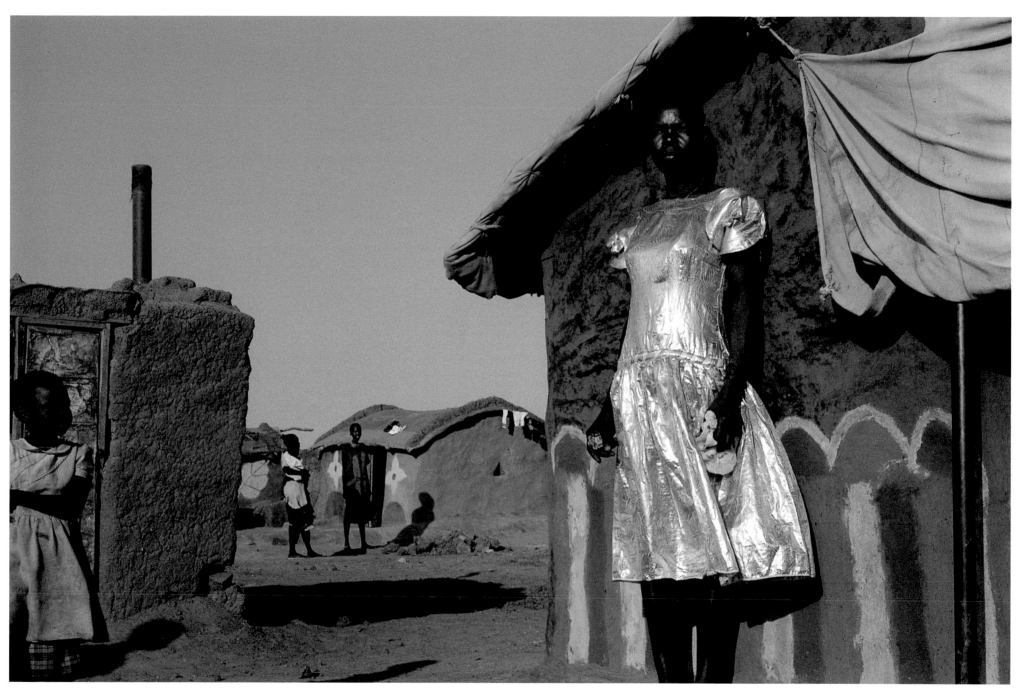

SUDAN, 1995. Forty kilometers south of Khartoum, the Sudanese capital, a half-million displaced people from southern Sudan are packed into camps like this one at Jabal Al Awliya. This young Shilluk woman wears an evening gown donated by a humanitarian organization. In these camps, Christian animists from the south await the end of a war that has been ongoing since 1983, and that has taken the lives of more than two million people.

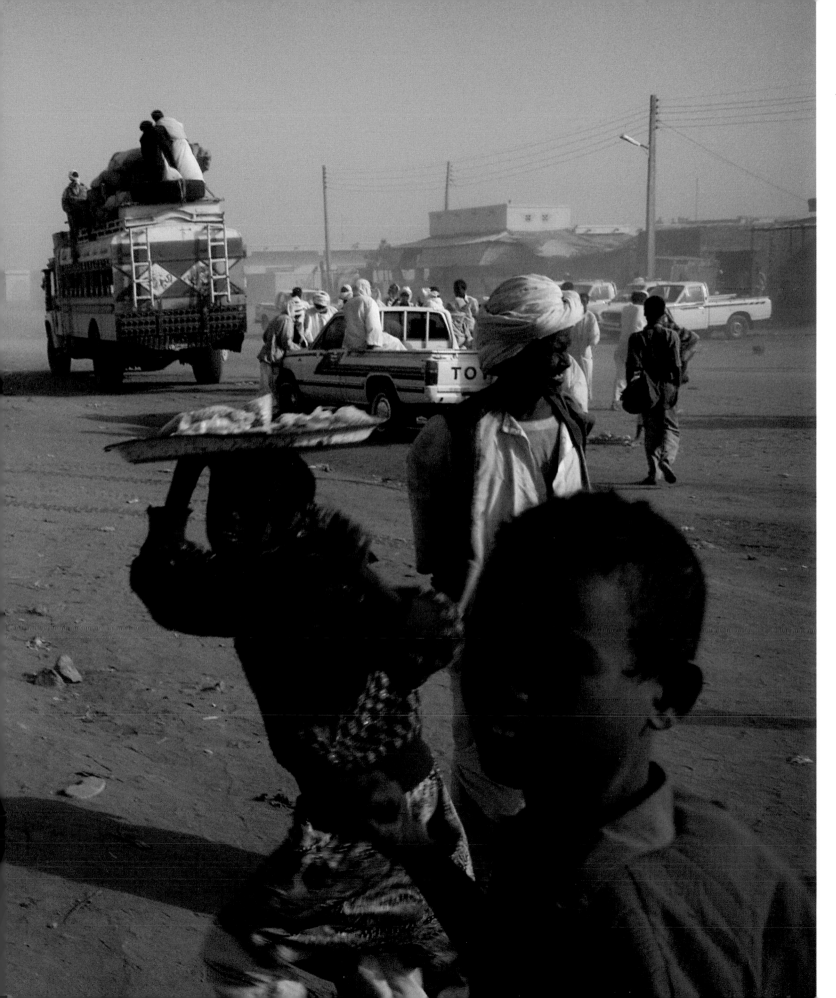

SUDAN, 1995. A lively moment in the city of Omdurman, enveloped in a sandstorm from the nearby desert. Although Omdurman is very close to Khartoum, it has its own unique history. Lord Kitchener destroyed the silver-domed mosque of the Tomb of the Mahdi in 1898, after the Mahdi's body was burned and his ashes thrown into the river. Today the Whirling Dervishes—Sufis who follow the teachings of sheikh Hamdu Niil—still perform ritualistic dances here.

119

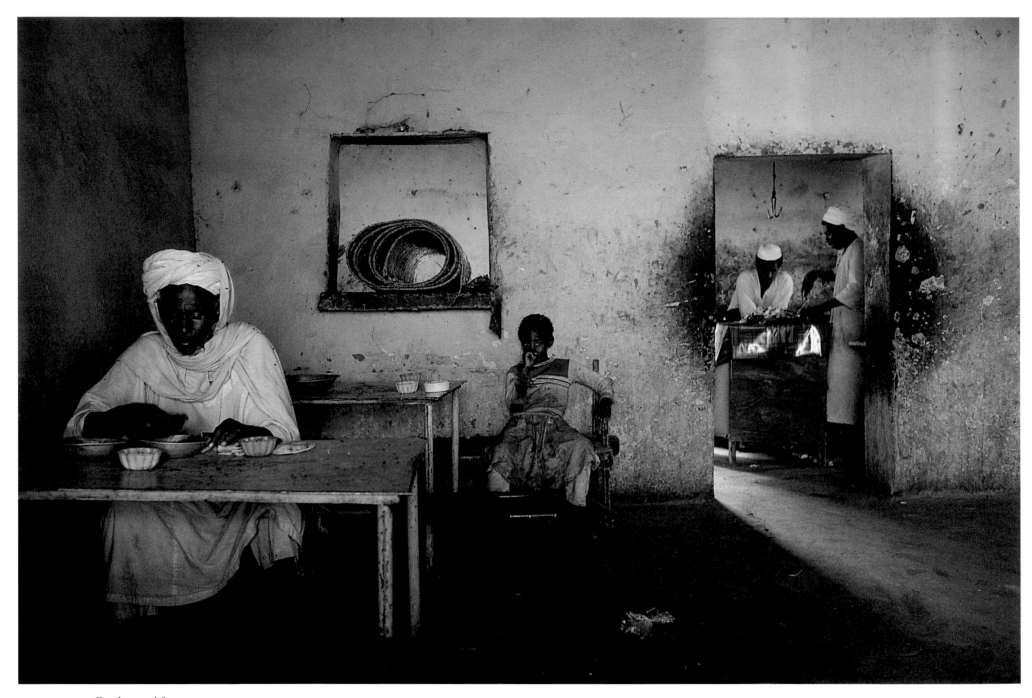

SUDAN, 1995. On the road from Dunqulah, or Dongola, caravans stop for food at Ad-Dabbah. Bedouins travel along this road, taking their camels to the slaughterhouses of Egypt.

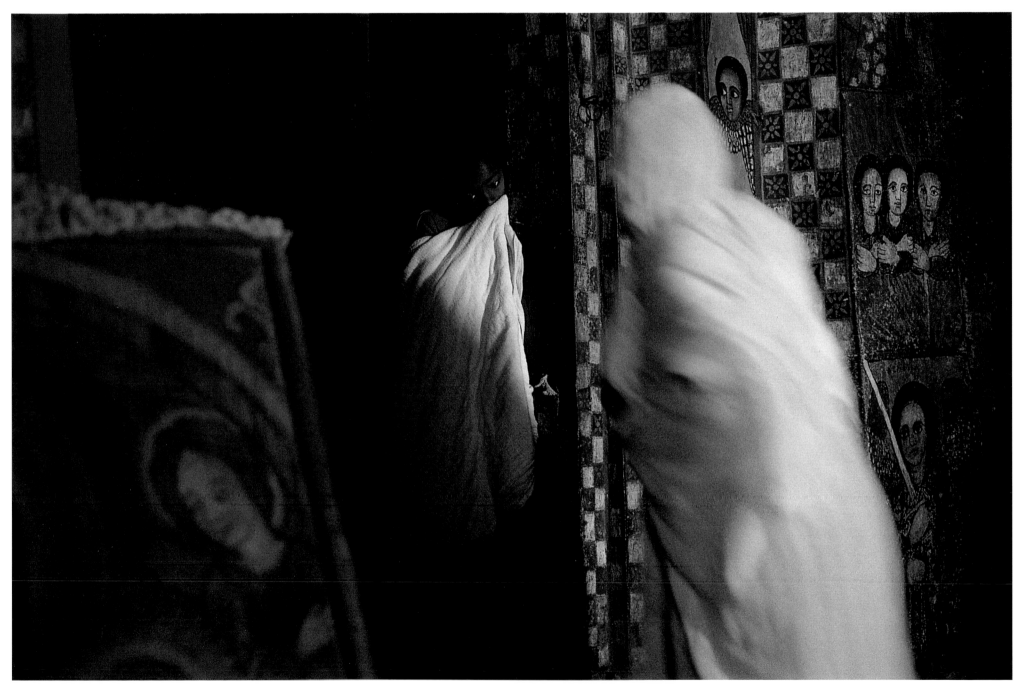

ETHIOPIA, 1998. This child awaits Mass in the Church of Debre Berhan Selassié (Mount of the Light of the Trinity) in Gonder, the old capital. The church, built by Iyasus the Great (1682–1706) is renowned for its paintings of angels.

121

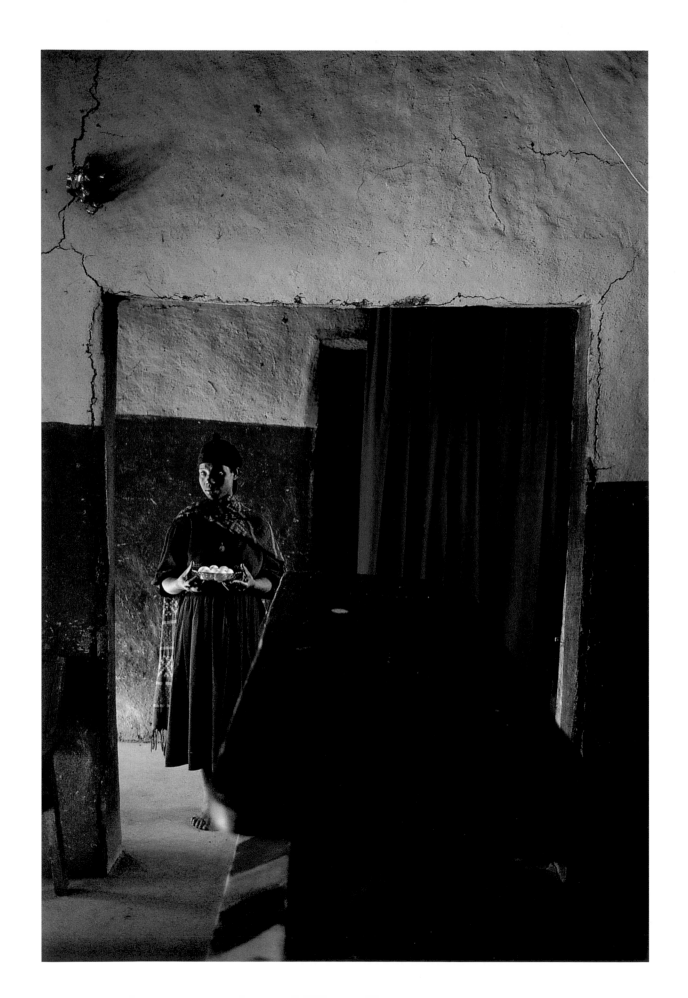

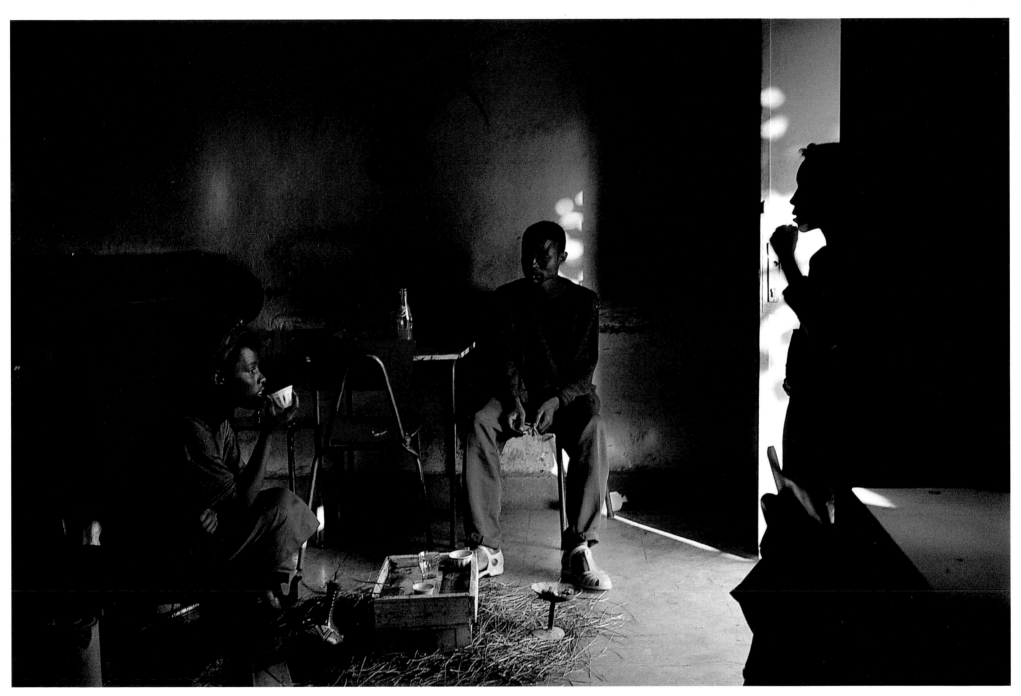

ETHIOPIA, 1998. *(opposite and above)* A typical "*buna boit or* home café," found in all Ethiopian cities, towns, and villages. The front room is where one drinks coffee—often for free—and eats. The rest of the rooms are for rent. Some hostesses are also prostitutes. If so, they close the home café while it moonlights as a brothel.

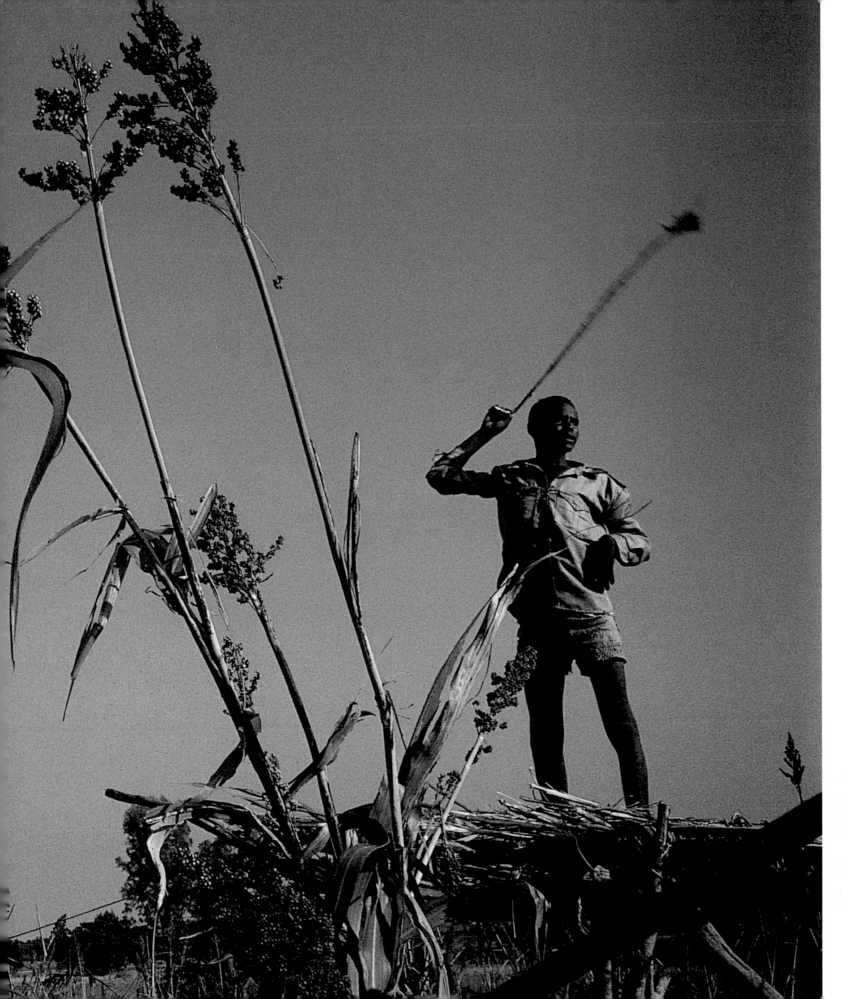

ETHIOPIA, 1998. This young man spends his days and nights on a platform in the millet fields. With his slingshot, he hunts the birds that come to eat the ripe grain. The high Abyssinian plateau is often used for the country's cultivation of wheat and *tef*, the local grain.

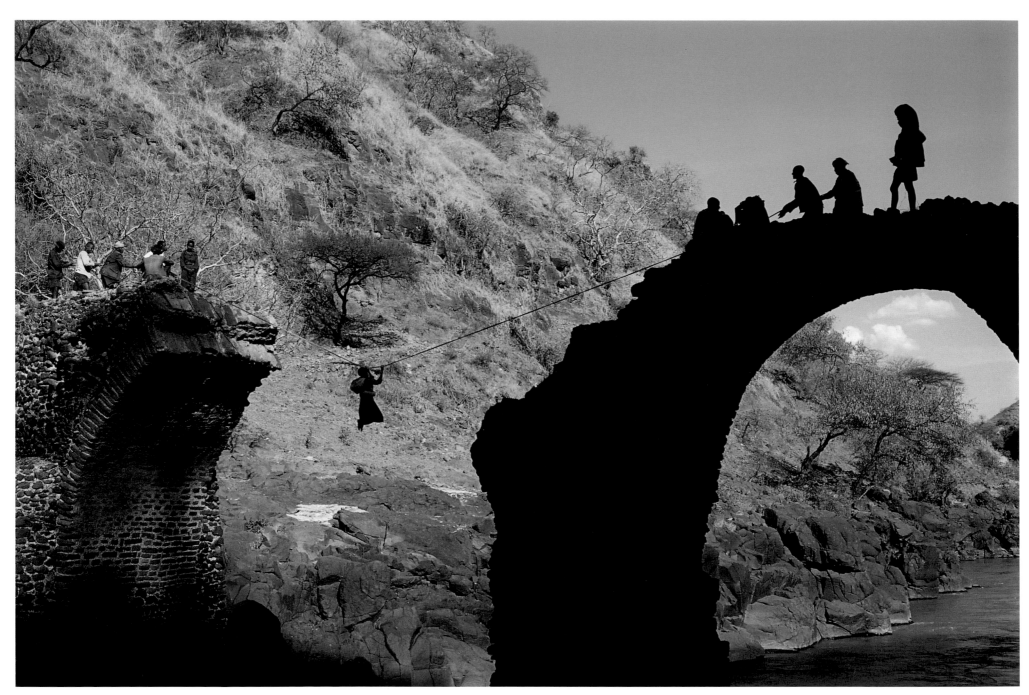

ETHIOPIA, 1998. Near Mota, the remains of a bridge built by Italians, called the "Broken Bridge." Before it was destroyed during World War II, it was the only crossing point over the Nile for hundreds of kilometers. Today, for about fifty cents, men take travelers across the river; they traverse the gap by hanging from a rope.

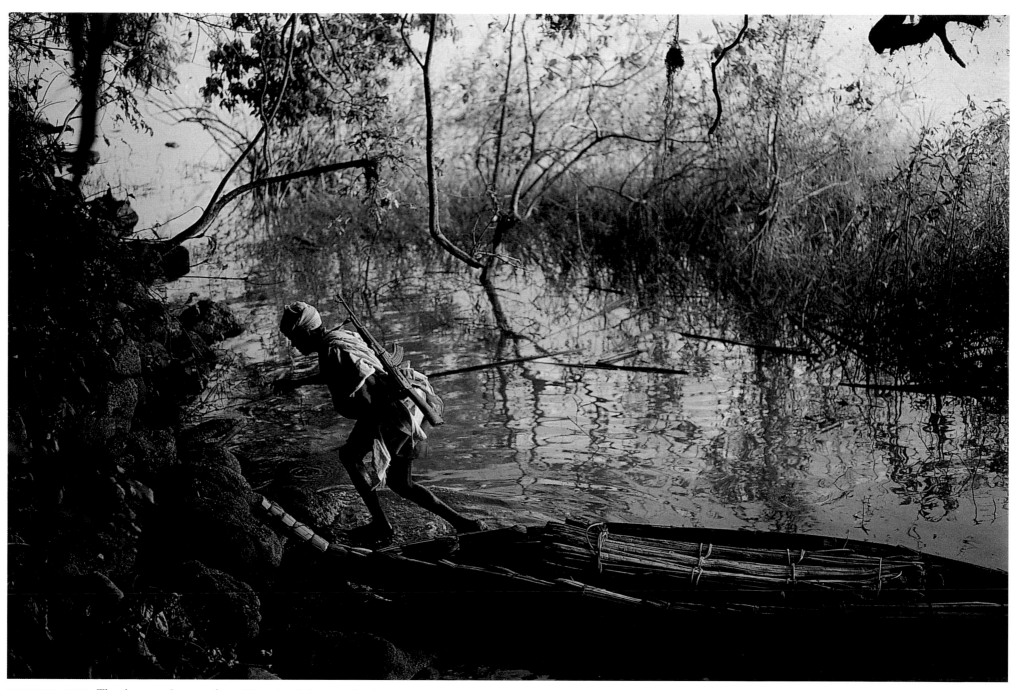

ETHIOPIA, 1998. The deacon of the Narga Selassié Church, on Dek Island in Lake T'ana, never goes out without his Kalashnikov, even when he gets into his *tanqwa* (a traditional-style boat made of reeds). The church's old paintings and books attract the interest of robbers.

127

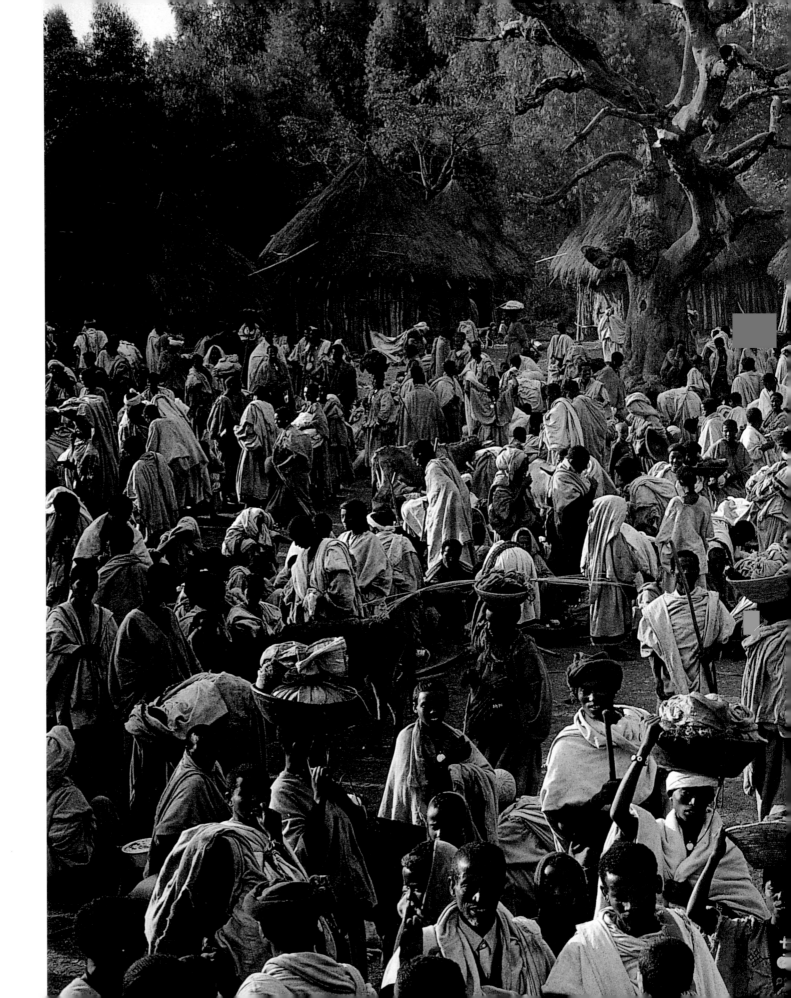

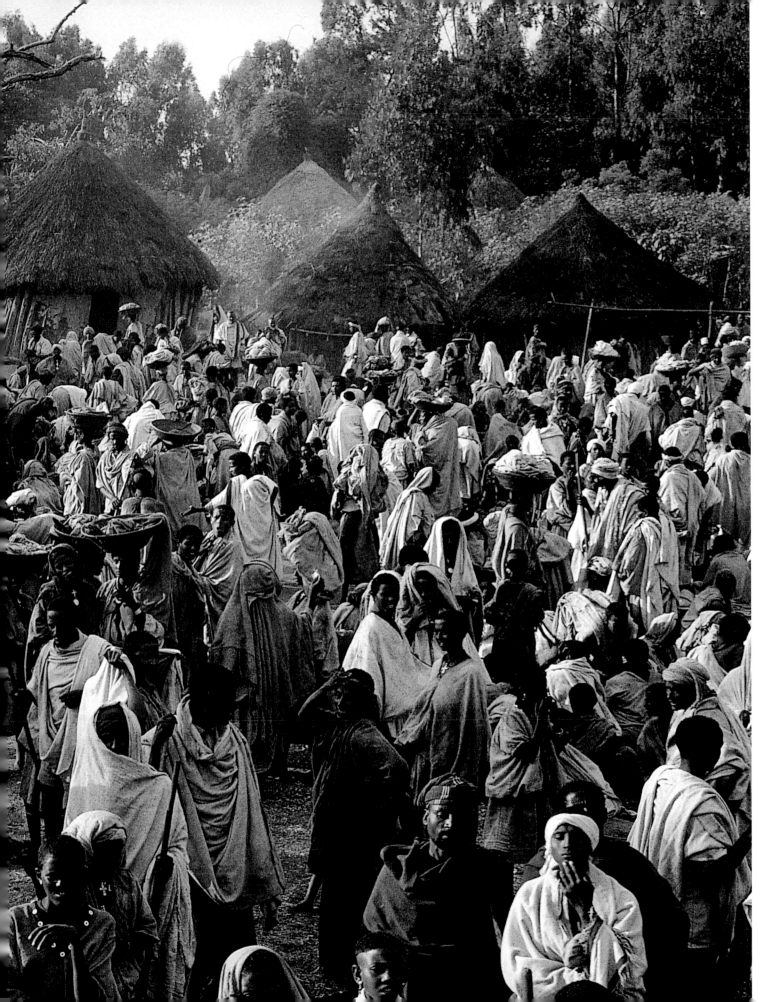

ETHIOPIA, 1998. The locals, dressed in their *shemmas* (large white cotton coverings that protect them from the cold), come to the weekly market to have their grain milled and to buy necessities. The market takes place by the side of the road beside Lake T'ana.

ERITREA, 1992. The city of Nak'fa, once the command post of the Eritrean People's Liberation Front (EPLF), has been bombed hundreds of times; only the mosque has been rebuilt again and again. The first thing the new governing body plans to do is install electricity in the small streets.

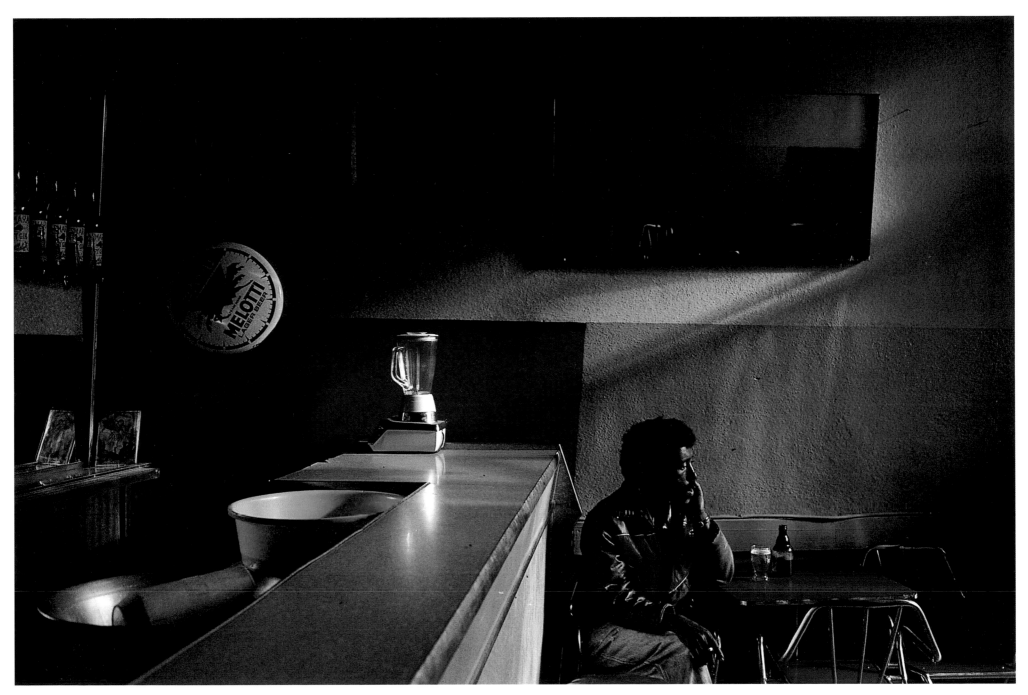

ERITREA, 1992. At a bar in Asmara, the colonial Italian influence is still apparent. Unlike many of the other towns in Eritrea, Asmara is relatively unscathed by the thirty-year war with Ethiopia, as Ethiopian forces fled the city without fighting a full-scale battle.

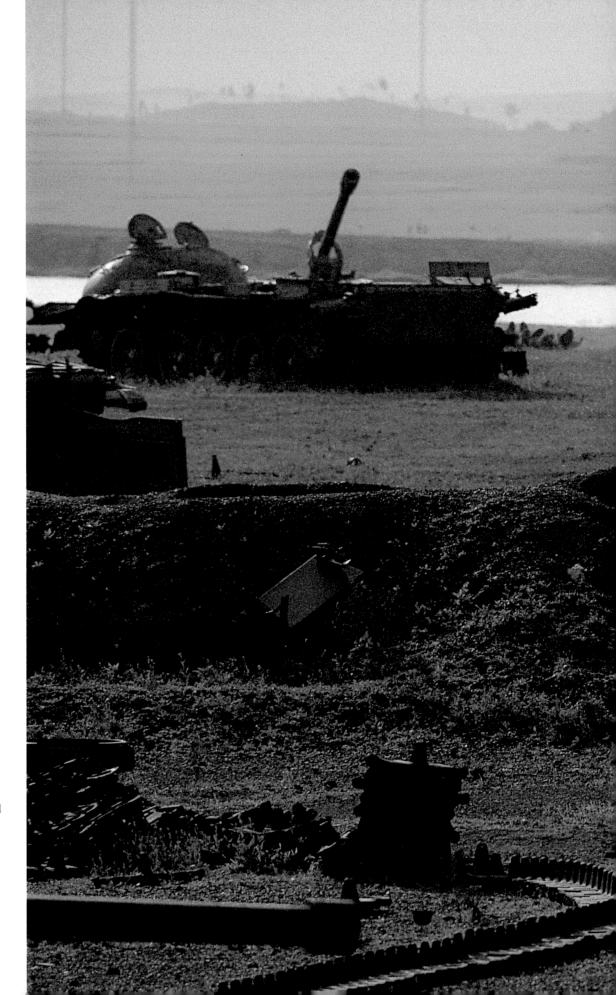

ERITREA, 1992. At Asmara, this is the cemetery for Russian tanks and other military equipment from Mengistu's army that was destroyed in the battles against the Eritrean Liberation Front. The Ethiopians built a wall surrounding these grounds to prevent the inhabitants of the capital from seeing the damage and becoming demoralized.

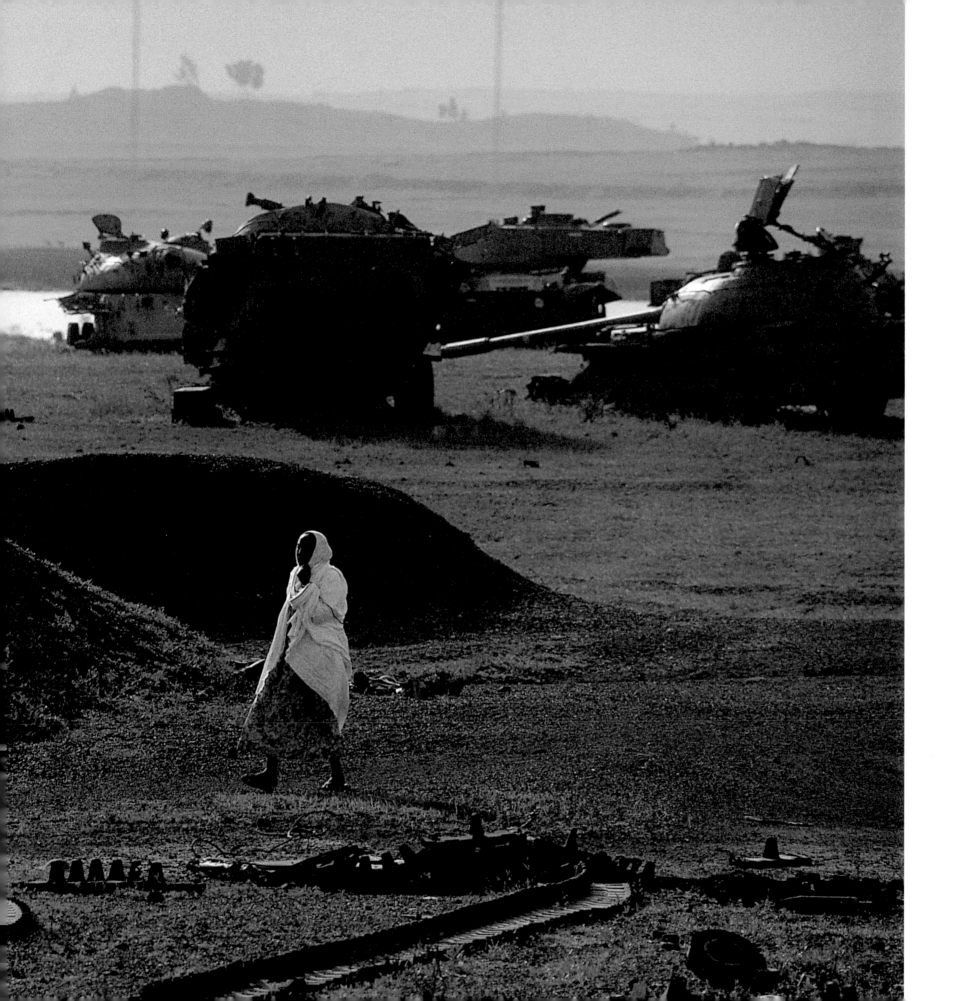

133

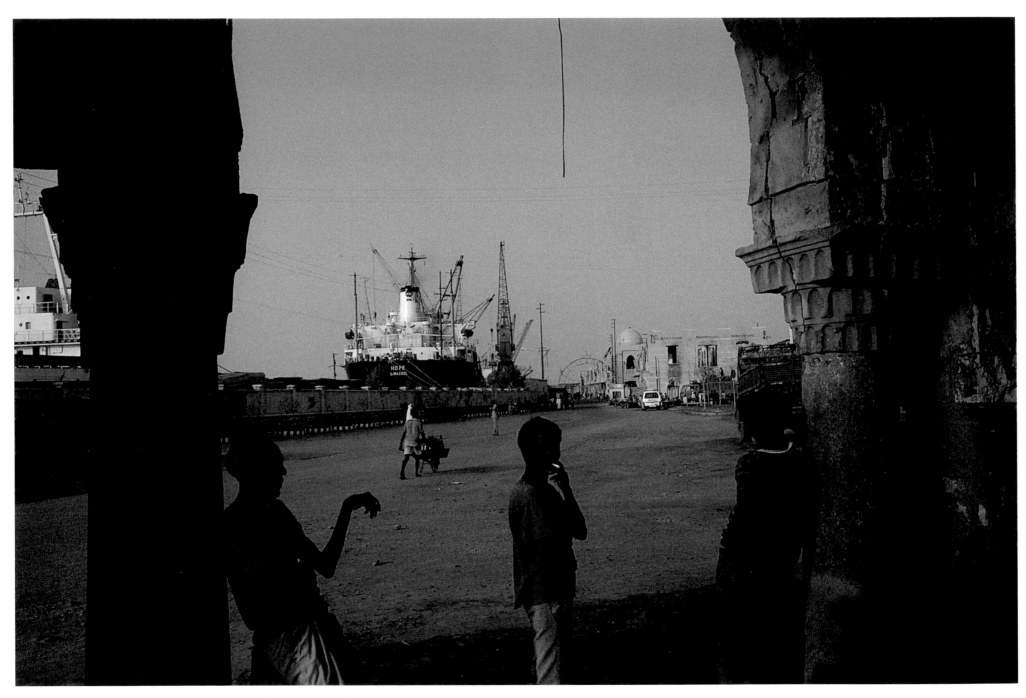

ERITREA, 1992. Massawa, a Red Sea port, fell into the hands of guerrillas in February 1990. In reprisal, the Ethiopians bombed the city, destroying the city once known as "the Pearl of the Horn of Africa."

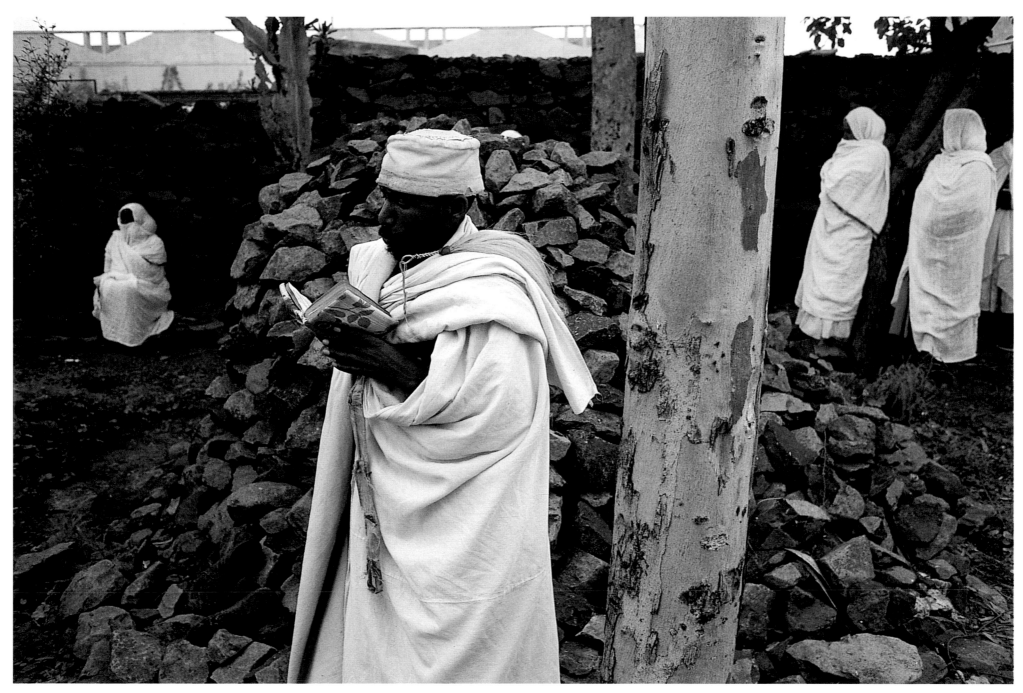

ERITREA, 1992. Sunday morning
Mass in the Church of Santa
Maria. The Eritrean population is
50 percent Muslim and 50 percent
Christian.

SOUTHERN AFRICA

A Land Blessed by the Gods

Having left Lisbon in August 1487, the fragile caravels of Bartholomeu Dias, the Portuguese navigator, traveled the length of the west coast of Africa, passing the shores of Senegal, the "Lands of the Southern Rivers" (Guinea), the "Tooth Coast" (Côte D'Ivoire), and the "Shrimp River" (Cameroon). Then, as they crossed the equator, they steered for Angola (the Kingdom of the Congo) and Namibia (formerly South-West Africa) in the Southern Hemisphere. In early 1488, six months after leaving Europe, the Portuguese ships were confronted with a stormy sea and thrown against a promontory, which for this reason came to be called the Cape of Storms (a little later, it would receive its current name, the Cape of Good Hope). At this promontory, the land, like the stem of a ship, separates two bodies of water, the Atlantic Ocean to the west and the Indian Ocean to the east.

Dias and his companions accomplished an unprecedented feat—they were the first Europeans to reach the tip of Africa, four years before Columbus "discovered" America. Ten years later, the Portuguese Vasco da Gama took the very same route and then continued the full length of the eastern side of Africa, thereby inaugurating the new over-water path to the Indies.

A FABULOUS TREASURE. For Dias and Vasco da Gama, the Cape of Good Hope was nothing more than a good anchorage where they could stock up on fresh meat and fresh water.

NAMIBIA, 1990. *(right and page 140)* Since the war between the South West Africa People's Organization (SWAPO) and South Africa began, the Himba nomads who live in Kaokoland have made it their habit to pay visits to military bases in big cities. Even today they come into the largest city of the region, Opuwo, to shop and drink fresh beer. Because of their isolation, the Himba have not adopted Western customs. Each day, the women coat their bodies with a red pomade made of animal fat and powdered rocks from the desert.

136

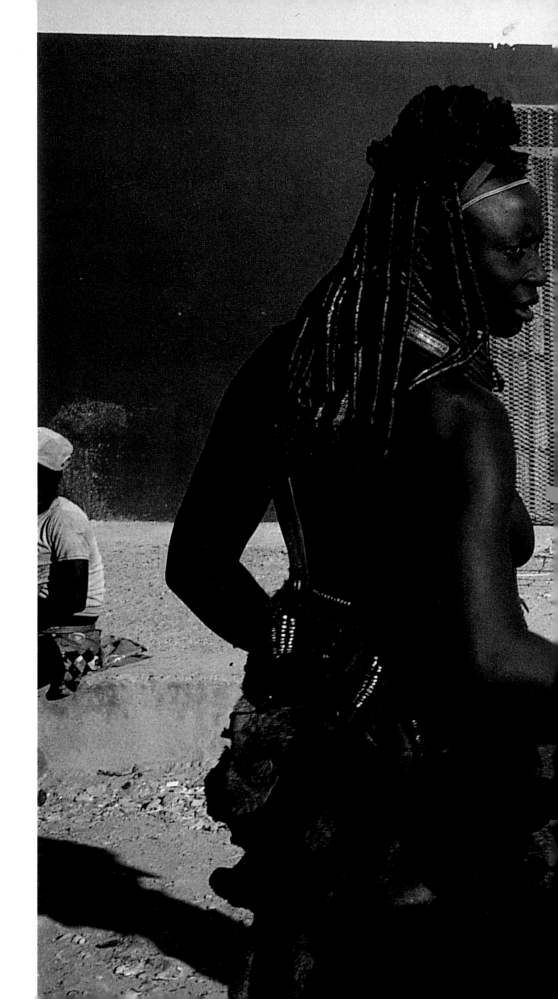

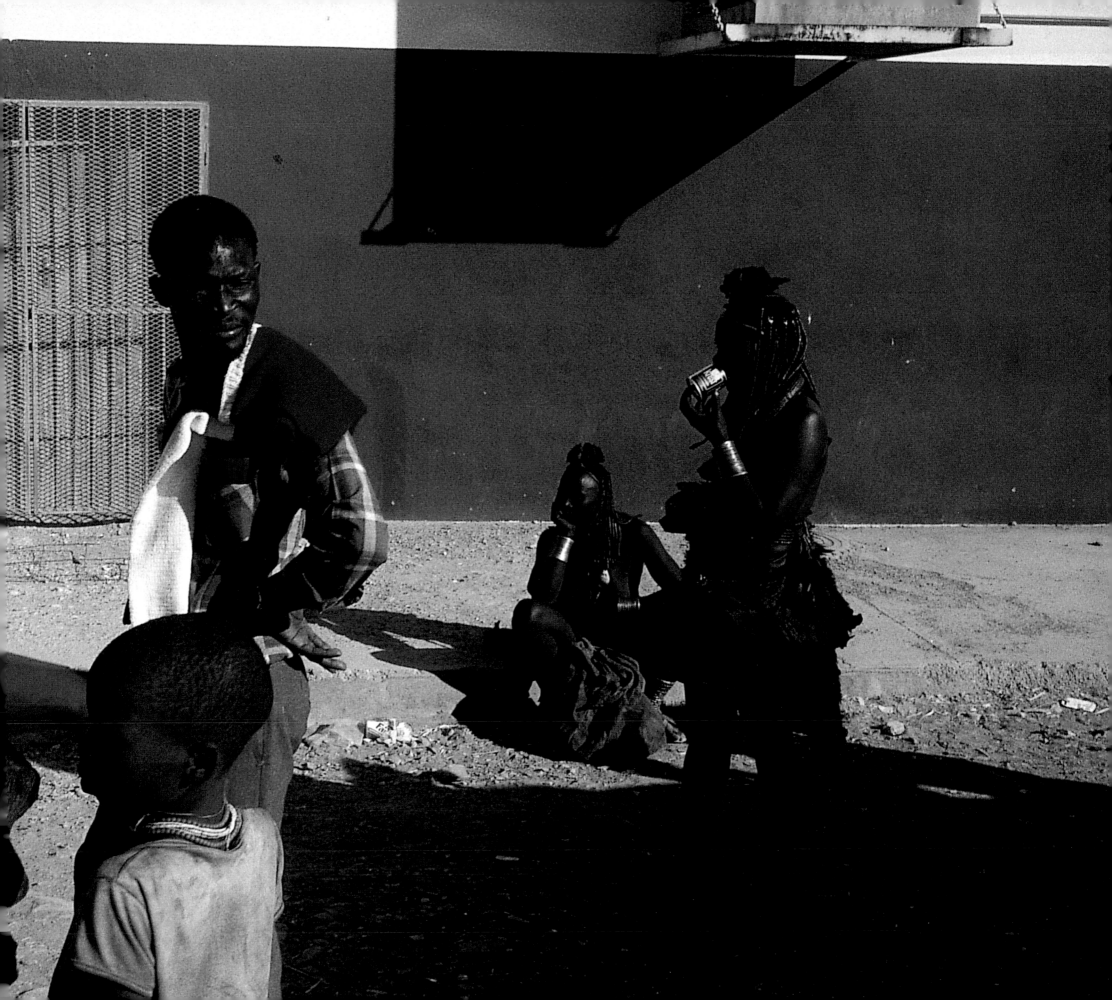

Lingering was out of the question. That was to be the attitude of all Portuguese mariners for more than a century as they retraced the route: they would put into port at the Cape with no intention of founding a new route, obsessed only with the riches to be brought home from the Indies: silk and spices. This was shortsighted, as the South African soil hid a fortune in metals and minerals. It has even been characterized by modern geologists as a "geological scandal"! South Africa truly is a land blessed by the gods, for not only does its earth contain gold and diamonds galore, but also copper, nickel, manganese, iron, vanadium, antimony, and more, although these were not discovered until the end of the nineteenth century.

A POPULATED CONTINENT. When the Portuguese "discovered" Africa in the fifteenth century, the continent was far from empty. In the south, they made contact with one of the oldest peoples of Africa: the Khoisan (Bushmen and Hottentot), who still hunted and gathered berries and roots for food. When the Dutch settlers arrived, they pushed the Khoisan back toward more barren land, into areas such as the Kalahari Desert (between the Zambezi and Orange rivers). The Bantu, though, were another story. Beginning more than a thousand years ago, the Bantu expansion southward—first from Lake Chad, then from the Congo—took place slowly, over the span of several centuries. These peoples, long familiar with the techniques of metallurgy, built great empires such as Monomotapa, whose only remains today are the impressive ruins of the imperial capital at Zimbabwe, south of the Zambezi. As they multiplied, the Bantu eventually broke up into numerous ethnicities. Thus, in the Republic of South Africa alone, there are the Zulu, the Xhosa, the Ndebele, the Swazi, the Tswana, the Sotho, the Venda, and so on.

The Portuguese settled in Angola and Mozambique. Meanwhile the Germans and the Dutch set their sights on the southern lands—the former settling in South-West Africa (now Namibia) and the latter on the Cape of Good Hope. Following the example of the Portuguese, in 1652 the Dutch East Indian Company built a port for its vessels at the foot of Table Mountain.

THE BRITISH AXIS: CAIRO/THE CAPE. Early in the nineteenth century, South Africa witnessed the arrival of the English in force. They chased Dutch settlers away from the Cape and forced them to undertake "the Great Trek," a massive migration inland, before finally waging a full-scale war on them (the Boer War, 1899–1902). As masters of the southern lands (including Botswana, Zimbabwe, and Zambia), the British were finally able to realize their master plan of a continuous empire stretching from the Cape to Sudan, Uganda, Tanzania, and Kenya. First they eliminated their Portuguese rivals, who wanted to link Mozambique to Angola, and then the French, who, from West Africa to Lake Chad, were trying to establish a dominion across Sudan.

THE SONS OF HEAVEN. Spurred by Chaka—the "African Napoleon"—the Zulu people (or "sons of heaven") claimed supremacy over all others due to their military might. They did not hesitate to confront their new masters, the British, and they often succeeded. Thus, on January 11, 1879, in Isandhlwana, the Zulu chief Cetewayo, a nephew of Chaka, launched 30,000 warriors against the British army. Despite the 16,500 soldiers, innumerable cannons, and modern rifles of the British army, the Zulus inflicted the greatest defeat on the Union Jack in its colonial history.

TOWARD INDEPENDENCE. The African peoples' defiance of European colonialism in southern Africa finally resulted in the independence of the region's various territories. Unfortunately, the price of independence was a series of colonial and civil wars, notably in Angola, Mozambique, Zimbabwe, and Namibia. The largest area was South Africa, where from the beginning the black majority had fought zealously to end the policy of apartheid.

With the liberation of Nelson Mandela, the black leader of the African National Congress (the main party opposing the white Afrikaners), and his rise to the presidency there was suddenly a new opportunity for economic growth. Given its mining potential and its increasing industrialization, South Africa can now serve as a catalyst for economic growth throughout southern Africa, pulling neighboring countries, such as Namibia, Botswana, and Mozambique, in its wake. Now that it is reconciled with Mozambique, the South African giant is developing a grandiose project called the Maputo Corridor, a major highway and railroad axis, lined with a string of industrial zones, that would link the two countries' capitals. This should contribute vastly to the increase of trade between Mozambique and the Republic of South Africa. Grouping all the nations of southern Africa together, this project should also allow for a common market, which could lead to a level of prosperity approaching that of the European countries after World War II, when they formed the European Economic Community.

CULTURE AND TRADITIONS. Whites in Africa now have a chance to learn about the civilizations of the peoples they have subjugated for centuries. A rich cultural history offers everything from Khoisan rock paintings to the contemporary music of black singer Miriam Makeba and "white Zulu" Johnny Clegg; from the Makonde statuary of Mozambique to the murals of the Ndebele houses and the paintings of the South African townships; from the jewelry of the Himba and the Herrero of Namibia to the architectural vestiges of the city of Zimbabwe, which are included on the list of UNESCO World Heritage Sites.

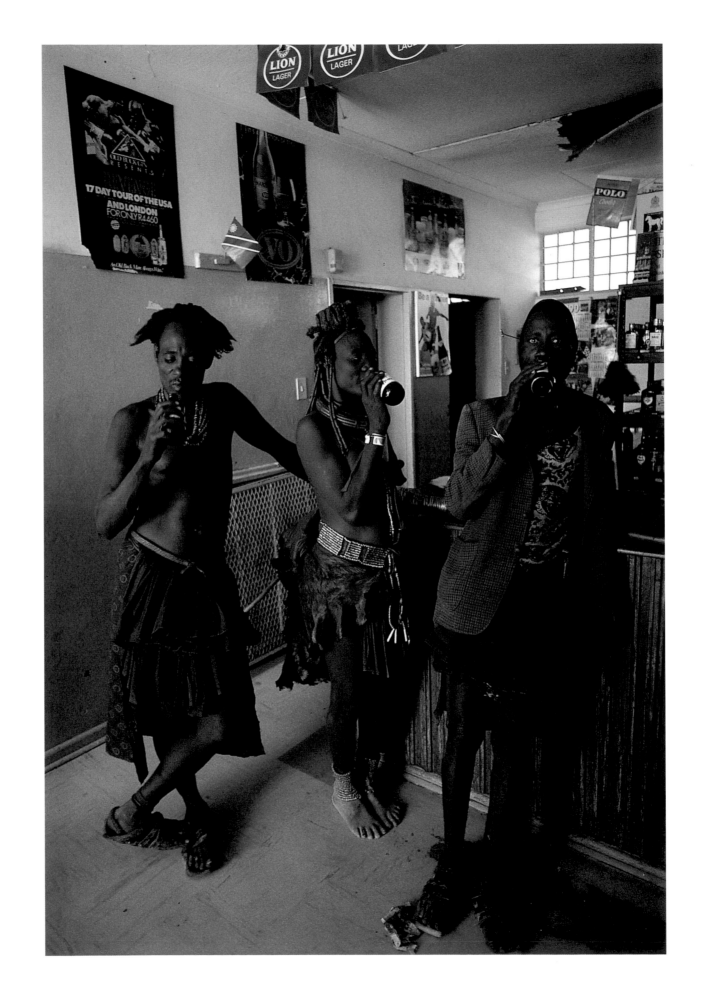

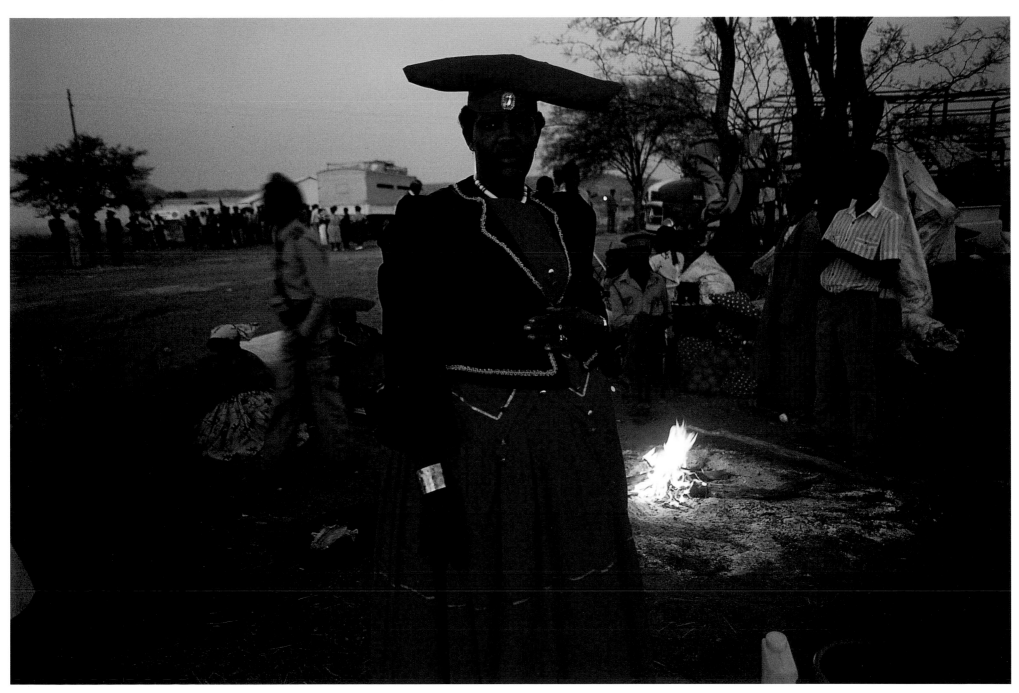

NAMIBIA, 1990. Each year on August 25, more than two million Herero assemble at Okahandja to remember the massacre of their people at the hands of German colonists in 1850, as well as the continued onslaughts. Over 75 percent of the Herero were murdered by so-called German protection forces in 1904 and 1905. Here, the women wear red nineteenth-century Victorian-style dresses. Red is the color of mourning, and red and black are also the colors of Herero nationalism and the nineteenth-century German Empire. The men wear German volunteer uniforms.

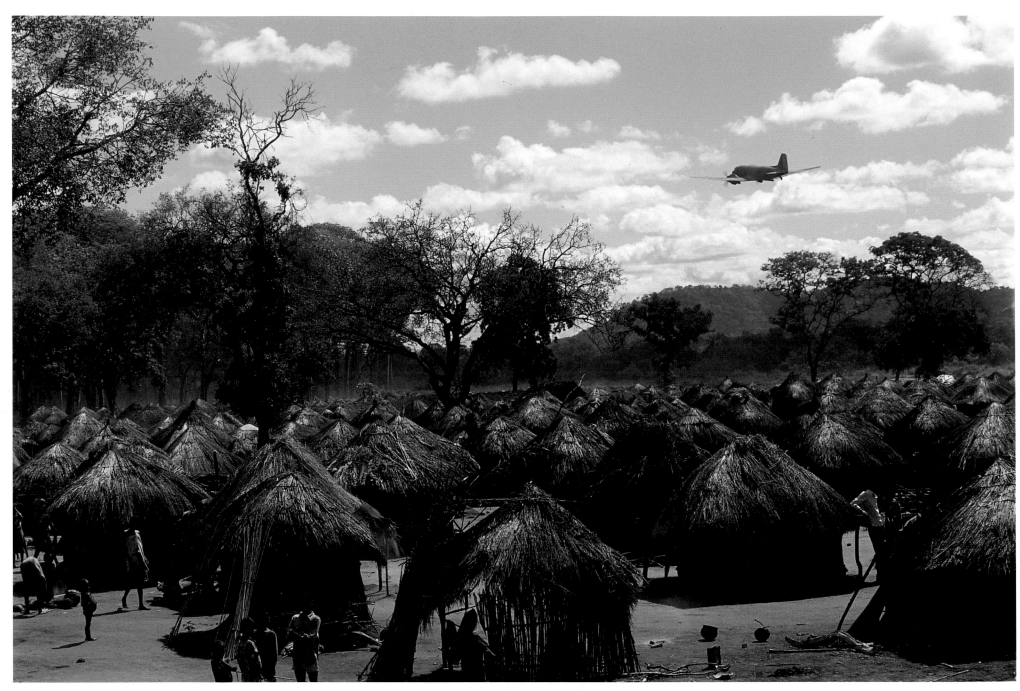

MOZAMBIQUE, 1989. At the Casa Bana camp, people are protected by the Zimbabwean army. Although they are safe here, they are also extremely isolated: they cannot leave the camp. Their supplies are delivered by military planes. All around them, Mozambique National Resistance (RENAMO) rebels kill or mutilate everyone they encounter.

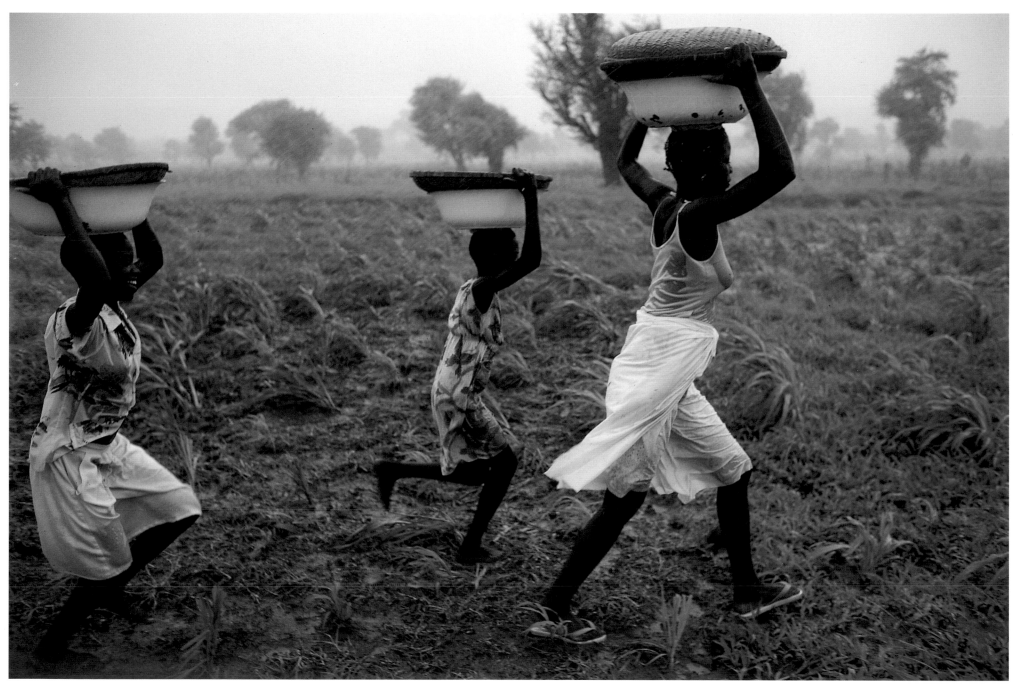

MOZAMBIQUE, 1990. In a tropical storm, young women of the Benga camp near Tete return from collecting water.

143

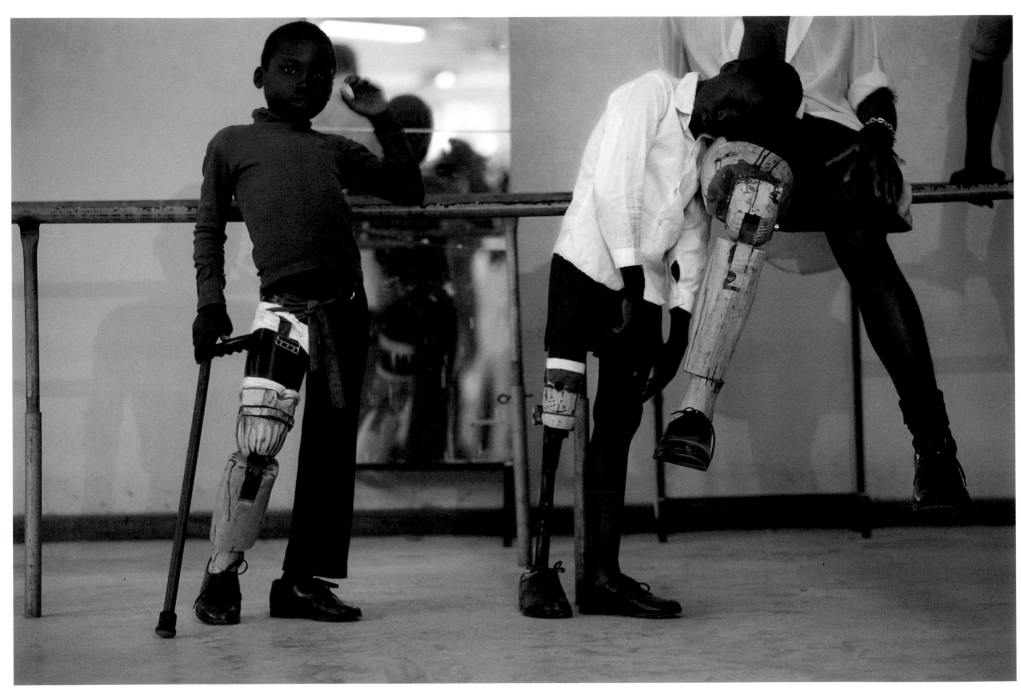

MOZAMBIQUE, 1990. Every morning children come to the Red Cross center to learn to walk with artificial legs; it is an exhausting process. The conflicts with RENAMO were some of the most brutal on the continent. More than 90 percent of the country was destroyed. RENAMO forces mutilated people by cutting off ears, noses, breasts, and genitals. They deported many others, and sent children to the front, loaded with drugs.

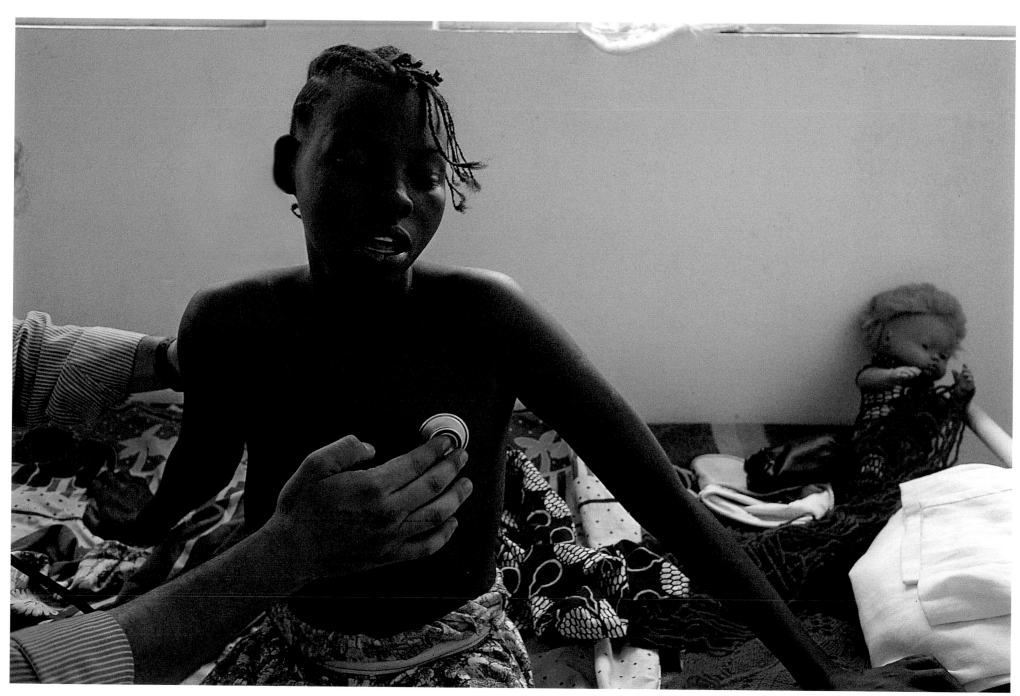

ANGOLA, 1998. A little girl is cared for by an NGO doctor in the Menongue hospital; in this country devastated by war, diseases spread quickly.

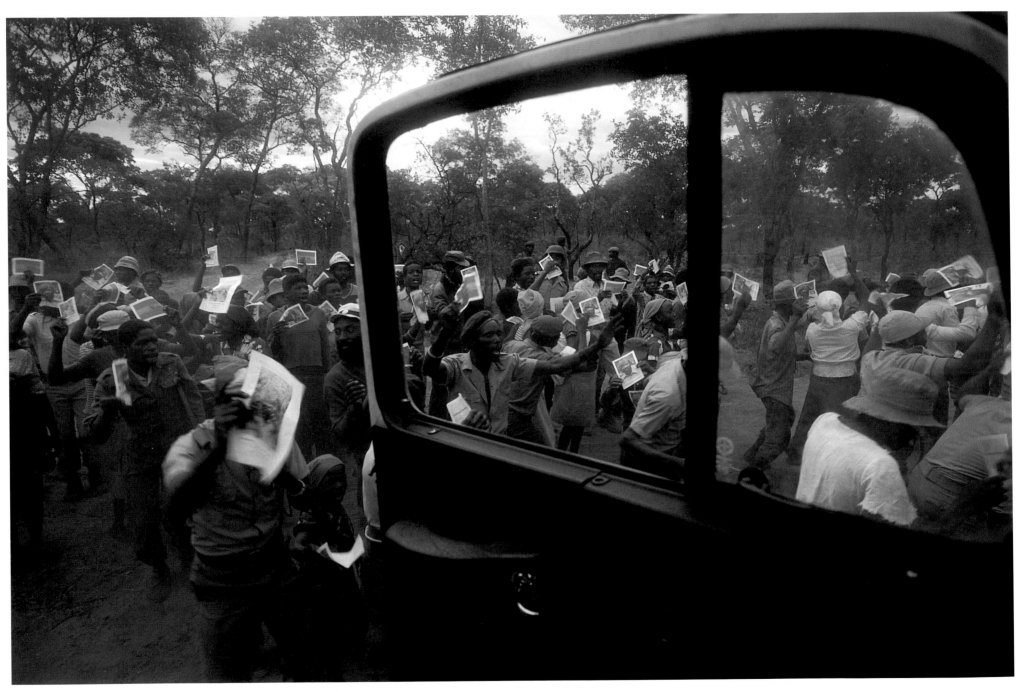

ANGOLA, 1984. In Mavinga, the crowd unleashes its anger. They chant the anthem "A victoria para nos" at a meeting of UNITA (National Union for the Total Independence of Angola), the movement formed by Jonas Savimbi.

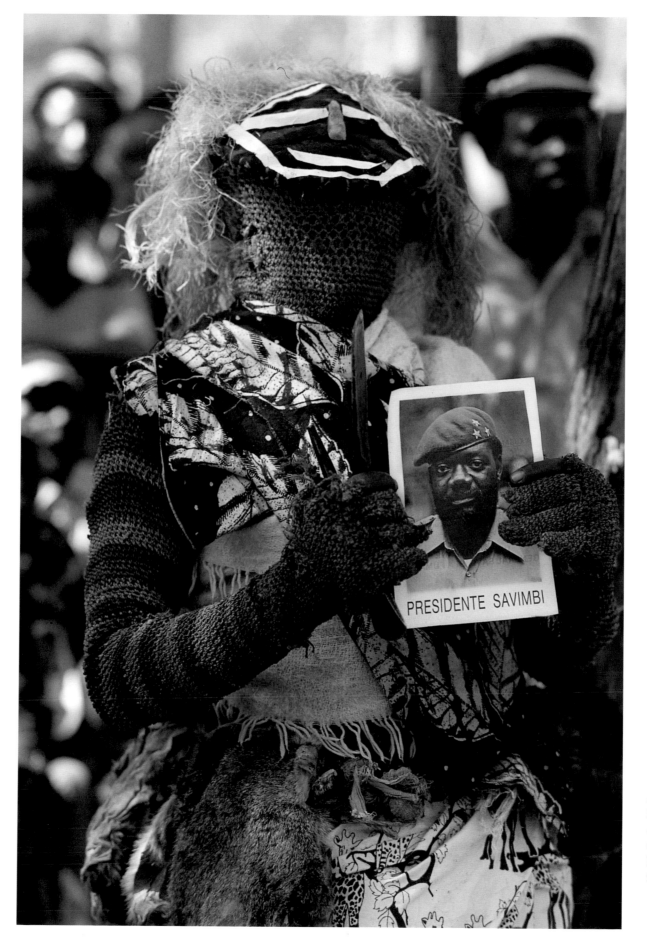

ANGOLA, 1984. At a meeting in Lumbala Kaquengue, an *oviangangi* (sorcerer) holds up a portrait of Jonas Savimbi, the leader of UNITA and spokesman for the resistance.

PRESIDENTE SAVIMBI

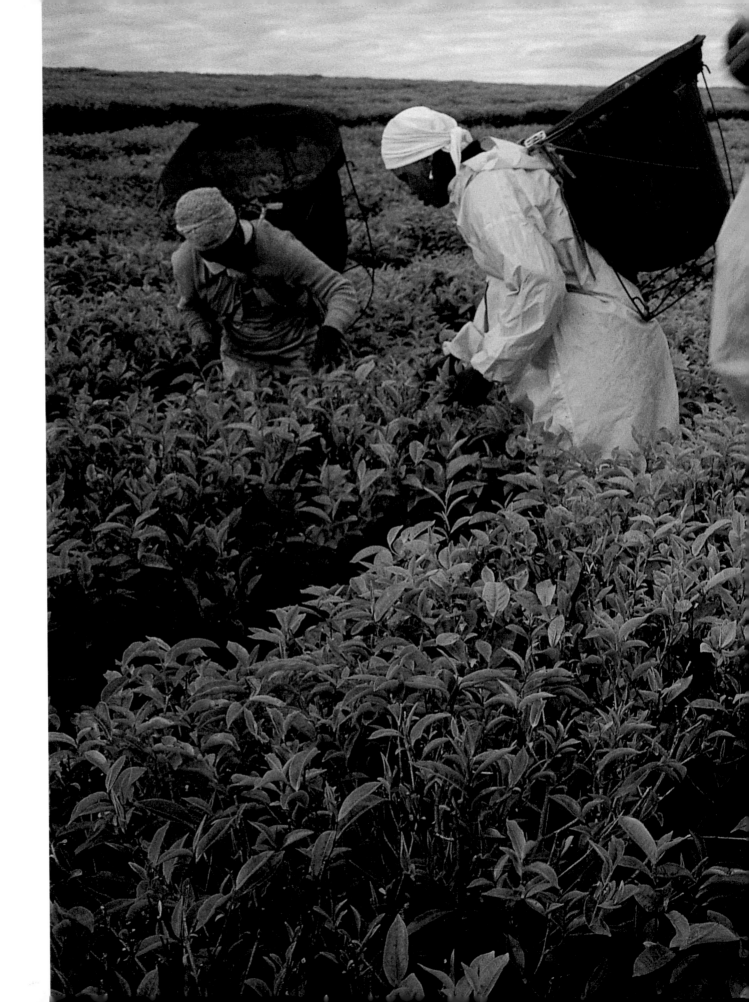

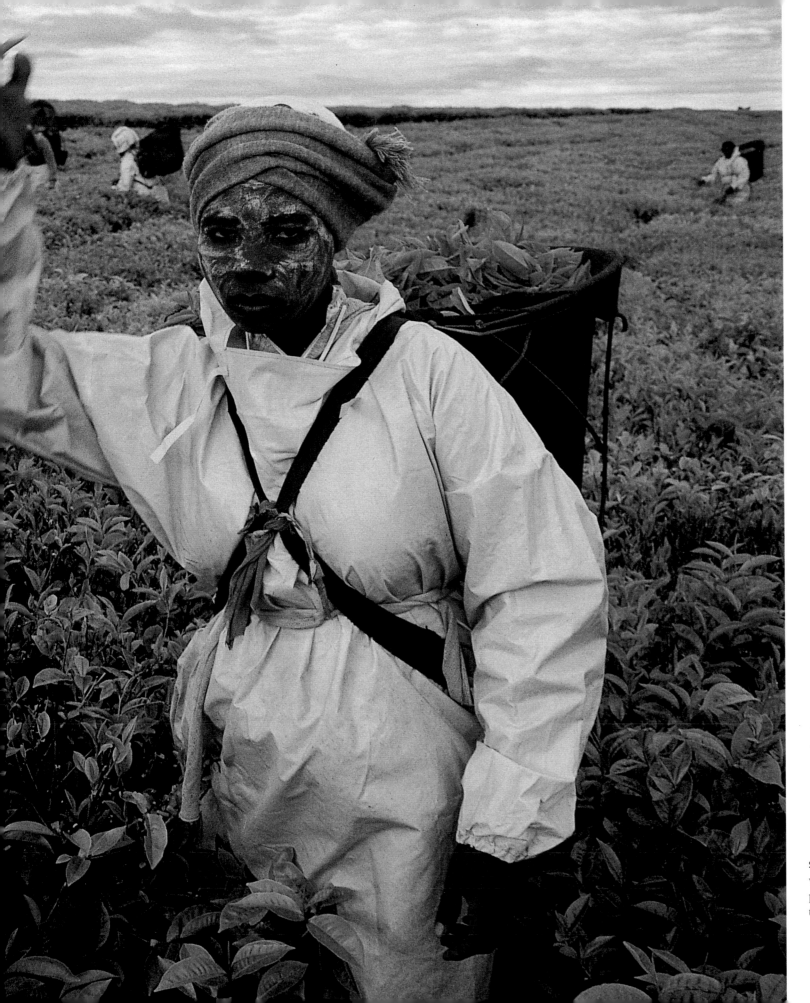

SOUTH AFRICA, 1992. Xhosa women gather tea in the Lusikisiki plantation in Transkei–tea that they will undoubtedly never taste.

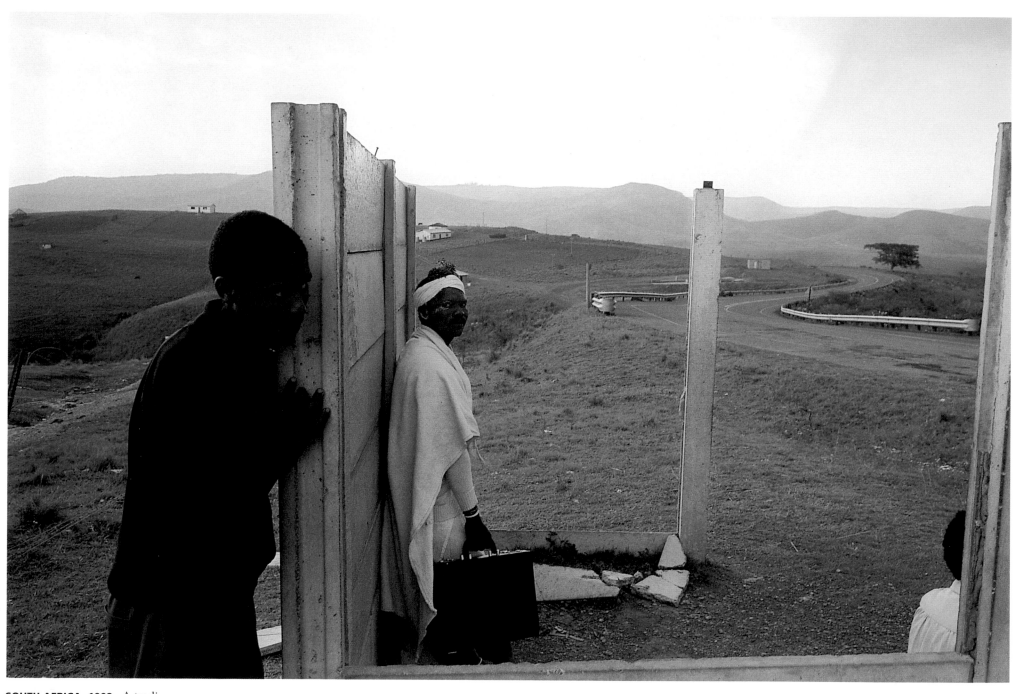

SOUTH AFRICA, 1992. A traditional healer waits at a bus stop by the road from Transkei.

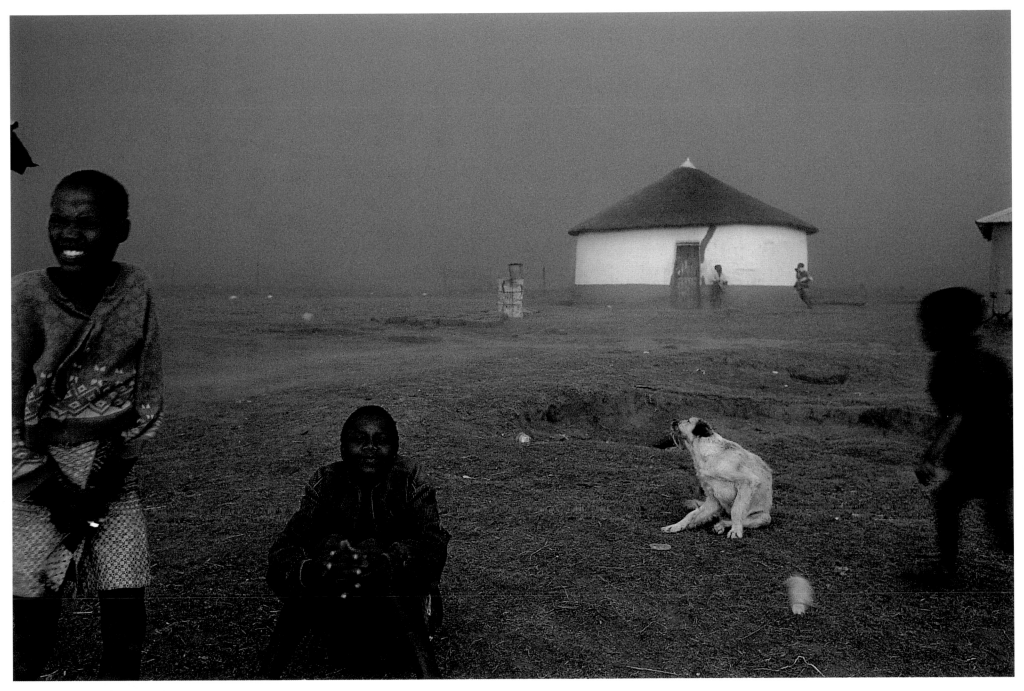

SOUTH AFRICA, 1992. A sand-
storm invades the village of Caba
Vale in the heart of Transkei.

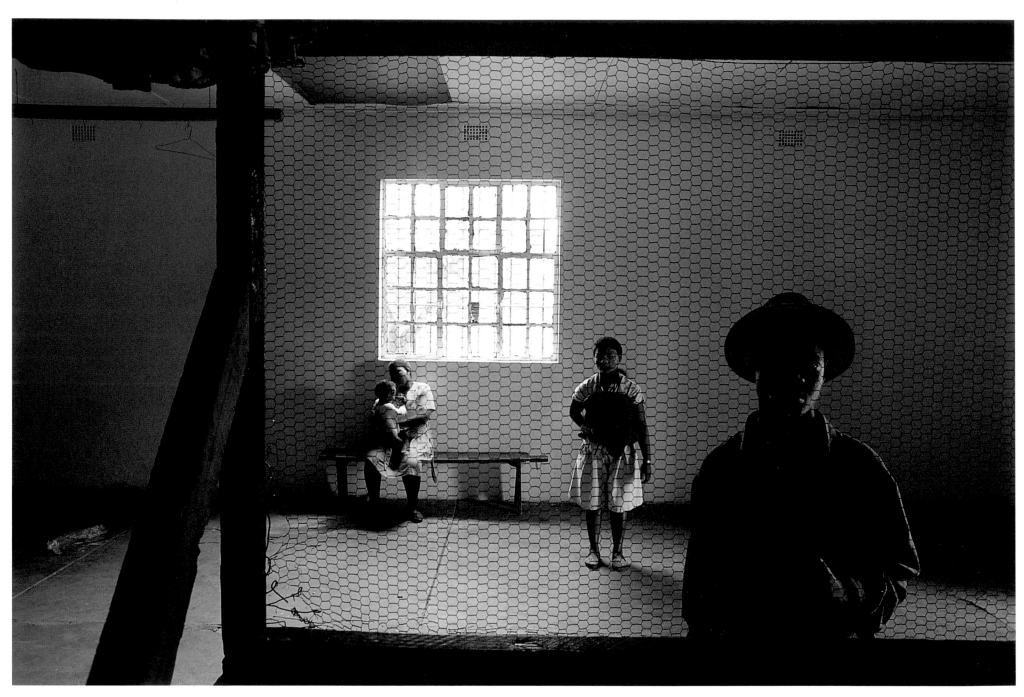

SOUTH AFRICA, 1992. In this Transkei bush-shop, the owner protected his merchandise and cash with a wire grille. This sort of fearfulness was very prevalent, particularly at the time of the conflicts between the Zulus of the Inkatha Freedom Party (IFP) and the Xhosa of the African National Congress (ANC).

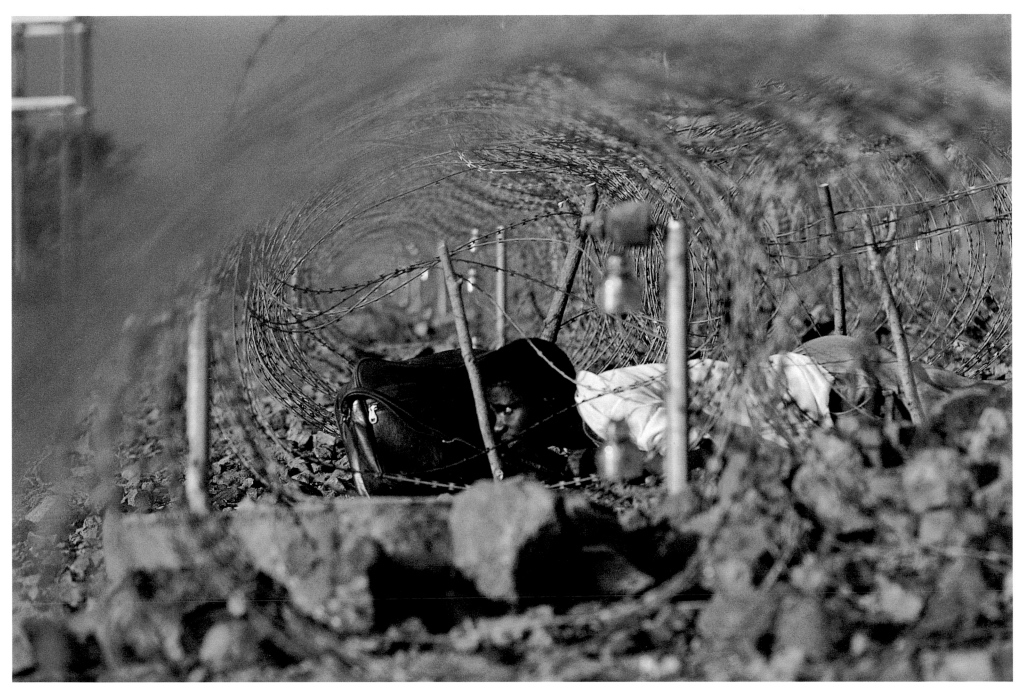

MOZAMBIQUE, 1993. A young Mozambican attempts to get through the barrier that served as the border along seventy-two kilometers between Mozambique and South Africa. In order to get through, the seven wires of the electric fence (3,500 volts) had to be lifted with a wooden fork. Next, the army and police patrols had to be evaded before the South African "Eldorado" was reached. Between 1987 and 1989, ninety-four people died trying to get through the barrier (dubbed the "Serpent of Fire" by locals). Although the fence was still up after Nelson Mandela came to power, the electricity was shut off.

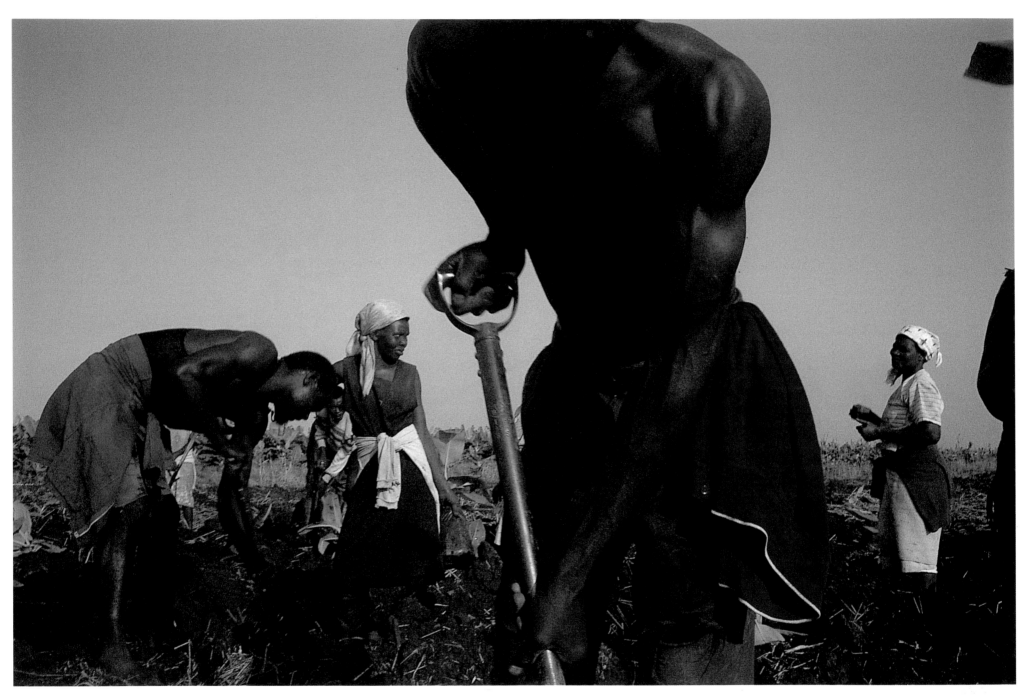

SOUTH AFRICA, 1993. *(above and opposite)* Excellent farm laborers, illegal immigrants from Mozambique, are a great boon to white farmers. Normally, once they are hired onto a farm, they are able to escape army and police raids. But it sometimes happens that dishonest farmers turn them in to the authorities just before payday, to avoid paying them. In this case, they are sent back to Mozambique and must start from scratch.

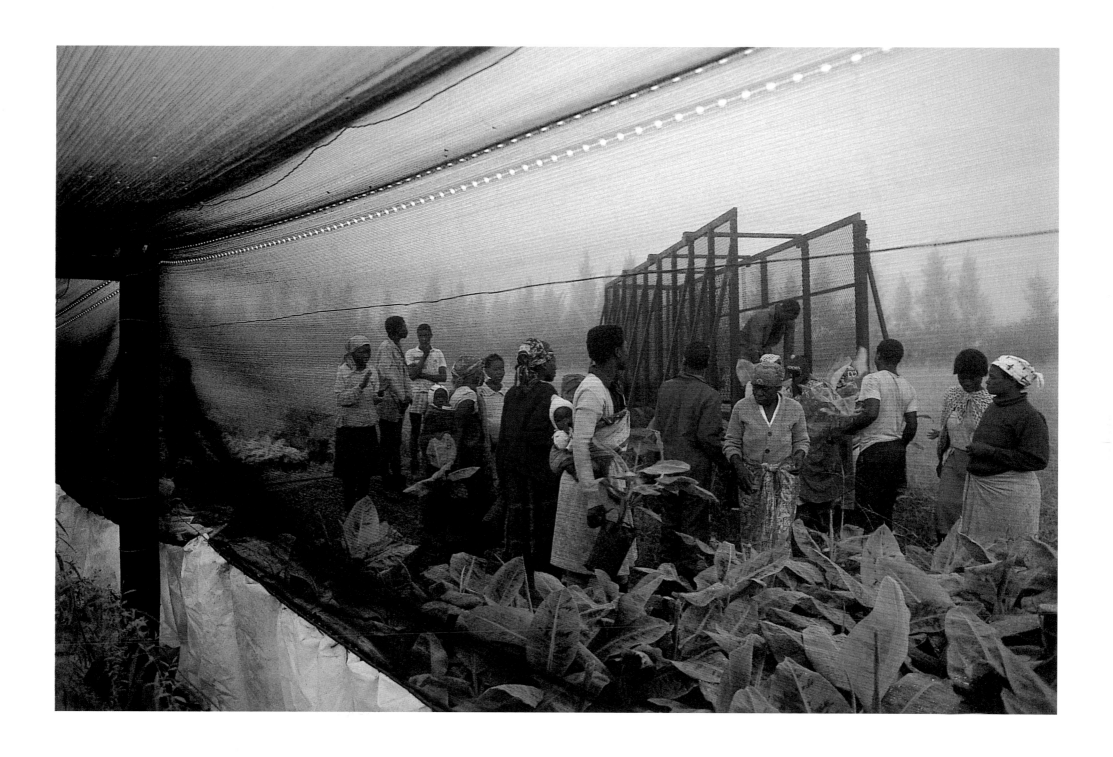

155

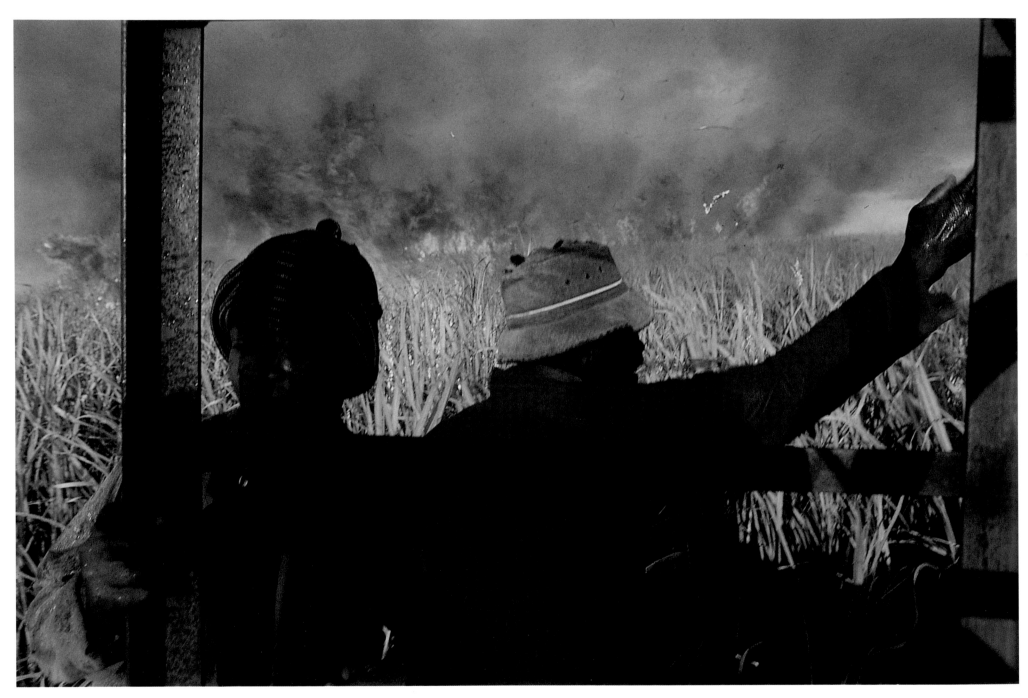

SOUTH AFRICA, 1991. In Empangeni, the cradle of the Zulu people, peasants burn the weeds in sugarcane fields before the harvest.

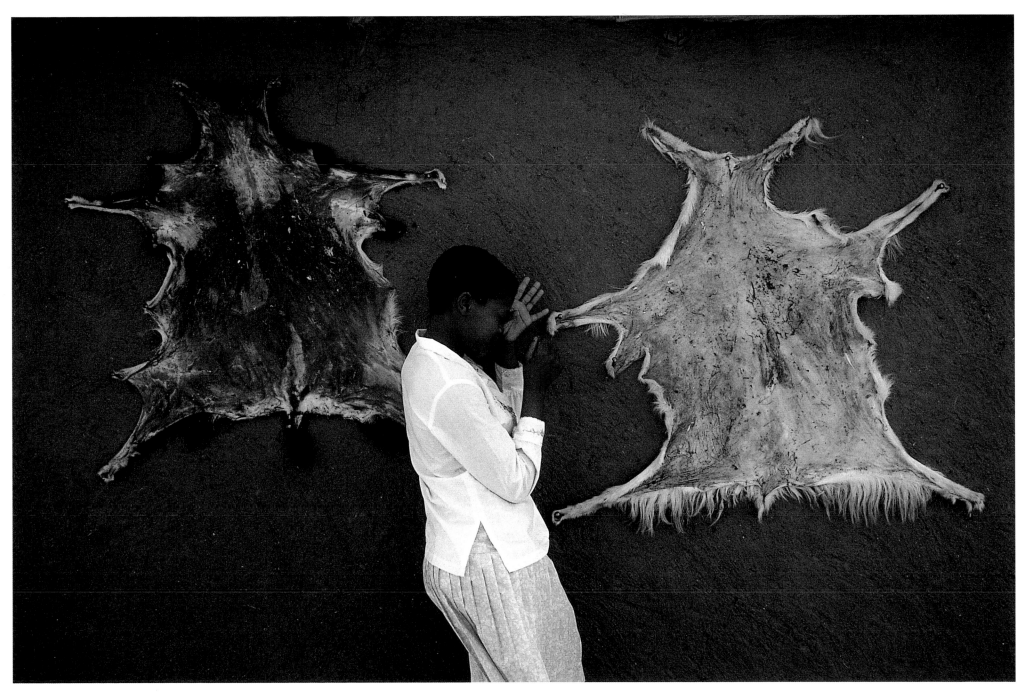

SOUTH AFRICA, 1991. In the village of Bhakimbazo, this young girl weeps for her Zulu brother, killed in a conflict between Zulus of the Inkatha and Xhosas of the ANC at Alexandra, Johannesburg Township. The funerals of village community members killed in the big cities were occasions for large political demonstrations in Zulu areas.

ENCOUNTER WITH AFRICA

Pascal Maitre

There are several ways to present Africa, but I have deliberately chosen to do so by way of large geographic areas rather than themes, for in each of these areas the elements of which it consists—nature and landscapes, people and their traditions, lifestyles and dramas—are all intimately linked and mixed. Without a doubt, here more than anywhere else in the world, nature has shaped the people. The African landscape is so abrupt, so dry and severe, or so green, oppressive, and mysterious, that in exploring it one better understands the caliber of the people who inhabit it.

Soon it will be twenty years that I have been traveling the length and breadth of more than thirty countries in black Africa, some of them as many as a dozen times, and slowly but surely I have begun to feel a little as if I were at home there.

During my first stay on the continent, in Burundi and Rwanda (names which until then I did not even know existed, as is true for the majority of Westerners), I was lucky enough to travel with Mohamed Maïga, an African colleague from the magazine *Jeune Afrique* (Young Africa). While we were exploring the roads of these small countries, Maïga explained many things to me: the life of the people, politics, the economy, traditions, and more. I flung myself into African life headfirst; at night we stayed with people in the bush, sleeping on the floor and sharing in the experience of the family. Often we arrived very late, but even then they would offer us hospitality and food; killing, preparing, and serving us chicken at four o'clock in the morning. This is how I discovered the notion of African time; this was also my apprenticeship in patience and hours of talk.

On my next trip, I spent three weeks in Brazzaville, and once again I was lucky enough to travel with another colleague from *Jeune Afrique*, the Congolese Jean Bruno Thiam. During this stay, I had my meals at Thiam's mother's house every day, where a dozen of his friends would congregate and I would listen to them, patiently continuing my inner apprenticeship. Thiam was also a close friend of Seigneur Rochereau, one of the greatest African musicians, and of M'Billia Bel, a Congolese singer. We spent every night together, standing in the wings during concerts, in bars; that was where I had the privilege of discovering the universe of African music—again, from the inside.

It is true that the more I go to Africa, the more I feel at ease there. At one point, I noticed that the lifestyle in rural areas is quite close to that of my childhood in Berry. In the house of my maternal grandfather, a small farmer, there was always a plate turned upside down on the table, in case someone who hadn't eaten stopped by at mealtime—a bit like African hospitality. My grandfather's worries about his land and his cattle, too, were not very different from those of the farmers in Burkina Faso. On my father's side, my great-grandfather, my grandfather, and my father were all blacksmiths and healers, much like the blacksmiths in Africa.

Crossing the Cuango River in silence, on a boat with Jonas Savimbi (leader of the UNITA guerrilla movement in Angola), I could only think of my own childhood nights of poaching, when my father and I would take up the fish traps or the ropes. It was the same when I clandestinely crossed the Algerian border at night to join the Tuareg rebellion in Niger. That reminded me of nighttime trips to pick up bird traps without getting caught. I was raised in that world, which allowed me to approach the Africans more directly, to go straight to the heart of things and, undoubtedly, to speak a common language.

I finally understood that I was searching for what I already knew.

In Africa I attended many magic celebrations, extraordinary events that left me completely overwhelmed; but one day in Burkina Faso I became conscious of the grave, solemn, and sacred character of these rituals. Panga, the chief of the Bwa village Boni, had written me twice to invite me to the great funeral celebrations of the Leader of the Masks. I attended the ceremonies in my role as photographer, but, more important, as a guest of the chief. For several days the celebration continued in full swing and I worked without any problems. I only had to make a ritual sacrifice for the ancestors to accept my photographs.

On the most important day, the great procession of masks began and my friend, chief Panga, explained to me that there was a small but very powerful mask at the head of the cortege that I should not pass in front of while I was taking pictures. I followed his instructions and passed behind its back. Then, suddenly, the celebration stopped. Big uproar: I was not supposed to cut through the line between the masks. A tribunal was set up and I was judged. Panga told me there was nothing he could do anymore; I had to pay a fine of 1,000 French francs for having broken a taboo. The money would be used for sacrifices, the chief explained, and if I failed to comply he would be held responsible for any calamity that might befall the village—drought, diseases, poor harvests, etc.—since he had allowed a stranger to break the laws that directed the life of the group. That day I realized that one pays harshly, and in cash, for the least mistake in Africa. There is no protection whatsoever, nor any safeguard.

Africa does not surrender easily, and even if it continues to be magical and bewitching I cannot forget the hours spent in official buildings waiting for permission to work, obtaining visas, or fixing problems that didn't exist. Nor can I forget the many times I was taken in for questioning because I had taken photographs, sometimes just of a landscape. Nor the times I had to calm down soldiers, raging mad with bulging eyes, as they threatened me with their weapons. My only hope in those situations was patience, kindness, and sometimes humor to defuse a situation that was about to get out of hand.

There were times when it was hard to control my anger and disgust. I am thinking now of the camp at Bati, where Ethiopian peasants fleeing the drought were gathered, and where, at the end of their rope, some sixty of them were dying every night. Early in the morning, mothers would come and, crying out their despair to me, pull me by the cuff of my pants to come and photograph their child who had just died. But above all else, Africa is full of courage and life, and an indestructible strength—like a boxer who, though groggy, goes on fighting to avoid being KO'd.

The greatest lesson in strength and life I ever learned was in 1990 in Mozambique, then still in the midst of a war. I was in the small village of Vilancoulos. In a hospital room, a man was sitting on a bed. The previous day, as he was returning home from the fields with a companion, he had run into a RENAMO group (the guerrilla movement). The rebels had killed his friend and then cut off the surviving man's genitals. It was a message of intimidation intended for the other men of the village should they refuse to collaborate. And there I was, facing this man, shocked and distraught, who had the strength to smile at me and say, "You see, it's hard here. But then, how is it where you are?" He said this with a large smile, the will to live having already won out.

By my going to Africa frequently, Africa ended up capturing me. Today I have a wife and children with the blood of the continent running through their veins. Despite my vast experience of Africa, I have the feeling that it is thanks to them that my initiation has actually begun.

ACKNOWLEDGMENTS

Many are the people without whom this book would never have seen the light of day. All of my gratitude goes first and foremost to my African friends who, without any hesitation, opened their lives, their homes, and their hearts to me. Most especially Burundi Maggy, who taught me the greatest lessons in courage, dignity, and generosity; my friend Romuald Hazoume, an artist from Benin; chief Panga of the Bobo in Burkina Faso; Kali of the Bassari in Senegal; Mano Dayak of the Tuareg in Niger, who, alas, was gone too soon to see this book; and Mohamed Ixa, Limane Feltou, and Kalakoa. I would also like to express gratitude here to Ruth Eichorn, who believed in this project from the start, and tirelessly defended and supported it throughout the two years of its preparation.

Also to Peter Mathias Gaede for his confidence and support throughout our many years working together, which, at least in part, ended with this book.

I especially want to thank Christiane Breustedt, whose marvelous advice, friendship, and unfailing support have allowed me to make progress and love this profession. I am grateful to Jean Luc Marty and Sylvie Rebbot, whose friendship and advice have been inestimable for the completion of my work and for this book in particular.

My gratitude goes to all my colleagues in journalism: Pierre Gaillard, Bart Grill, Alain Louyot, Mohamed Maïga, François Soudan, and Emanuel Transon, who had the patience and kindness to support me during my reporting in Africa. And especially to Jean Claude Nouvelière and Michael Stuhrenberg, who were so willing to participate in the work on this book as well.

Thanks also to Robert Fiess and Yan Meot, who entrusted me with reports that led to some of the photos in this book; to Christine Laviolette and Valerie Bellamy of the photo service GEO France; to Juliane Berensmann-Nagel, Elisabeth Degler, Barbel Edse, Christian Gargele, Venita Kaleps, Sabine Wuensch, and Geneviève Tegler of GEO Germany for their invaluable help throughout my reportages on Africa. To my photographer friends Hélène Bamberger, Alain Keler, Daniel Laîné, and Serge Sibert for their encouragement and critical acumen.

I am grateful to the whole team at Aperture for their help, their understanding, and their work, particularly to Michael Hoffman, my publisher, Michael Sand, my editor, and Wendy Byrne, the artistic director of this book, and Mary Walling Blackburn for her careful research. I thank the teams of the photo agencies for their collaboration: Focus in Hamburg, Matrix in New York, and Cosmos in Paris.

To Calixthe Beyala, for her marvelous preface, I am greatly indebted.

I most especially thank Marcel Maître, my father, for having taught me the notion of freedom and for having had confidence in me since the beginning of time; and Shungu Albert, my father-in-law, for having welcomed me into his large African family. Alas, both of them have gone too soon to see this book.

I do not know how to thank my family—Ekanga, Chubert, and Nicolas—for having put up with my absences, which were too long, and for having supported me in this project despite all odds.

Library of Congress Catalog Card Number: 00-103931
Hardcover ISBN: 0-89381-916-6

Book design by Wendy Byrne
Jacket design by Peter Bradford and Joshua Passe
Printed and bound by Sfera International srl., Milan, Italy

The Staff at Aperture for *Mon Afrique*:
Michael E. Hoffman, *Executive Director*
Michael L. Sand, *Executive Editor*
Stevan A. Baron, *V.P., Production*
Lisa A. Farmer, *Production Director*
Mary Walling Blackburn, *Assistant Editor*
Paige McCurdy, *Production Work-Scholar*
Nadia Turpin, *Administrative Work-Scholar*

Aperture Foundation publishes a periodical, books, and portfolios of fine photography and presents world-class exhibitions to communicate with serious photographers and creative people everywhere. A complete catalog is available upon request.

Aperture Customer Service: 20 East 23rd Street, New York, New York 10010. Phone: (212) 598-4205. Fax: (212) 598-4015. Toll-free: (800) 929-2323. E-mail: customerservice@aperture.org

Aperture Foundation, including Book Center and Burden Gallery: 20 East 23rd Street, New York, New York 10010. Phone: (212) 505-5555, ext. 300. Fax: (212) 979-7759. E-mail: info@aperture.org

Visit Aperture's website: www.aperture.org

Aperture Foundation books are distributed internationally through:

CANADA: General/Irwin Publishing Co., Ltd., 325 Humber College Blvd., Etobicoke, Ontario, M9W 7C3. Fax: (416) 213-1917.

UNITED KINGDOM, SCANDINAVIA, AND CONTINENTAL EUROPE: Robert Hale, Ltd., Clerkenwell House, 45-47 Clerkenwell Green, London, United Kingdom, EC1R OHT. Fax: (44) 171-490-4958.

NETHERLANDS, BELGIUM, LUXEMBURG: Nilsson & Lamm, BV, Pampuslaan 212-214, P.O. Box 195, 1382 JS Weesp, Netherlands. Fax: (31) 29-441-5054.

AUSTRALIA: Tower Books Pty. Ltd., Unit 9/19 Rodborough Road, Frenchs Forest, Sydney, New South Wales, Australia. Fax: (61) 2-9975-5599.

NEW ZEALAND: Southern Publishers Group, 22 Burleigh Street, Grafton, Auckland, New Zealand. Fax: (64) 9-309-6170.

INDIA: TBI Publishers, 46, Housing Project, South Extension Part-I, New Delhi 110049, India. Fax: (91) 11-461-0576.

For international magazine subscription orders to the periodical *Aperture*, contact Aperture International Subscription Service, P.O. Box 14, Harold Hill, Romford, RM3 8EQ, United Kingdom. One year: $50.00. Price subject to change. Fax: (44) 1-708-372-046.

To subscribe to the periodical *Aperture* in the U.S.A. write Aperture, P.O. Box 3000, Denville, New Jersey 07834. Toll-free: (800) 783-4903. One year: $40.00. Two years: $66.00.

First Edition

10 9 8 7 6 5 4 3 2 1